Franz Ackermann
Matthew Barney
Janet Cardiff
John Currin
Hanne Darboven
Thomas Demand
Mark Dion
Willie Doherty
Olafur Eliasson
Kendell Geers
Felix Gonzalez-Torres
Ann Hamilton
José Antonio Hernández-Diez
Pierre Huyghe
Alex Katz
William Kentridge
Bodys Isek Kingelez
Suchan Kinoshita
Martin Kippenberger
Kerry James Marshall
Takashi Murakami
Shirin Neshat
Ernesto Neto
Chris Ofili
Gabriel Orozco
Markéta Othová
Laura Owens
Edward Ruscha
Gregor Schneider
Ann-Sofi Sidén
Roman Signer
Sarah Sze
Sam Taylor-Wood
Nahum Tevet
Diana Thater
Luc Tuymans
Kara Walker
Jeff Wall
Jane & Louise Wilson
Chen Zhen

CI:99/

00/V.01

Nov 6, 1999 – Mar 26, 2000

Carnegie International 1999/2000

Carnegie Museum of Art/Pittsburgh, Pennsylvania

Curator/Madeleine Grynsztejn

Assistant to the 1999/2000
Carnegie International/**Alyson Baker**

Advisory Committee/
Okwui Enwezor
Susanne Ghez
Lars Nittve

Carnegie Prize Jury/
Richard Armstrong, Pittsburgh
Okwui Enwezor, New York, Chicago, Kassel
Edith H. Fisher, Pittsburgh
Susanne Ghez, Chicago
Marcia M. Gumberg, Pittsburgh
Lars Nittve, London

Lenders

Albright-Knox
Art Gallery, Buffalo,
New York

Alexander and Bonin,
New York

American Fine Arts Co.,
New York

Judith and Adam
Aronson, St. Louis

The Arts Council
of England

The Baltimore
Museum of Art

Barbara and Peter
Benedek

The Berardo Collection

Blum & Poe,
Santa Monica

Marianne Boesky
Gallery, New York

The Bohen Foundation

Bonakdar Jancou
Gallery, New York

Sammlung Boros,
Wuppertal

Stefania Bortolami

The British Museum,
London

Gavin Brown's
enterprise, New York

C.A.A.C. – The Pigozzi
Collection, Geneva

Galeria Camargo Vilaça,
São Paulo

Galerie Luis Campaña,
Cologne

Galerie Gisela Capitain,
Cologne

Janet Cardiff

Carnegie Library of
Pittsburgh

Carnegie Museum
of Natural History,
Section of Birds

Deutsche Bank AG,
Frankfurt am Main

Mark Dion

Frances Dittmer

The Hon. and Mrs.
Thomas F. Eagleton

Stefan T. Edlis and
Gael Neeson

Martin and Rebecca
Eisenberg

Olafur Eliasson

Konrad Fischer Galerie,
Düsseldorf

Gagosian Gallery

Kendell Geers

Stuart and Lisa
Ginsberg, New York

Barbara Gladstone
Gallery, New York

Sammlung Goetz,
Munich

The Estate of Felix
Gonzalez-Torres

Marian Goodman
Gallery, New York
and Paris

Galerie Hauser & Wirth,
Zurich

Marieluise Hessel
Collection on permanent
loan to the Center
for Curatorial Studies,
Bard College,
Annandale-on-Hudson,
New York

Max Hetzler, Berlin

Susan and Michael Hort

Jablonka Gallery,
Cologne

The Dakis Joannou
Collection, Athens

Jay Jopling, London

Wendy Evans Joseph

Sean Kelly Gallery,
New York

Suchan Kinoshita

The Estate of Martin
Kippenberger

Koplin Gallery,
Los Angeles

Susanne Küper, Berlin

Lisson Gallery, London

Vicki and Kent Logan

Louisiana Museum of
Modern Art, Humlebæk,
Denmark

Michael and Ninah
Lynne

Marlborough Gallery,
New York

Kerry James Marshall

Matt's Gallery, London

Silvia Menzel, Berlin

Friedrich Meschede,
Berlin

Victoria Miro Gallery,
London

Warren and Victoria
Miro, London

MORA Foundation

Jane and Marc
Nathanson

Ernesto Neto

neugerriemschneider,
Berlin

Galerie Nordenhake,
Stockholm

Patricia and Morris
Orden, New York

Museo Alejandro
Otero, Caracas

Markéta Othová

Meredith Palmer Gallery,
Ltd., New York

Lari Pittman and
Roy Dowell

Anthony T. Podesta,
Washington, D.C.

Private Collections

Michael Reifenrath,
Karlsruhe

Mima and Cesar
Reyes, Viejo San Juan,
Puerto Rico

Lydia W. Robinson,
New York

A.G. Rosen, Wayne,
New Jersey

Andrea Rosen Gallery,
New York

Rubell Family Collection

Allison and Neil Rubler,
New York

San Francisco Museum
of Modern Art

Scharpff Collection,
Stuttgart

Gregor Schneider

The Schorr Family
Collection

Alexander Schröder,
Berlin

Jack Shainman Gallery,
New York

Ann-Sofi Sidén

Brent Sikkema, New York

S.M.A.K., Stedelijk
Museum voor Actuele
Kunst, Ghent

Giovanni Solari

Sperone Westwater,
New York

Speyer Family
Collection, New York

Städtisches Museum
Abteiberg,
Mönchengladbach

Sarah Sze

Philip Taaffe, New York

Tate Gallery

Nahum Tevet

Diana Thater

1301PE, Los Angeles

303 Gallery, New York

Dean Valentine
and Amy Adelson,
Los Angeles

Collection van Loon,
Amsterdam

Sammlung Volkmann,
Berlin

Jeff Wall

Galerie Barbara Weiss,
Berlin

Thea Westreich and
Ethan Wagner

Andrew Wheatley and
Kaethe Cherney, London

Terry Winters, New York

Neda Young

Zeno X Gallery, Antwerp

Mary and Harold Zlot

David Zwirner, New York

Carnegie International 1999/2000
November 6, 1999 – March 26, 2000

The 1999 *Carnegie International* is sponsored by Mellon Bank. **Ⓜ Mellon**

Major support is provided by income from the A.W. Mellon Educational and Charitable Trust Endowment Fund, and by The Grable Foundation; The Heinz Endowments; the National Endowment for the Arts; the Pennsylvania Council on the Arts; US Airways; The Andy Warhol Foundation for the Visual Arts; The Bohen Foundation; The Peter Norton Family Foundation; and the Commonwealth of Pennsylvania.

Additional support has been received from Simone and Heinz Ackermans; the Danish Contemporary Art Foundation; The Broad Art Foundation, Santa Monica; the Department of Foreign Affairs and International Trade of Canada/Ministère des Affaires étrangères et Commerce international du Canada; ArtPace, A Foundation for Contemporary Art/San Antonio; Susan and Lewis Manilow; The Juliet Lea Hillman Simonds Foundation, Inc.; the Mondriaan Foundation; The British Council; and the Trust for Mutual Understanding.

Additional in-kind contributions have been provided by Safway Steel Scaffolds Company of Pittsburgh; The Dakis Joannou Collection, Athens; Nextel Communications; and the *Pittsburgh Post-Gazette*.

ISBN 0-88039-037-9
ISSN 1084-4341

Published in 1999 by Carnegie Museum of Art, 4400 Forbes Avenue, Pittsburgh, Pennsylvania 15213-4080.

Produced by the Carnegie Museum of Art Publications Department: Gillian Belnap, Head of Publications; Elissa Curcio, Publications Associate; and Beth Levanti, Coordinator of Photographic Services.

Editor: David S. Frankel
Copy Editor: Bob Brunning
Design: 2 x 4, New York
Typesetting: Moveable Type Inc., Toronto
Lithography and Printing: Grafisches Zentrum Drucktechnik, Ditzingen-Heimerdingen, Germany
Typeset in Swiss. The paper is Ikono Gloss and Planoscript.
The paper used in this publication meets the minimum requirements of the American National Standard for Information Sciences—Permanence of Paper for Printed Library Materials, ANSI Z39.48-1984.

Contents

Sponsor's Statement / Martin G. McGuinn

Carnegie Museum of Art is an extraordinary public institution and a great cultural treasure, both within this region and beyond. Mellon is honored and pleased to sponsor the 1999 *Carnegie International*. The exhibition's long and distinguished record of presenting the works of the most significant artists of its time is as inspiring as it is informative.

Like Carnegie Museum of Art, Mellon's history is also a distinguished one, and its longtime commitment to enriching lives and invigorating the economy through the arts is profound. We salute the artists whose work comprises the 1999 *Carnegie International*, recognizing that what they create both reflects today and provides a window into the future.

It is also fitting to recognize the countless months of hard work and dedication of the many who have been involved in this project, especially Museum director Richard Armstrong and *Carnegie International* curator Madeleine Grynsztejn. Within this dramatic showcase, they are embracing the diversity of art in all its forms and underscoring its importance in the world. For that, we are extremely grateful, and we are proud to be part of the enterprise.

Martin G. McGuinn
Chairman and Chief Executive Officer
Mellon Financial Corporation

 Mellon

Foreword/Richard Armstrong

The *Annual* exhibition at the Department of Fine Arts, Carnegie Institute, begun in 1896 at the behest of patron Andrew Carnegie, was intended by him to be "something as nice as a salon in Paris." Paintings by contemporary European and American artists were hung by country of origin on the skylit, leather-covered walls of the galleries and Pittsburghers flocked to see them. Throughout its first half-century, the exhibition grew in scope, was discontinued because of wars and lack of funds, and then was begun again. Renamed the *Pittsburgh International* by 1950, it gained notoriety and artistic credibility in succeeding decades. With the inauguration of the generous galleries of the Scaife wing in 1974, the *Pittsburgh International* reassumed its stature in a larger and radically changed art world. Endowed with funds from the A.W. Mellon Educational and Charitable Trust in 1980, the yet rechristened *Carnegie International*—meant to appear triennially—has become a mecca for the worldwide audience interested in contemporary art.

It is the region's premier visual arts event, and North America's only international survey exhibition. The sensibilities of its organizers and the vigor of each era's practicing artists lie beneath what might appear as the monolithic history of the show. Carnegie's wish that it "spread goodwill among nations through the international language of art" was characteristic of his seemingly evangelical direction; in retrospect, it has proven a noble and accommodating goal.

I think each curator of this show, as I was in its last incarnation in 1995, grows in organizing it, savors its presentation, and hands it on to successors with relief, high hopes, and empathy for the nearly endless challenges it entails. Such were my feelings in asking Madeleine Grynsztejn to take on this task two and a half years ago. She undertook and has pursued the *International* with her unique combination of open-mindedness and a powerful, synthesizing intelligence. A more capable, engaging, and responsible curator for an exhibition of this prominence is unimaginable; I know the artists whose work is represented here join me and her co-workers in saluting Madeleine with admiration and gratitude.

Episodic surveys of contemporary art have become more widespread since 1896—particularly in the last forty years. The *Carnegie International* recognizes and relishes its status as a progenitor of so many exhibitions. Thus, we are especially gratified in 1999 to have gained sponsorship for it from so venerable and visionary a neighbor as Mellon. We owe a particular debt to its chairman and Carnegie Museum of Art board member, Marty McGuinn, and to Mellon's remarkable staff. We further applaud the many gracious lenders to the 1999 *Carnegie International*; to the artists whose work animates it goes our great and aroused respect.

Richard Armstrong
The Henry J. Heinz II Director

Acknowledgments/Madeleine Grynsztejn

A project of this size and scope could not have been achieved without the enlightened interest and generous support of several agencies. We are grateful to Mellon and Martin G. McGuinn for the pivotal support of this exhibition in its earliest stages, with thanks as well to Sandra McLaughlin and James P. McDonald. We are fortunate that in 1980 the A.W. Mellon Educational and Charitable Trust created an endowment to support the *Carnegie International*. For their handsome grant in support of educational programming, we wish to thank The Grable Foundation. We also salute The Heinz Endowments. The contributions of the National Endowment for the Arts are accepted with utmost gratitude, as are those of the Pennsylvania Council on the Arts and US Airways. I am indebted to The Andy Warhol Foundation for the Visual Arts, especially Pamela Clapp and Archibald Gilles. Frederick B. Henry of The Bohen Foundation has my heartfelt thanks for the support of the commissioning and presentation of media works, with appreciation to Joan Weakley. I am grateful to Peter and Eileen Norton and to Susan Cahan of The Peter Norton Family Foundation for their largesse. We also thank the Commonwealth of Pennsylvania. For their support of specific artists' projects I wish to thank Simone and Heinz Ackermans; the Danish Contemporary Art Foundation; Eli Broad of The Broad Art Foundation, Santa Monica; the Government of Canada/Gouvernement du Canada; ArtPace, with special thanks to Linda Pace and Laurence Miller; Susan and Lewis Manilow; Lea Simonds, longtime ally of the museum; the Mondriaan Foundation; The British Council; and the Trust for Mutual Understanding. Additional in-kind contributions were generously given by Safway Steel Scaffolds of Pittsburgh; The Dakis Joannou Collection, Athens; Nextel Communications; and the *Pittsburgh Post-Gazette*, with special recognition to John G. Craig, Jr.

This exhibition would have been impossible without the initiative and constant support of Richard Armstrong, The Henry J. Heinz II Director of Carnegie Museum of Art, who with Michael Fahlund, assistant director, and Milton Fine, Museum of Art Board chairman, and other board members demonstrated an unfailing commitment to this ambitious endeavor. I am particularly indebted to Richard for inviting me to undertake this time-honored exhibition and for his valuable advice and constant encouragement over the entire length of this project.

In the course of organizing this exhibition, I have incurred many debts to artists I visited and to fellow curators, scholars, gallery representatives, critics, collectors, and friends whom I value greatly and whose contributions were extremely helpful. I benefited foremost from the counsel of an exceptional three-member advisory committee: Okwui Enwezor, artistic director of *Documenta XI*; Susanne Ghez, director of The Renaissance Society at the University of Chicago; and Lars Nittve, director of the Tate Gallery of Modern Art. Their intelligent and rigorous assessment of my concepts and their generous recommendations have been central to this exhibition's success. Former *Carnegie International* organizers and advisors likewise lent their ear, shared ideas, and gave suggestions and encouragement; I thank Lynne Cooke, Mark Francis,

John R. Lane, and Nicholas Serota for their keen insights. Other individuals gave intellectual advice and support; their names are listed, and their acquaintance has been one of this project's greatest rewards.

In preparation for travels to twenty-seven countries over the course of two and a half years, I relied on the counsel of a great many individuals. I would like to extend particular thanks to those colleagues who welcomed and guided me for days at a time while I visited their home countries: Carolyn Christov-Bakargiev, James Lingwood, Midori Matsui, Tomas Pospiszyl, Dirk Snauwaert, Adam Szymczyk and Andrzey Przywara, Jolie Van Leeuwen, and Toby Webster. My travels were both intellectually and financially subvented by The Peter Norton Family Foundation, whose Curators Workshop in March 1997 allowed me to glean advice from colleagues, and whose sponsorship of travel to South Africa influenced my work. I also wish to acknowledge Tomás Ybarra-Frausto of The Rockefeller Foundation, whose support of Arts International's "Bellagio Conference on International Exhibitions," with Noreen Tomassi as organizer, gave me the unusual opportunity to engage in many informative discussions. Frank Ligtvoet at the Consulate General of the Netherlands subsidized my research trip to the Netherlands, and Lars Grambye and the staff of the Danish Contemporary Art Foundation sponsored my travel to Denmark, further providing me with information and a warm welcome.

For their gracious assistance in facilitating arrangements and providing research materials, I am indebted to the following gallery heads and their staffs: Carolyn Alexander, Kirsty Bell, Elba Benítez, Walter Biggs, Kirsten Biller, Tim Blum, Marianne Boesky, Tanja Bonakdar, Ted Bonin, Irene Bradbury, Gavin Brown, Robert T. Buck, Brian Butler, Ellen Callamari, Karla Meneghel Ferraz de Camargo, Luis Campaña, Gisela Capitain, Isabelle Cart, Angela Choon, Candy Coleman, Pilar Corrias, Jeffrey Deitch, Colin De Land, Frank Demaegd, Dorothee Fischer, Stephen Friedman, Jess Frost, Larry Gagosian, Sandra Gering, Linda Givon, Barbara Gladstone, Marian Goodman, Sophia Hunt, Rafael Jablonka, Marc Jancou, Michael Jenkins, Jorg Johnen, Jay Jopling, Sean Kelly, David Leiber, Andrew Leslie, Jenny Liu, Nicholas Logsdail, Matthew Marks, Daniel McDonald, Victoria Miro, Tim Neuger, Claes Nordenhake, Sheri Pasquarella, Wim Peeters, Jeffrey Poe, Eva Presenhuber, Shaun Caley Regen, Michelle Reyes, Andrew Richards, Andrea Rosen, Julia Royse, Jack Shainman, Annushka Shani, Brent Sikkema, Ethan Sklar, Lisa Spellman, Jill Sussman, Marcantonio Vilaça, Barbara Weiss, Angela Westwater, Ealan Wingate, Iwan Wirth, Glenn Scott Wright, and David Zwirner.

We are enormously grateful to the private collectors and public institutions that have agreed to share work; without their generosity this exhibition could not have been realized. Their names are acknowledged in the list of lenders. Additionally we cite Indira Aguilera, Doreen Bolger, Philippe Boutté, Frances Carey, Amada Cruz, Mark Fletcher, Gary Garrels, Katerina Gregos, Jan Hoet, Steingrim Laursen, Veit Loers, André Magnin, Miguel Miguel, Sandy Nairne, Jean Pigozzi, David A. Ross, Douglas G. Schultz, Elfie Semotan, Vasco Szinetar, and Sheena Wagstaff.

The 1999 *Carnegie International* has works installed in the adjacent Carnegie Museum of Natural History and Carnegie Library. For their generous cooperation and enthusiasm I wish to thank Jay Apt, director of Carnegie Museum of Natural History, Herbert Elish, director of Carnegie Library of Pittsburgh, and Ellsworth Brown, president, Carnegie Institute. I am particularly grateful to Bradley Livezey, Robin Panza, Mary Dawson, and James Senior at Carnegie Museum of Natural History; and Kathryn Logan at Carnegie Library of Pittsburgh. At The Andy Warhol Museum I am indebted to director Tom Sokolowski and Margery King, Geralyn Huxley, and Matt Wrbican for their kindnesses.

The Women's Committee, led by its president Jean McCullough, organized the exhibition's elegant opening celebrations. We extend our thanks to the entire committee and in particular thank event chair Kenny Nelson, as well as Mary Ann Bridenbaugh, Ann Bridges, Ranny Ferguson, Stephanie Flannery, Ruth Garfunkel, Diane Gerlach, Kitty Hillman, Charlie Humphrey, Nina Humphrey, Janet Krieger, Kathleen Lee, Betsy Marcu, Ann McGuinn, Pat Navarro, Gishie Scully, Alice Snyder, and Susie Steitz. Thanks, too, to party committee co-chairs Kate Gaier, Christine McCrady, Peggy McKnight, and Alex Mellon.

I am grateful to Jonathan Crary, Jean Fisher, Saskia Sassen, and Slavoj Žižek for enhancing this publication with their scholarly, thoughtful, and original contributions. Alyson Baker, assistant to the 1999 *Carnegie International*, has my deep respect and heartfelt thanks for her role in this project in all phases of its development, including her intelligent summary of the artists' bibliographies and exhibition histories published in this volume. Alyson's coordination of every aspect of this show was undertaken with her habitual great care, grace, and tenaciousness. I salute her professionalism, talent, humor, and commitment. I am also indebted to Lynn Corbett for her steady and calming influence as well as her expert skills, which she brought to all stages of the *Carnegie International*.

There is no way for me to give adequate thanks to Tom Shapiro, whose perceptive comments on this project, unfailing and vital encouragement, patience and support have helped me in every way. Richard Armstrong and I wish to dedicate this exhibition to the memory of Leon A. Arkus, director of Carnegie Museum of Art from 1968 to 1980, and organizer of the 1970, 1977, and 1979 *Pittsburgh International* exhibitions.

Finally, my greatest gratitude is extended to all the participating artists whose works and ideas prompted this project in the first place. They have contributed to the exhibition through the creation of works; they have endured countless conversations and interviews and have given unstintingly and graciously of their time and assisted me in innumerable other ways. For their extraordinary efforts, and for the opportunity to be enriched by them and their art in the process, I am profoundly grateful.

Madeleine Grynsztejn
Curator

Juana De Aizpuru
Audrey Alpern
Franic Alÿs
Christopher D'Amelio
Doris Ammann
Paul Andriesse
Paola Antonelli
Daina Augaitis
Roland Augustine
Ariella Azoulay
Eva Badura
Martha Baer
Bart De Baere
Mirosław Bałka
Carlos Basualdo
Ute Meta Bauer
Sonia Becce
Christiane Berndes
Klaus Biesenbach
Carol E. Bires
Iwona Blazwick
Bernard Blistène
Wieslaw Borowski
Saskia Bos
Sara Breitberg-Semel
Sabine Breitweiser
Michael Brenson
Bernhard Bürgi
Isabel Carlos
Rina Carvajal
May Castleberry
Jan Černý
Hervé Chandès
Leontine Coelewij
James Cohan
Sadie Coles
Sheryl Conkelton
Lisa Corrin
Chantal Crousel
Hugh M. Davies
Chris Dercon
Vishakha N. Desai
Hendrik Driessen
N. Fulya Erdemci
Trevor Fairbrother

Russell Ferguson
Jennifer Flay
Emi Fontana
Helmut Friedel
Dana Friis-Hansen
Kees van Gelder
Liz Glawe
Ingvild Goetz
Thelma Golden
Ann Goldstein
Marge Goldwater
Claudio Guenzani
John Hanhardt
Hou Hanru
Toshio Hara
Yuko Hasegawa
Tom Healy
Drue Heinz
Margot Heller
Lynn Herbert
Dave Hickey
Ludvik Hlavacek
Rolf and Erika Hoffmann
Kurt Hollander
Huang Du
Hudson
Xavier Hufkens
Marie Human
Junko Ii
Dvir Intrator
Yoshiko Isshiki
Junko Iwabuchi
Mary Jane Jacob
Maaretta Jaukkuri
Piet de Jonge
Georg Kargl
Clive Kellner
Yu Yeon Kim
Judith Russi Kirshner
Katy Kline
Hans Knoll
Jerry Koehler
Kazuko Koike
Shinji Komoto
Vasif Kortun

Tomio Koyama
Atsuko Koyanagi
Guillermo Kuitca
Suzanne Landau
Julie Lazar
James Lee
Yulin Lee
Stella Lohaus
Jenni Lomax
Ulrich Loock
Soledad Lorenzo
Barbara Luderowski
Bartomeu Mari
Declan McGonagle
Alexandre Melo
Friedrich Meschede
Ivo Mesquita
Eva Meyer-Hermann
Akiko Miki
Andrea Miller-Keller
Stuart Morgan
Frances Morris
Paola Morsiani
Christian Nagel
Fumio Nanjo
Philip Nelson
Katalin Neray
David Neuman
Bo Nilsson
Bera Nordal
Hans Ulrich Obrist
Maja Oeri and
Hans Bodenmann
Richard Ogle
Michael Olijnyk
Marcelo Pacheco
Roger Pailhas
Peter Pakesch
Kyong Park
Emmanuel Perrotin
Julia Peyton-Jones
Maria Anna Potocka
Adam Rabinowitz
Lawrence Rinder
Arno van Roosmalen

Anda Rottenberg
Doris Salcedo
Osvaldo Sanchez
Paul Schimmel
Britta Schmidt
Diana Schoef
Thomas Schulte
Martin Schwander
Dieter Schwarz
Sarit Shapira
Junichi Shioda
Milada Ślizińska
Matthew Slotover
Susan Snodgrass
Ilgin Somnez
Nancy Spector
Darthea Speyer
Jeremy Strick
Sandra Antelo Suarez
Jiří Švestka
Micheline Szwajcer
Susan Lubowsky Talbott
Michael Tarantino
Ann Temkin
Katalin Timar
Vicente Todolí
Chip Tom
Lilian Tone
Frederic Tuten
Jairo Valenzuela and
Ethel Klenner
Philippe Vergne
Theodora Vischer
Olga Viso
Robin Vousden
Keith Wallace
Nicolai Wallner
Allan Walton
Rachel Weiss
Loretta Yarlow
M. Catherine de Zegher
Lynn Zelevansky
Armin Zweite

Artists

Franz Ackermann
Matthew Barney
Janet Cardiff
John Currin
Hanne Darboven
Thomas Demand
Mark Dion
Willie Doherty
Olafur Eliasson
Kendell Geers
Felix Gonzalez-Torres
Ann Hamilton
José Antonio Hernández-Diez
Pierre Huyghe
Alex Katz
William Kentridge
Bodys Isek Kingelez
Suchan Kinoshita
Martin Kippenberger
Kerry James Marshall

Takashi Murakami
Shirin Neshat
Ernesto Neto
Chris Ofili
Gabriel Orozco
Markéta Othová
Laura Owens
Edward Ruscha
Gregor Schneider
Ann-Sofi Sidén
Roman Signer
Sarah Sze
Sam Taylor-Wood
Nahum Tevet
Diana Thater
Luc Tuymans
Kara Walker
Jeff Wall
Jane & Louise Wilson
Chen Zhen

Franz Ackermann

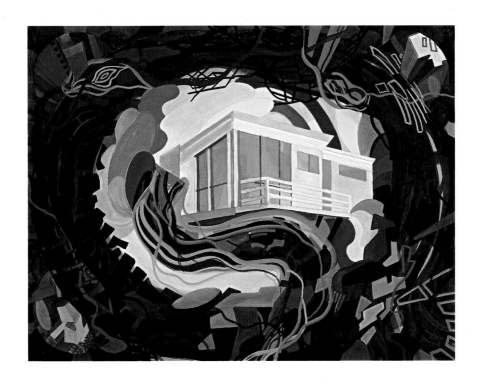

untitled (pacific no. 14: no one will
ever obstruct your view), 1998
mixed media on paper
9¹³⁄₁₆ x 13 in. (25 x 33 cm)
Collection van Loon, Amsterdam

untitled (pacific no. 4:
you make me believe), 1998
mixed media on paper
8 x 15¾ in. (20.3 x 40 cm)
Private collection, London

Matthew Barney

Cremaster 2, 1999 (stills)
high-definition television in color, transferred to 35mm
79 minutes, 17 seconds
Production stills by Michael James O'Brien
Courtesy Barbara Gladstone Gallery, New York

Janet Cardiff

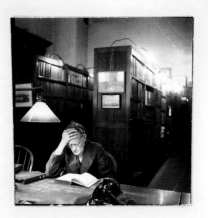

Carnegie Library of Pittsburgh.

Pennsylvania Division, second floor.

Photo by Erwitt. December 1950.

Carnegie Library, PA

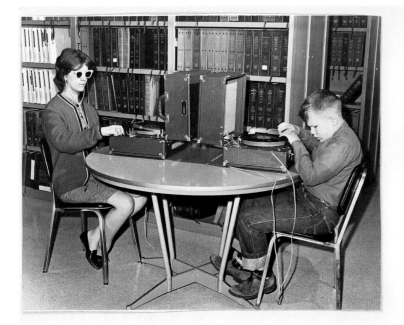

Library for Blind and
Physically Handicapped.
c1960's.

Also 14x17 mount

Carnegie Lib. Branches. LBPH

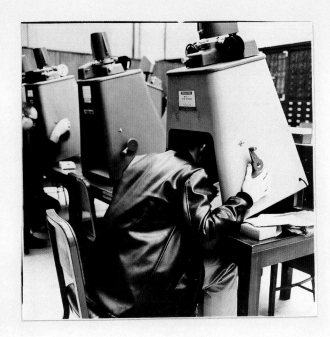

Carnegie Library of Pittsburgh

Microfilm Reader. c. 1966

Pittsburgh Press

C.L., Microfilm

3264

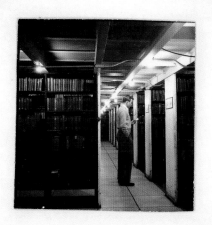

Carnegie Library of Pittsburgh.

Stacks open to the public on main floor.

Photo by Erwitt. December 1950.

Carnegie Library, Stacks

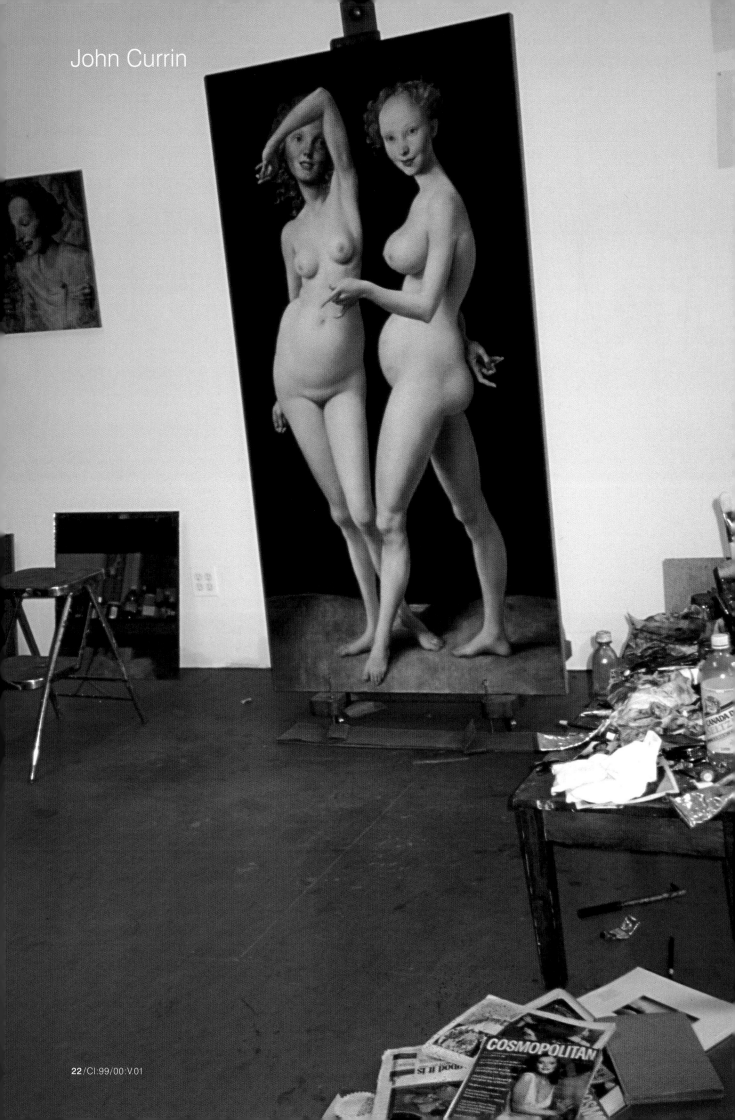

John Currin

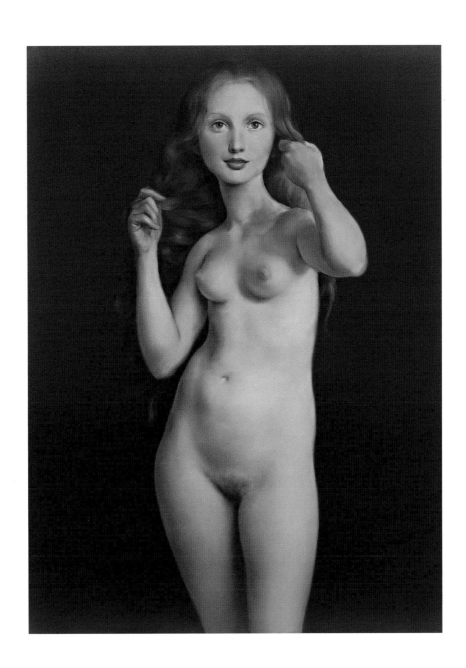

Nude with Raised Arms, 1998
oil on canvas
46 x 34 in. (116.8 x 86.4 cm)
Marieluise Hessel Collection on permanent
loan to the Center for Curatorial Studies, Bard College,
Annandale-on-Hudson, New York

The artist's studio, May 1999, with work in progress

Hanne Darboven

Leben, leben
Life, living

Teil A, 1900, I-XII

I
 1 + 1 + 00 = 2 31 + 1 + 00 = 32

II
 1 + 2 + 00 = 3 28 + 2 + 00 = 30

III
 1 + 3 + 00 = 4 31 + 3 + 00 = 34

IV
 1 + 4 + 00 = 5 30 + 4 + 00 = 34

V
 1 + 5 + 00 = 6 31 + 5 + 00 = 36

VI
 1 + 6 + 00 = 7 30 + 6 + 00 = 36

VII
 1 + 7 + 00 = 8 31 + 7 + 00 = 38

VIII
 1 + 8 + 00 = 9 31 + 8 + 00 = 39

IX
 1 + 9 + 00 = 10 30 + 9 + 00 = 39

X
 1 + 10 + 00 = 11 31 + 10 + 00 = 41

XI
 1 + 11 + 00 = 12 30 + 11 + 00 = 41

XII
 1 + 12 + 00 = 13 31 + 12 + 00 = 43

u.d, 1998

-I-

Leben, leben
Life, living

Teil A, 1900

Januar, I.	1 2 1 2 3 4 5 6 7 8 910111213141516171819 20 2122232425262728293031 32
Februar, II.	1 2 3 1 2 3 4 5 6 7 8 910111213141516171819 20 21222324252627282930
März, III.	1 2 3 4 1 2 3 4 5 6 7 8 910111213141516171819 20 2122232425262728293031 3233 34
April, IV.	1 2 3 4 5 1 2 3 4 5 6 7 8 910111213141516171819 20 2122232425262728293031 3233 34
Mai, V.	1 2 3 4 5 6 1 2 3 4 5 6 7 8 910111213141516171819 20 2122232425262728293031 32333435 36
Juni, VI.	1 2 3 4 5 6 7 1 2 3 4 5 6 7 8 910111213141516171819 20 2122232425262728293031 32333435 36
Juli, VII.	1 2 3 4 5 6 7 8 1 2 3 4 5 6 7 8 910111213141516171819 20 2122232425262728293031323334353637 38
August, VIII.	1 2 3 4 5 6 7 8 9 1 2 3 4 5 6 7 8 910111213141516171819 20 2122232425262728293031323334353637 38 39
September, IX.	1 2 3 4 5 6 7 8 910 1 2 3 4 5 6 7 8 910111213141516171819 20 2122232425262728293031323334353637 38 39
Oktober, X.	1 2 3 4 5 6 7 8 910 11 1 2 3 4 5 6 7 8 910111213141516171819 20 212223242526272829303132333435363738 39 40 41
November, XI.	1 2 3 4 5 6 7 8 9101112 1 2 3 4 5 6 7 8 910111213141516171819 20 212223242526272829303132333435363738 39 40 41
Dezember, XII.	1 2 3 4 5 6 7 8 910111213 1 2 3 4 5 6 7 8 910111213141516171819 20 212223242526272829303132333435363738 39 40 414243

1900-1999/A/1

(handwritten, right margin, vertical): 00 || 2 — 43 || 12 aufzeichnungen.

Leben, leben/Life, living, 1997–98 (detail: first two pages)
2,782 works on paper, 11¹³⁄₁₆ x 7⅞ in. (30 x 20 cm) each;
8 photographs, 11¹³⁄₁₆ x 7⅞ in. (30 x 20 cm) each;
2 dollhouses
installation dimensions variable
Courtesy Sperone Westwater, New York

Thomas Demand

Zeichensaal (Drafting Room), 1996
C-print and Diasec
6 ft. x 9 ft. 4 in. (183.5 x 285 cm)
Collection of Warren and Victoria Miro, London

Mark Dion

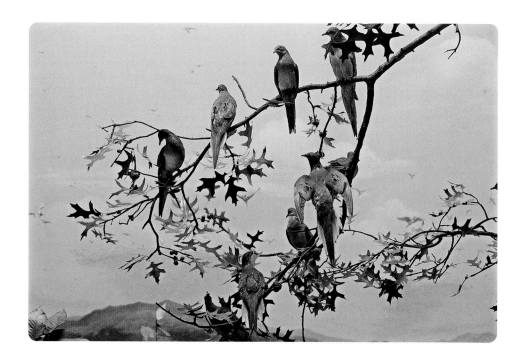

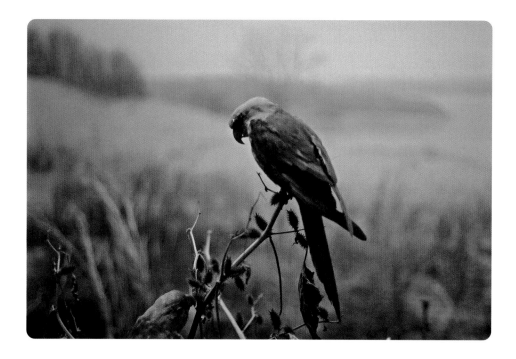

Diorama of passenger pigeons (top)
Diorama of Carolina parakeets (bottom)
Photographed by the artist at the National Museum of
Natural History, Smithsonian Institution, Washington, D.C., 1986
Both species extinct ca. 1914

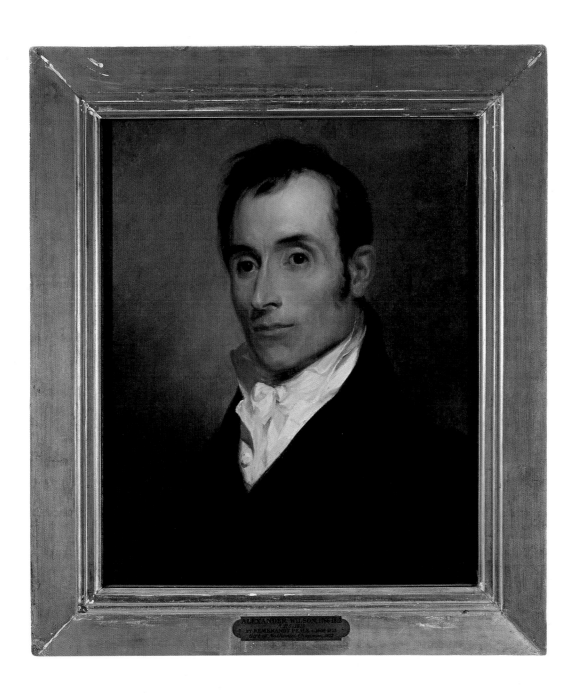

Thomas Sully
Alexander Wilson, ca. 1809–13
oil on panel
20¼ x 16¹¹⁄₁₆ in. (51.4 x 42.4 cm)
Collection of the American Philosophical Society, Philadelphia

Willie Doherty

Somewhere Else, 1998 (stills)
four-part video installation with sound
30 minutes
dimensions variable
Courtesy Alexander and Bonin, New York,
and Matt's Gallery, London

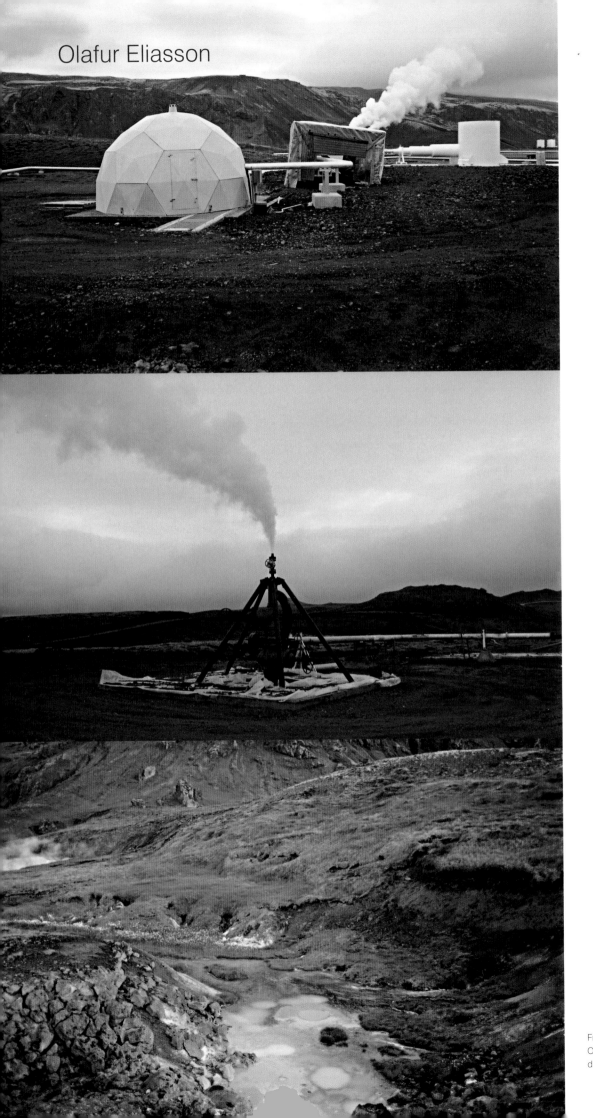

Olafur Eliasson

From **Icelandseries**, 1999
Ongoing photographic
documentation

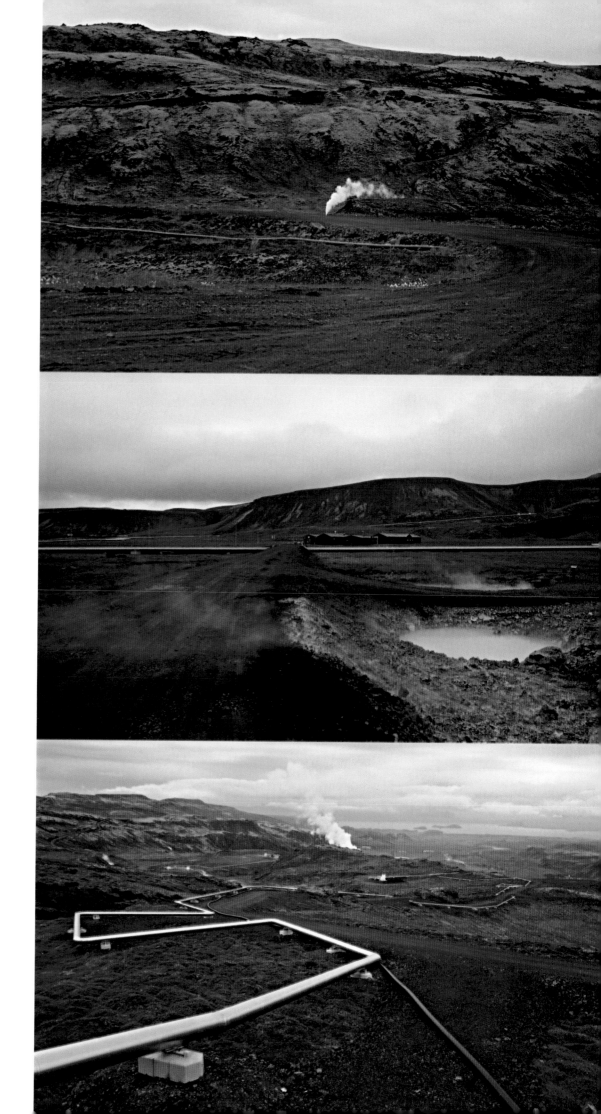

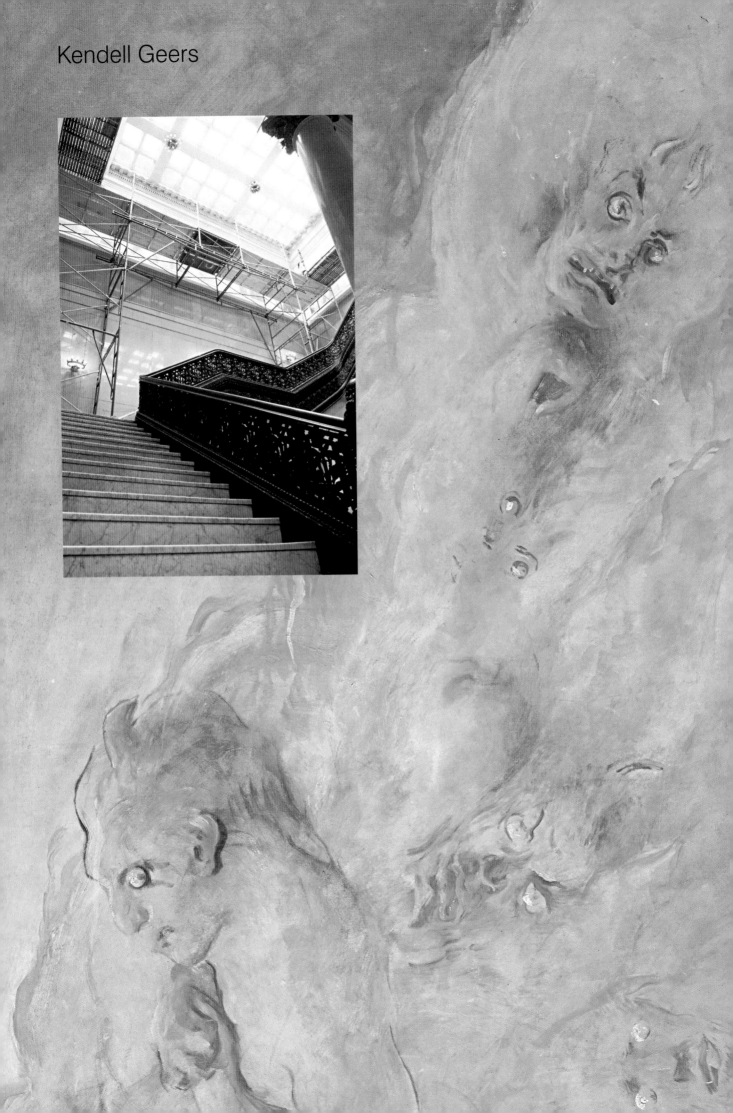

Kendell Geers

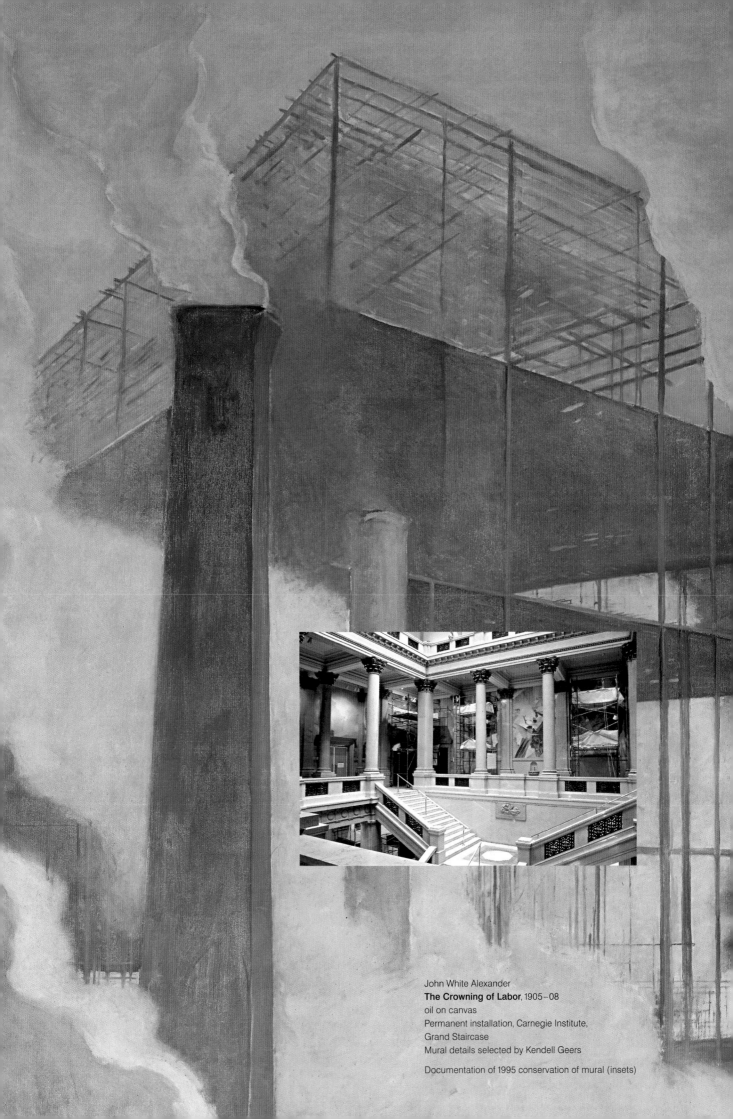

John White Alexander
The Crowning of Labor, 1905–08
oil on canvas
Permanent installation, Carnegie Institute,
Grand Staircase
Mural details selected by Kendell Geers

Documentation of 1995 conservation of mural (insets)

Felix Gonzalez-Torres

Untitled, 1994
2 C-prints, framed
26⅜ x 73¾ in. (67.1 x 187.3 cm) installed
Private collection

Untitled (Water), 1995 (detail)
plastic beads and metal rod
dimensions variable
Collection of The Baltimore Museum of Art:
purchased with exchange funds from
Bequest of Sadie A. May (BMA 1995.73)

Ann Hamilton

welle, 1998 (detail)
wall drilled with holes, water, and gravity-fed
electronically controlled pumping system
installation dimensions variable
Courtesy the artist and Sean Kelly Gallery, New York

José Antonio Hernández-Diez

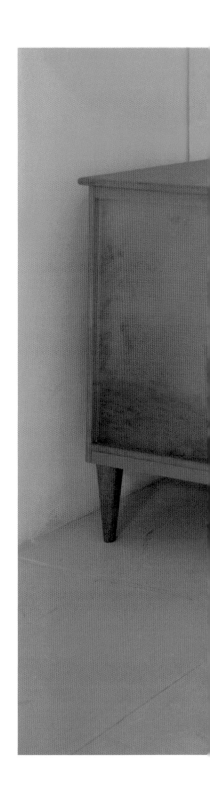

El Ceibó, 1998
wooden sideboard with glass doors,
6 ceramic plates, and video projection
35⅝ x 82¹⁄₁₆ x 23¹³⁄₁₆ in. (90.5 x 208.5 x 60.5 cm)
Collection of Museo Alejandro Otero, Caracas

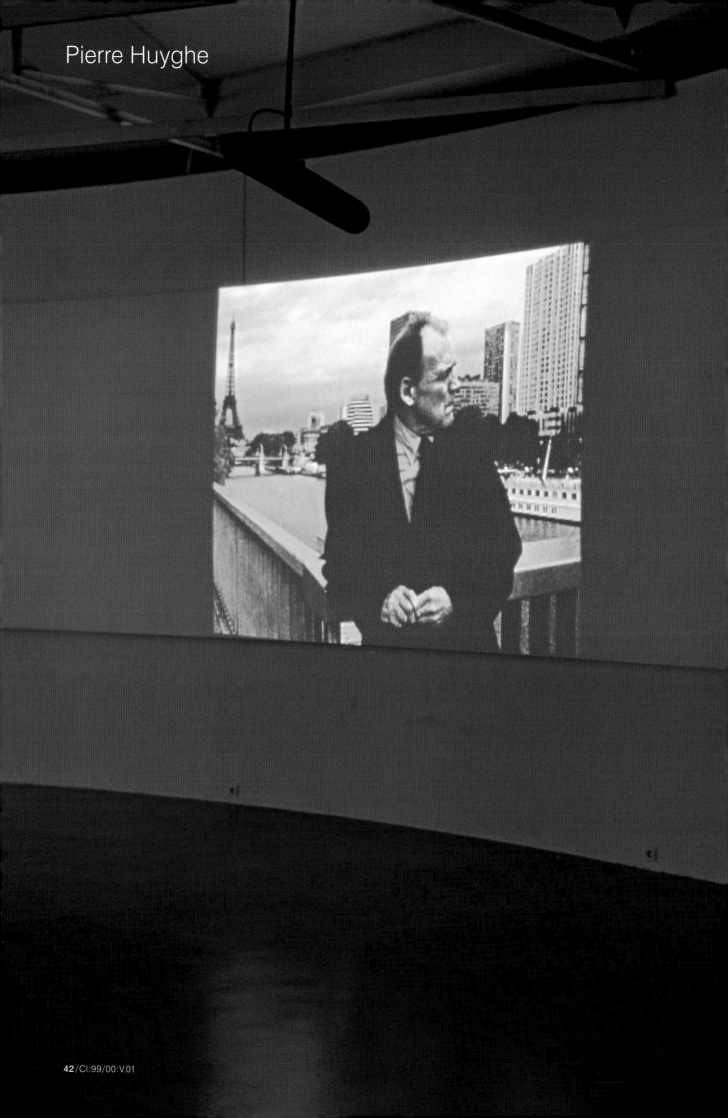

Pierre Huyghe

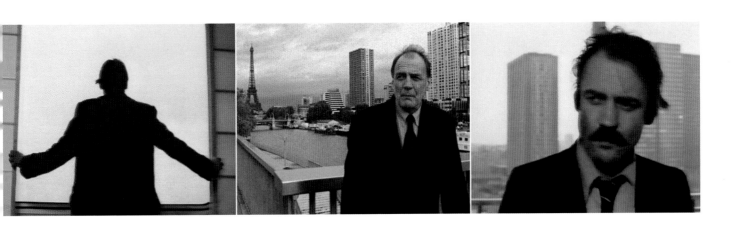

L'Ellipse, 1998 (stills)
three-part video projection, parabolic screen
13 minutes
installation dimensions variable
Courtesy Marian Goodman Gallery, New York and Paris

Installation view: Musée d'Art Moderne de la Ville
de Paris, October 30, 1998–January 10, 1999 (left)

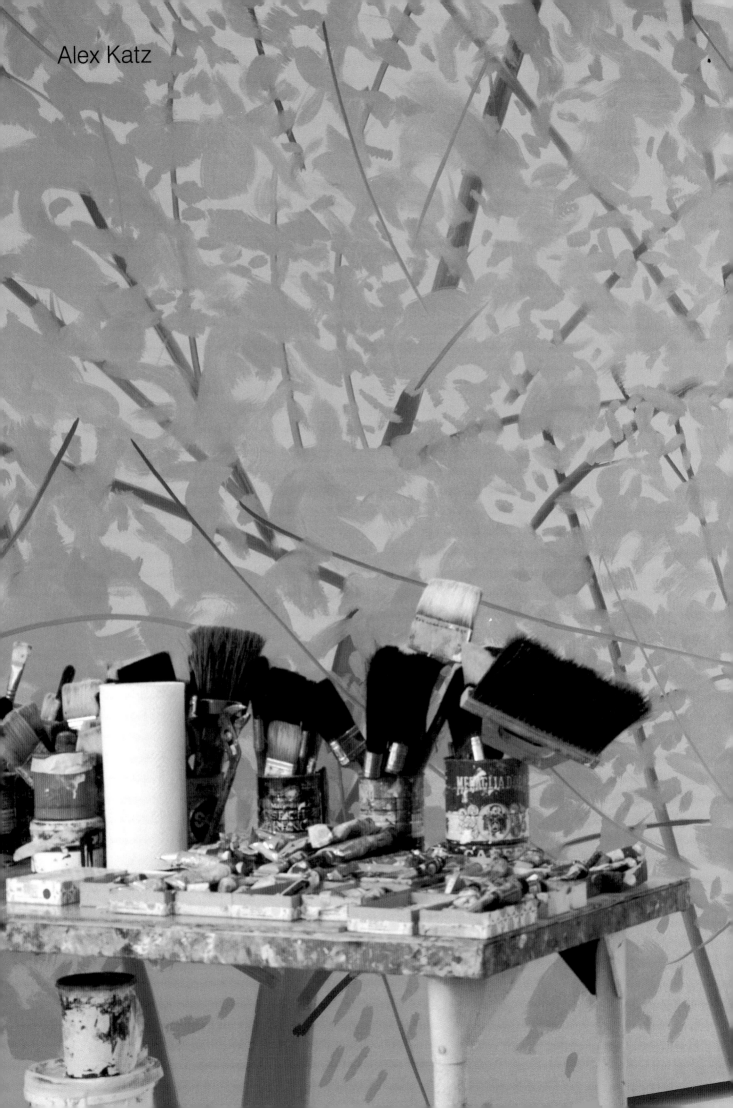
Alex Katz

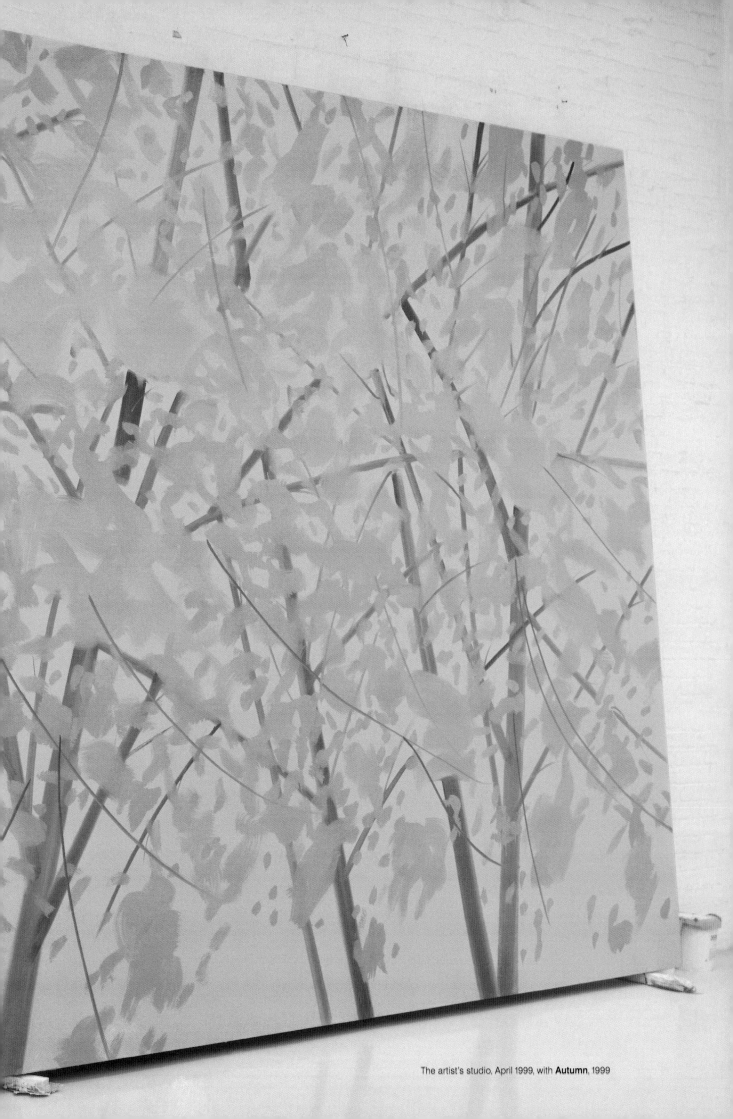

The artist's studio, April 1999, with **Autumn**, 1999

William Kentridge

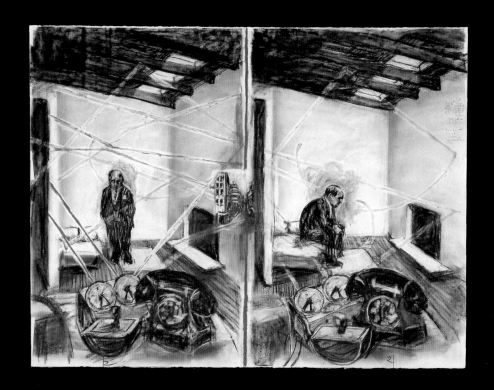

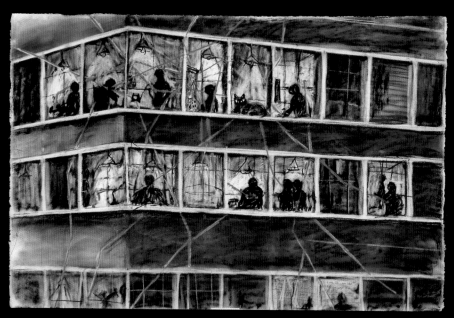

Drawing for **Stereoscope**, 1999
charcoal and pastel on paper
47 ¼ x 63 in. (120 x 160 cm)
Private collection, Johannesburg

Drawing for **Stereoscope**, 1999
charcoal and pastel on paper
31 ½ x 47 ¼ in. (80 x 120 cm)
Private collection, Los Angeles

Bodys Isek Kingelez

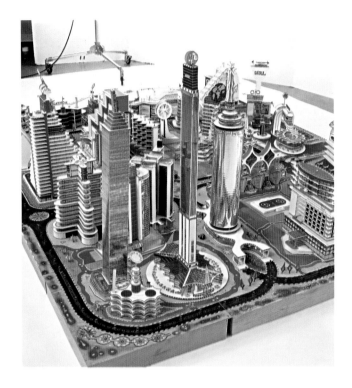

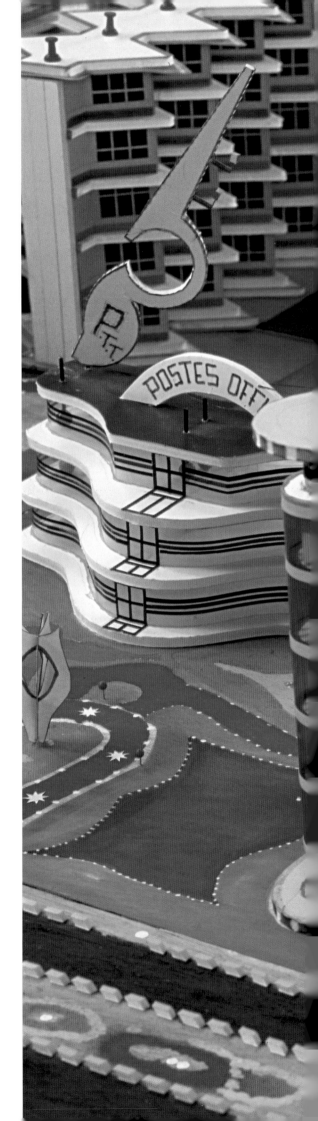

Ville Fantôme, 1996 (details)
paper, plastic, and cardboard
3 ft. 11¼ in. x 18 ft. 8¼ in. x 7 ft. 10½ in.
(120 x 569.9 x 240 cm)

C.A.A.C. – The Pigozzi Collection, Geneva

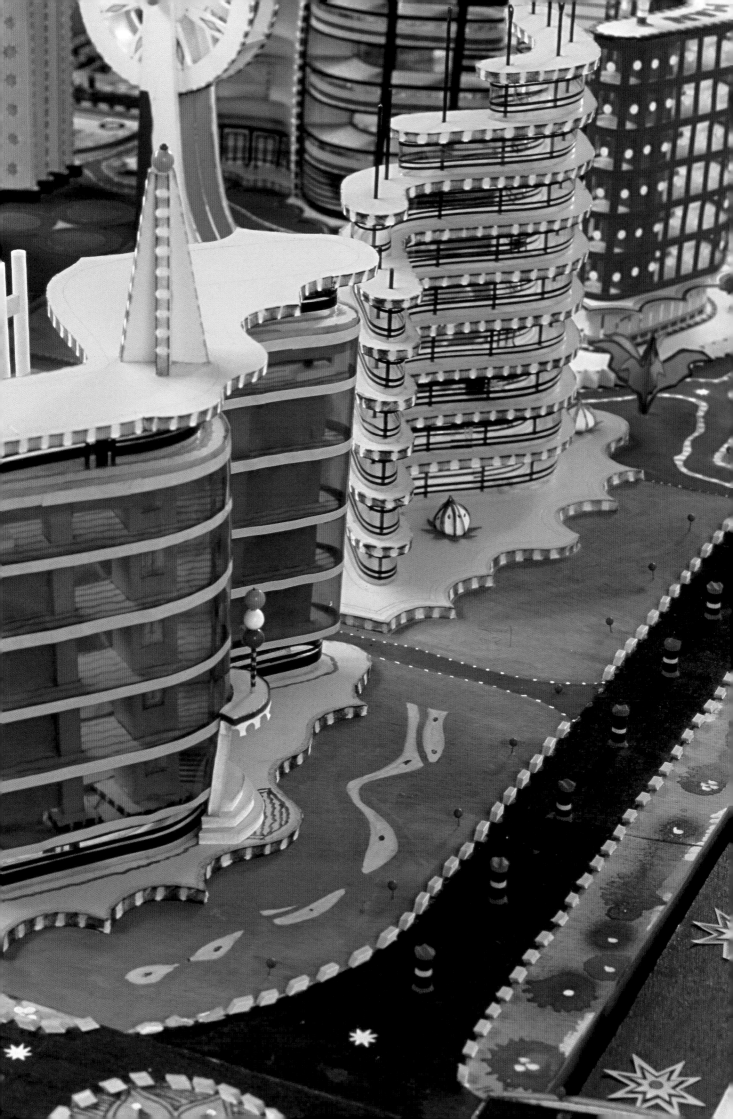

Suchan Kinoshita

oto Paul Mellaart

Untitled proposal for the
1999 *Carnegie International*, 1999
black and white and color photographs and ink
8 7⁄16 x 10 3⁄4 in. (21.5 x 27.25 cm)
Courtesy the artist

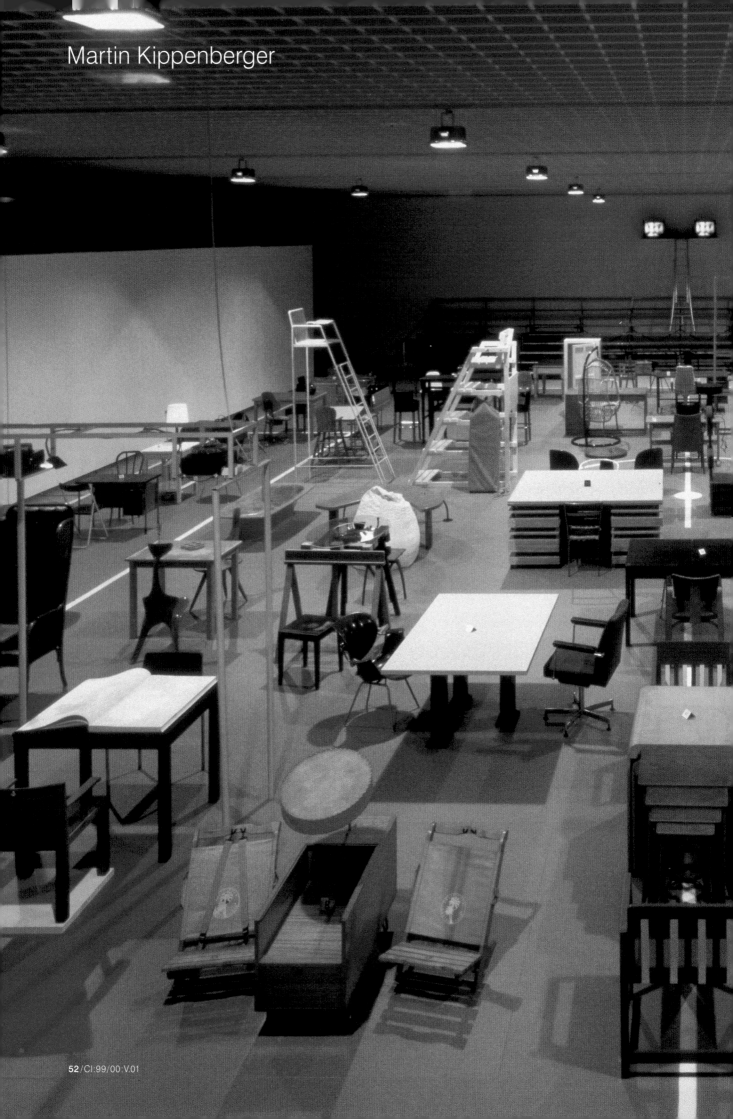

Martin Kippenberger

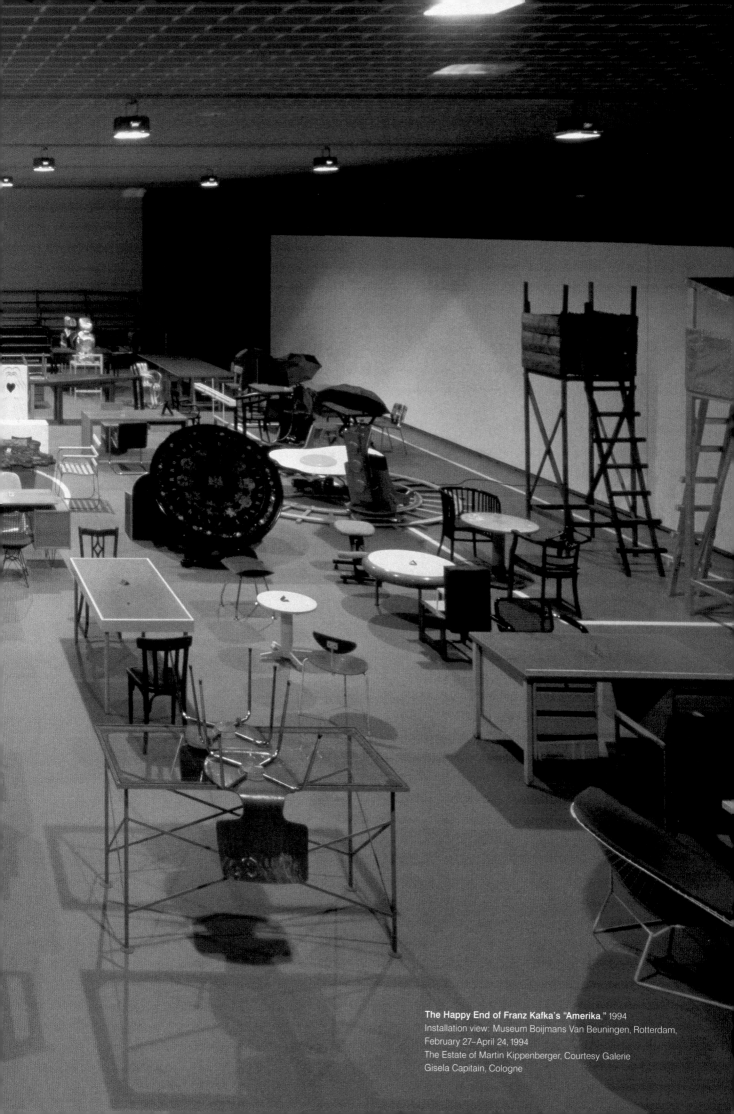

The Happy End of Franz Kafka's "Amerika," 1994
Installation view: Museum Boijmans Van Beuningen, Rotterdam,
February 27–April 24, 1994
The Estate of Martin Kippenberger, Courtesy Galerie
Gisela Capitain, Cologne

Kerry James Marshall

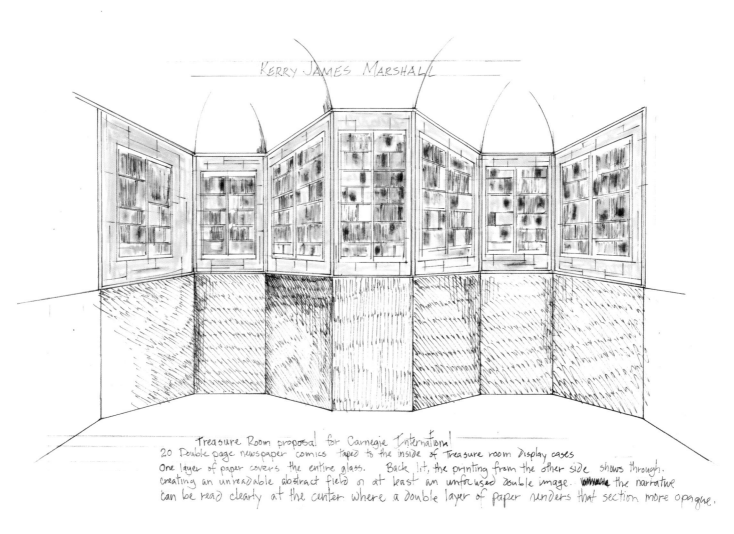

KERRY JAMES MARSHALL

Treasure Room proposal for Carnegie International
20 Double page newspaper comics taped to the inside of Treasure room Display cases
One layer of paper covers the entire glass. Back lit, the printing from the other side shows through.
creating an unreadable abstract field or at least an unfocused double image. the narrative
can be read clearly at the center where a double layer of paper renders that section more opaque.

Study for *RYTHM MASTR* installation, 1999
ink, pencil, and color pencil on tracing paper
14½ x 22 in. (36.8 x 55.9 cm)
Courtesy the artist; Jack Shainman Gallery,
New York; and Koplin Gallery, Los Angeles

Preliminary story board for *RYTHM MASTR*, 1999
ink and watercolor on board
33 x 19 in. (83.8 x 48.3 cm)
Courtesy the artist; Jack Shainman Gallery,
New York; and Koplin Gallery, Los Angeles

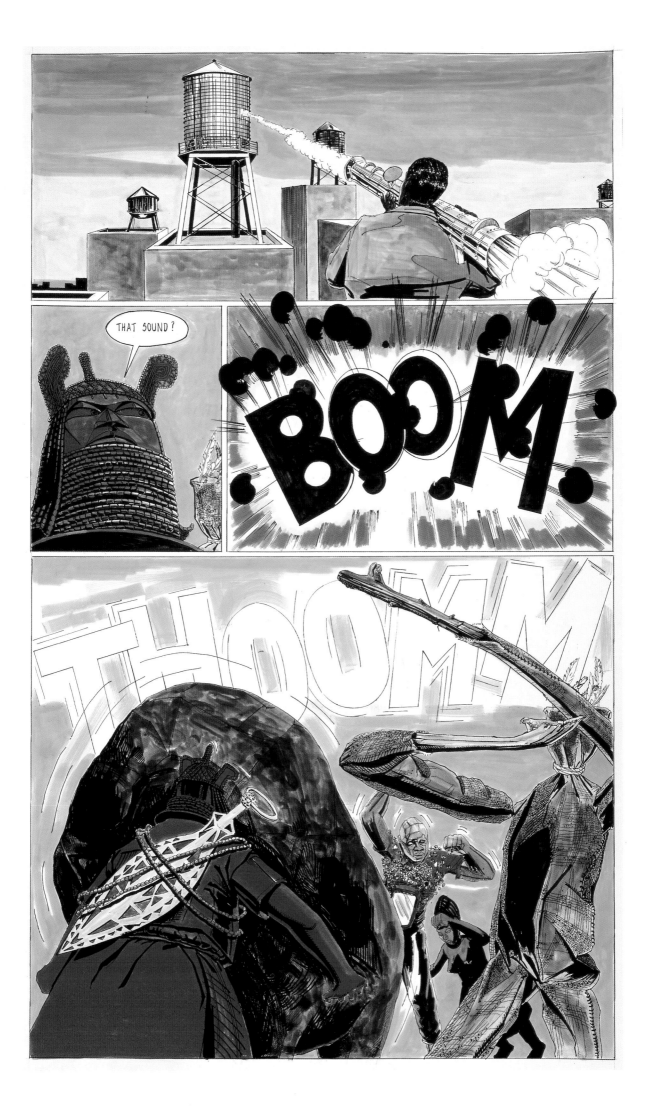

Takashi Murakami

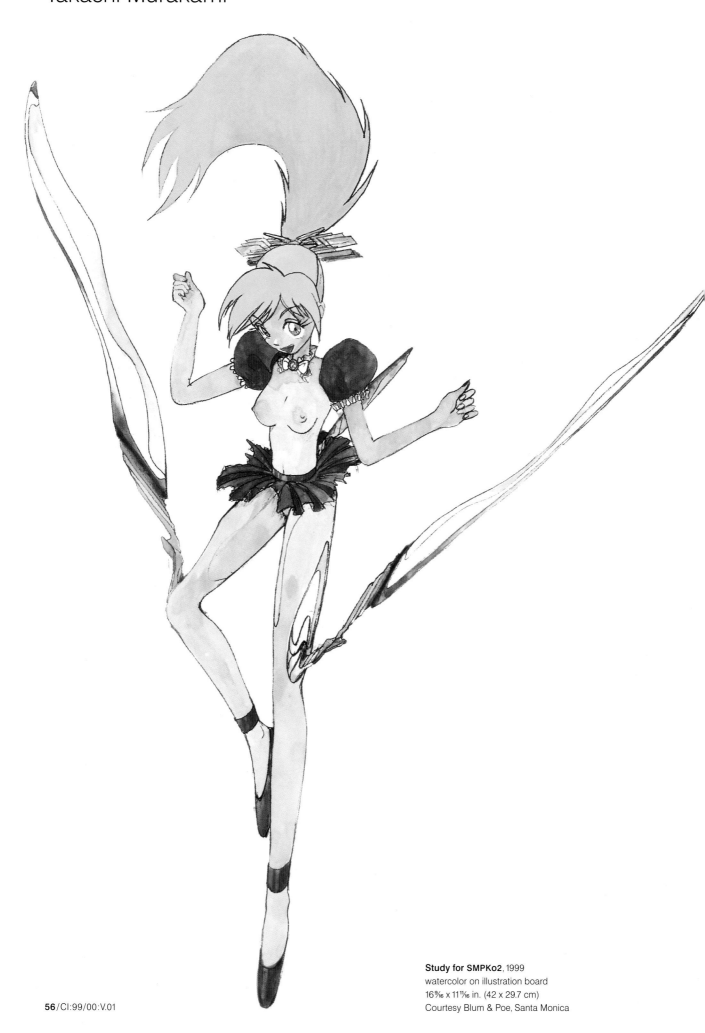

Study for SMPKo2, 1999
watercolor on illustration board
16⁹⁄₁₆ x 11¹¹⁄₁₆ in. (42 x 29.7 cm)
Courtesy Blum & Poe, Santa Monica

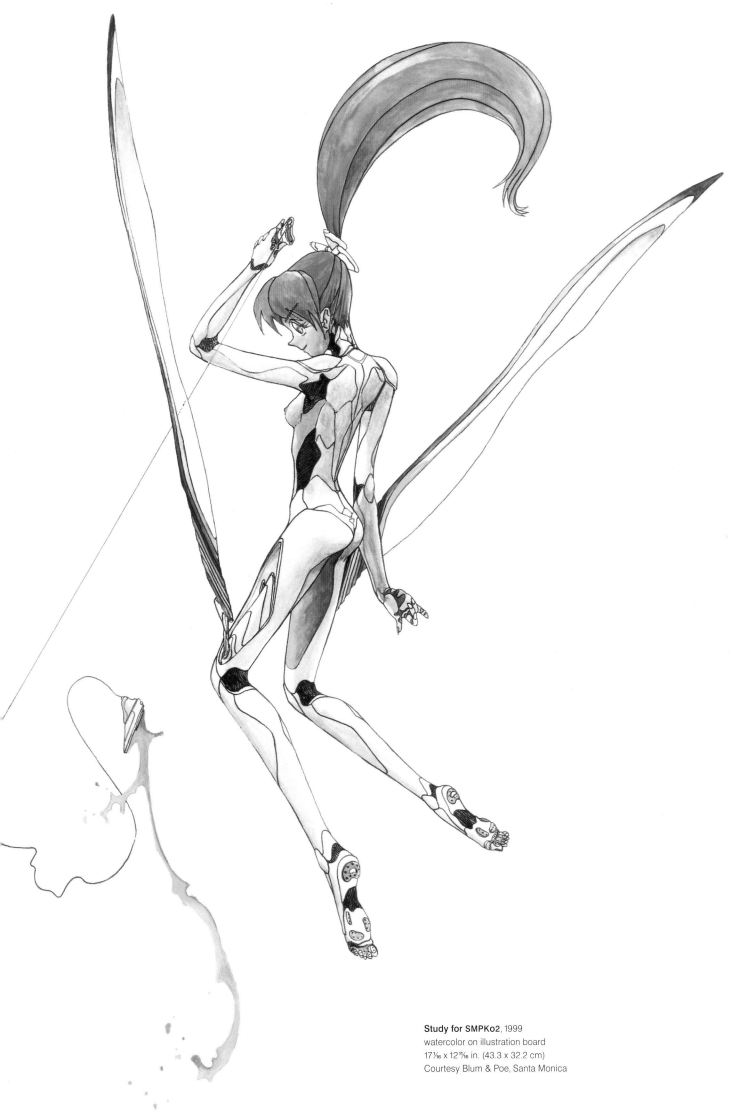

Study for SMPKo2, 1999
watercolor on illustration board
17⁷⁄₁₆ x 12¹¹⁄₁₆ in. (43.3 x 32.2 cm)
Courtesy Blum & Poe, Santa Monica

Shirin Neshat

Reference materials
Color photocopies of photographs of Los Angeles,
California, and Yazd, Iran

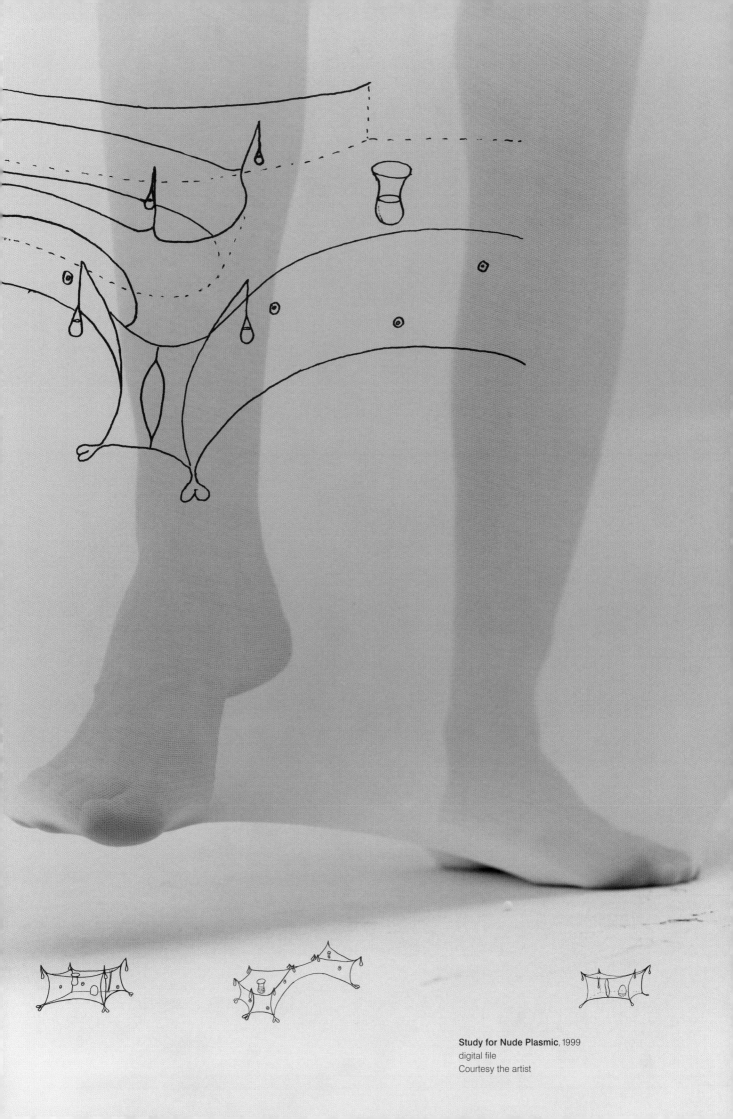

Study for Nude Plasmic, 1999
digital file
Courtesy the artist

Chris Ofili

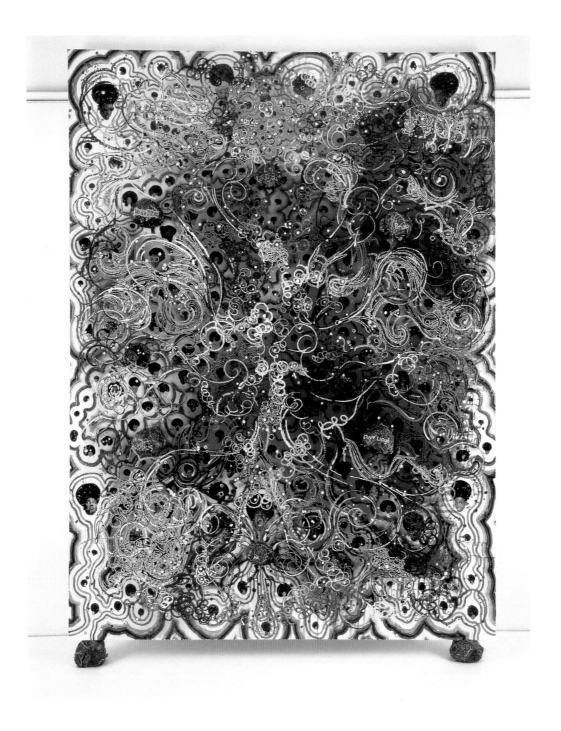

Afrodizzia (2nd version), 1996
mixed media
8 x 6 ft. (243.8 x 182.8 cm)
Collection of Warren and Victoria Miro, London

The Adoration of Captain Shit
and the Legend of the Black Stars
(3rd version), 1999
mixed media
8 x 6 ft. (243.8 x 182.8 cm)
Courtesy Victoria Miro Gallery, London,
and Gavin Brown's enterprise, New York

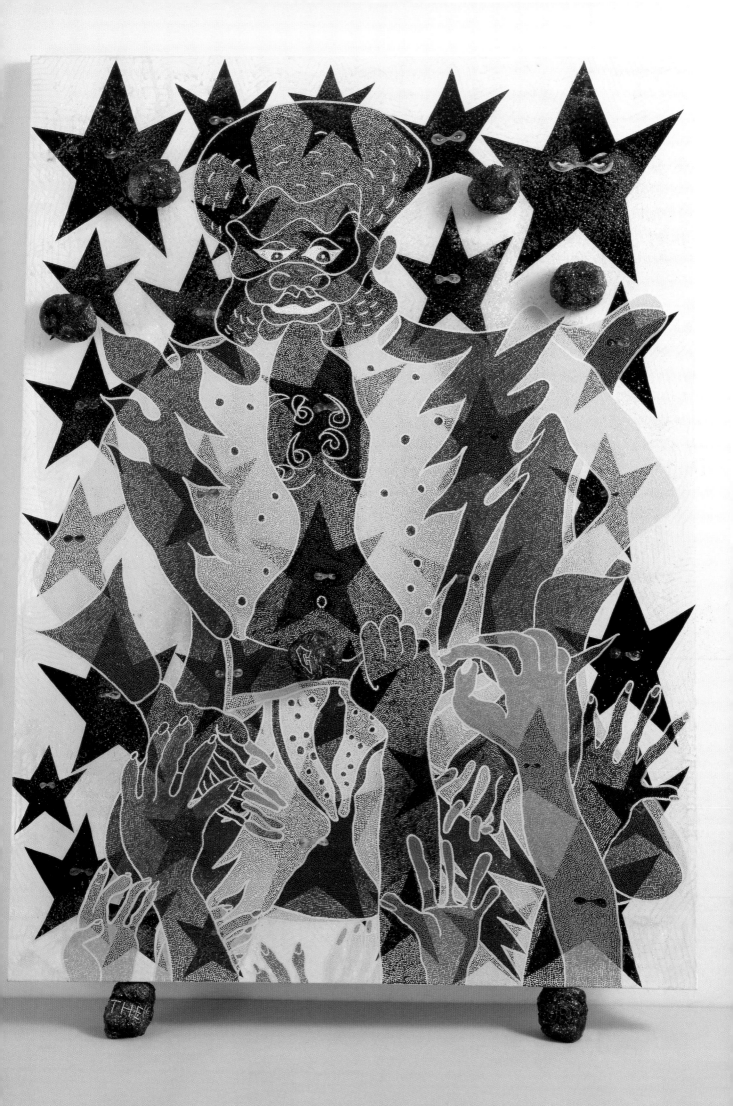

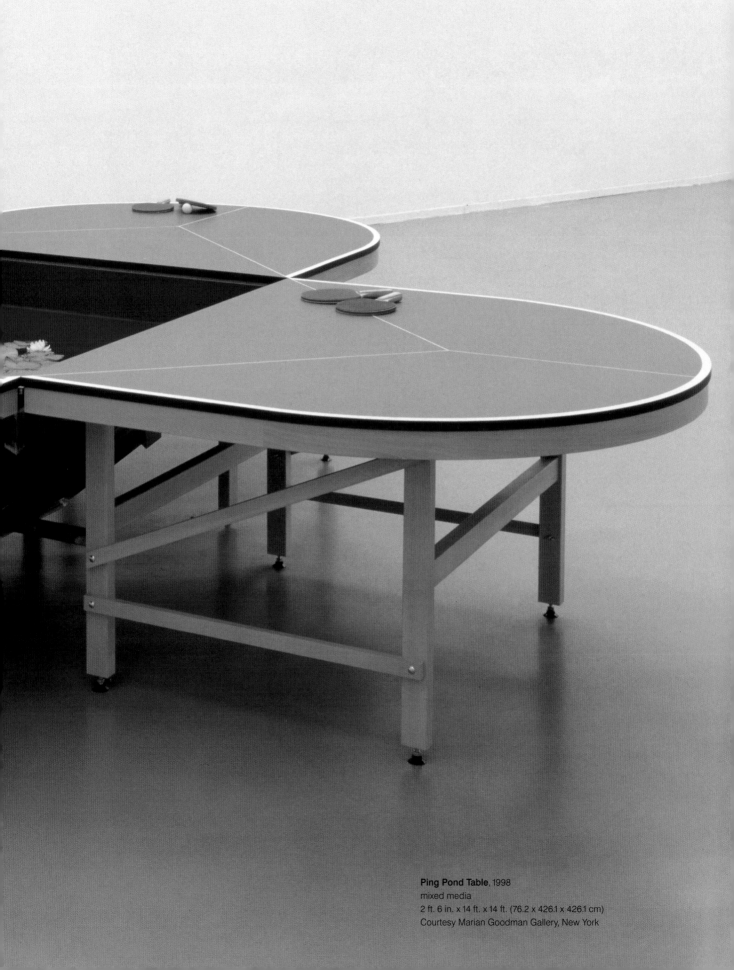

Ping Pond Table, 1998
mixed media
2 ft. 6 in. x 14 ft. x 14 ft. (76.2 x 426.1 x 426.1 cm)
Courtesy Marian Goodman Gallery, New York

Markéta Othová

Excalibur, 1999 (detail)
6 black and white photographs
39⅜ x 59¹⁄₁₆ in. (100 x 150 cm) each
installation dimensions variable
Courtesy the artist

Laura Owens

Untitled, 1998
acrylic and oil on canvas
46 x 50 in. (116.8 x 127 cm)
The Schorr Family Collection

Edward Ruscha

Artesia, 1998
acrylic on canvas
5 ft. 10 in. x 9 ft. (177.8 x 274.3 cm)
Collection of Jane and Marc Nathanson

Her, 1998
acrylic on canvas
38¾ x 39 in. (98.4 x 99.1 cm)
Private collection, Los Angeles

Gregor Schneider

Haus ur, 1985–
Unterheydener Str. 12, Rheydt, Germany
Courtesy the artist; Galerie Luis Campaña, Cologne;
and Konrad Fischer Galerie, Düsseldorf

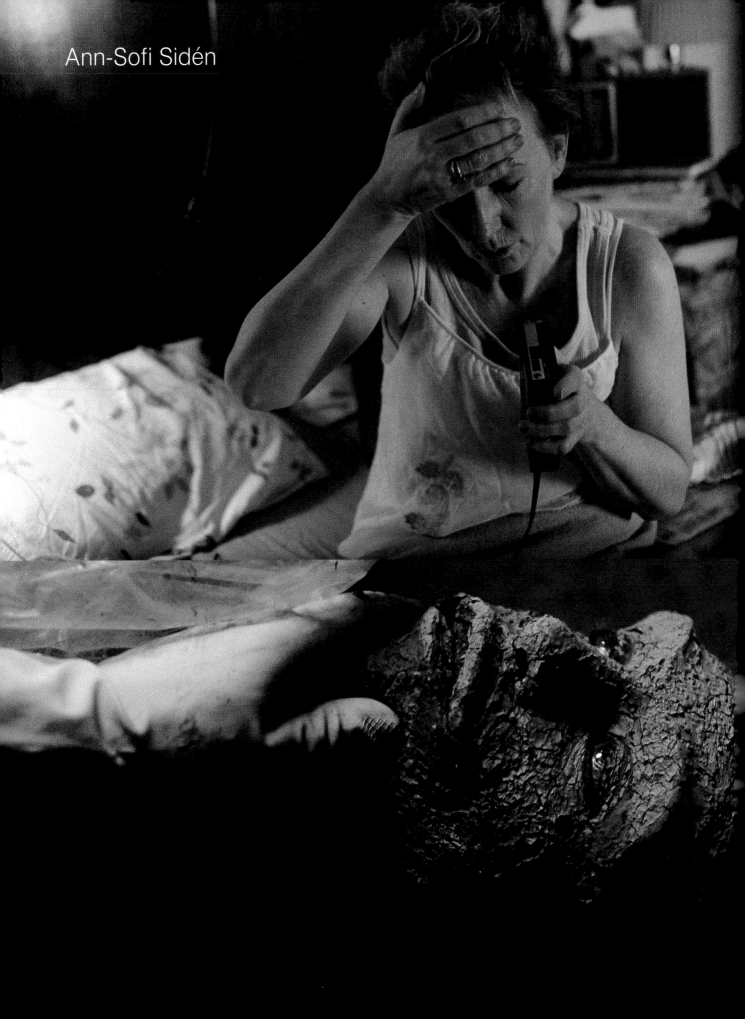

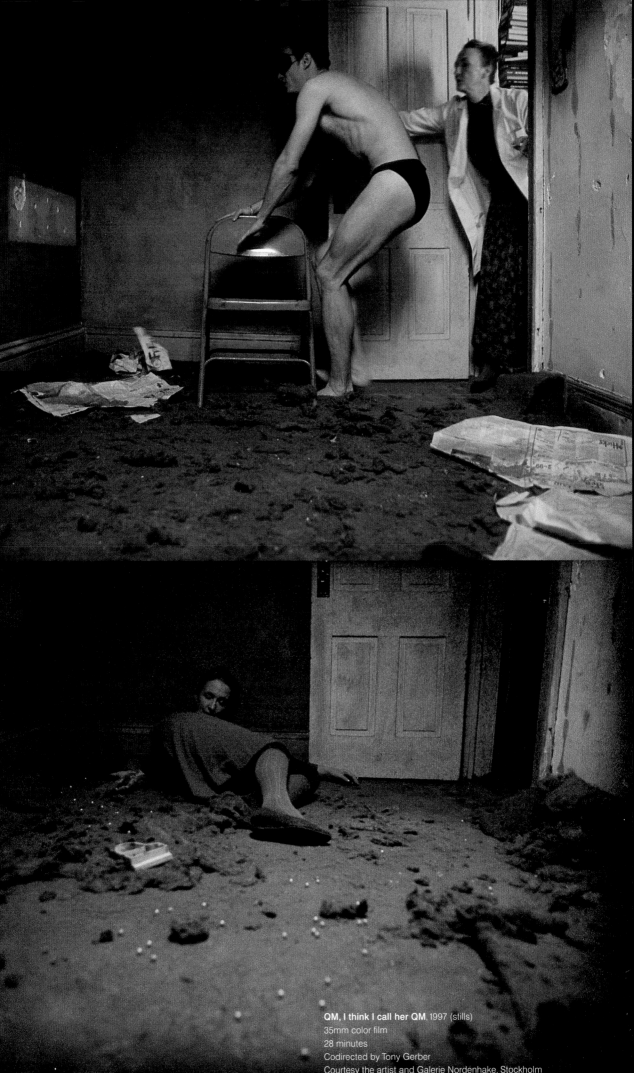

QM, I think I call her QM, 1997 (stills)
35mm color film
28 minutes
Codirected by Tony Gerber
Courtesy the artist and Galerie Nordenhake, Stockholm

Roman Signer

 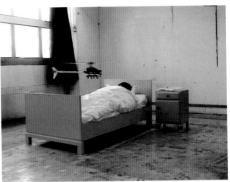

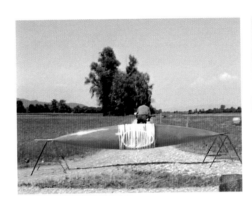 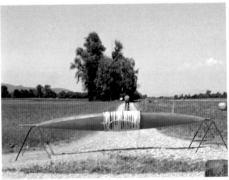

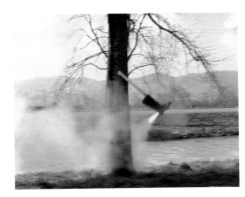

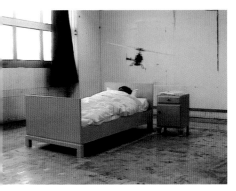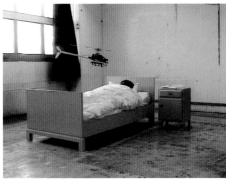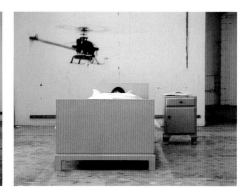

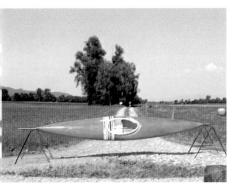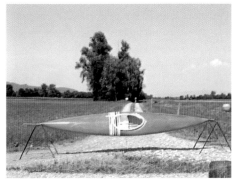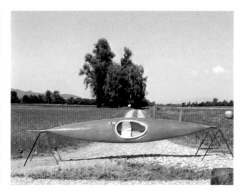

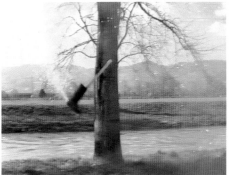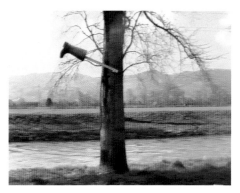

Video stills:
Bett, 1997 (top row)
4 minutes, 5 seconds
Eskimorolle, 1995 (center row)
1 minute, 26 seconds
Stiefel mit Rakete, 1995 (bottom row)
1 minute, 10 seconds
Courtesy the artist and Galerie Hauser & Wirth, Zurich

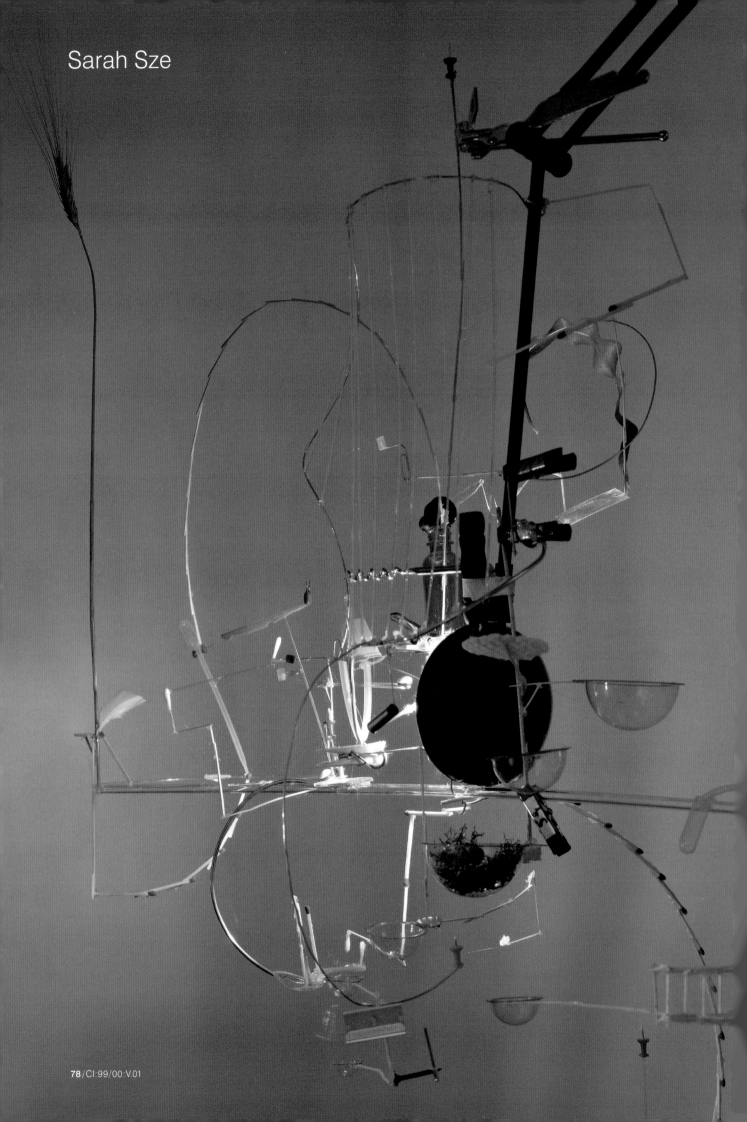

Sarah Sze

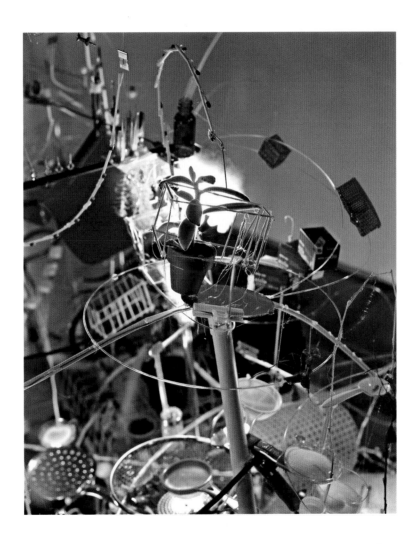

Many a Slip, 1999 (details)
mixed media with video projections
dimensions variable
Installation view: Museum of Contemporary Art, Chicago,
April 25–August 1, 1999
Courtesy the artist and Marianne Boesky Gallery, New York

Nahum Tevet

A Page from a Catalogue, 1998
painted wood
dimensions variable
Installation view: Chapelle des Jésuites, Nîmes, France,
November 17, 1998–January 6, 1999
Courtesy the artist

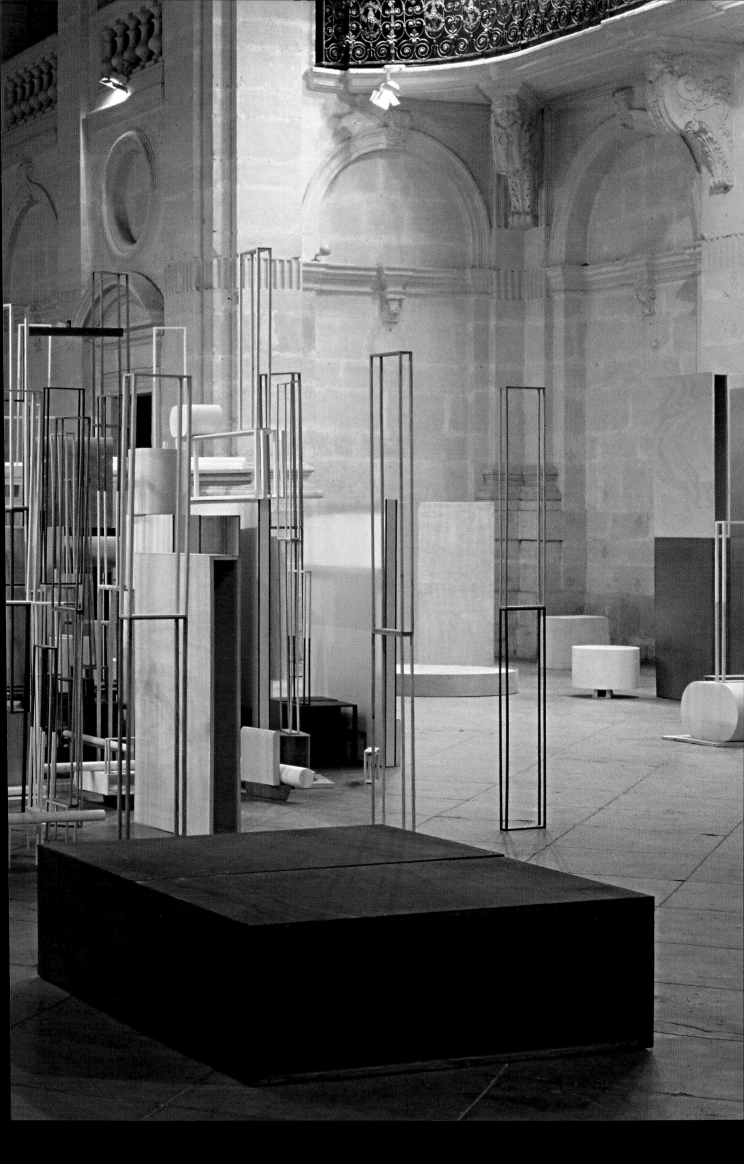

Diana Thater

Untitled proposal for the
1999 *Carnegie International*
(Forbes Avenue façade), 1999
ink on Mylar with Pantone and color copies
18 x 24 in. (45.7 x 61 cm)
Rendering by Dan Weinreber
Courtesy the artist; 1301PE, Los Angeles;
and David Zwirner, New York

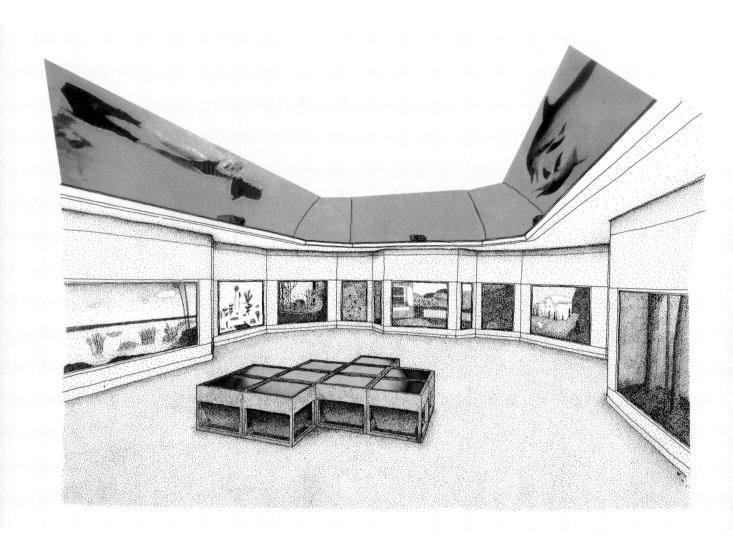

Untitled proposal for the
1999 *Carnegie International*
(Botany Hall), 1999
ink on Mylar with Pantone and color copies
18 x 24 in. (45.7 x 61 cm)
Rendering by Dan Weinreber
Courtesy the artist; 1301PE, Los Angeles;
and David Zwirner, New York

Luc Tuymans

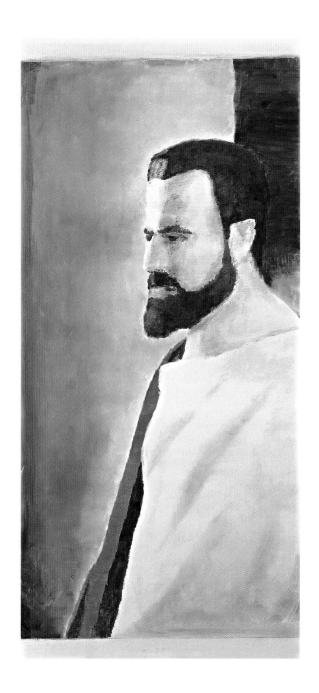

Christ, 1998
oil on canvas
48¼ x 22¹³⁄₁₆ in. (122.5 x 58 cm)
Rubell Family Collection

Gold, 1999
oil on canvas
6 ft. 2 in. x 3 ft. (187.5 x 90.5 cm)
Courtesy Zeno X Gallery, Antwerp

Kara Walker

Reference materials
Photomechanical reproductions in black ink
on newsprint mounted on newsprint

JAM BAGS
TODAY

Jeff Wall

**Morning Cleaning, Mies van
der Rohe Foundation, Barcelona**, 1999
production stills
Courtesy the artist

Jane & Louise Wilson

Silo: Gamma, 1999
C-print on aluminum
5 ft. 3 in. x 8 ft. 10 in. (160 x 270 cm)
Courtesy The Arts Council of England and
Lisson Gallery, London, with thanks
for the support of 303 Gallery, New York

Mirrored Figure: Gamma, 1999
C-print on aluminum
5 ft. 11 in. x 5 ft. 11 in. (180 x 180 cm)
Courtesy The Arts Council of England and
Lisson Gallery, London, with thanks
for the support of 303 Gallery, New York

Chen Zhen

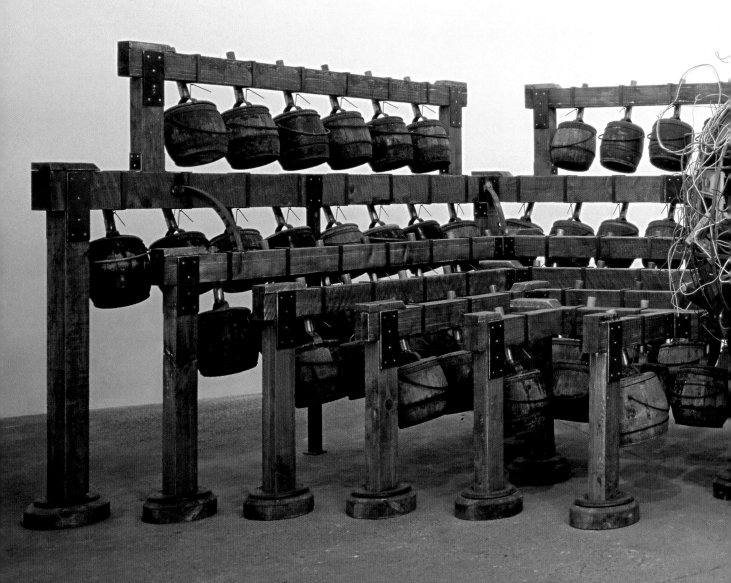

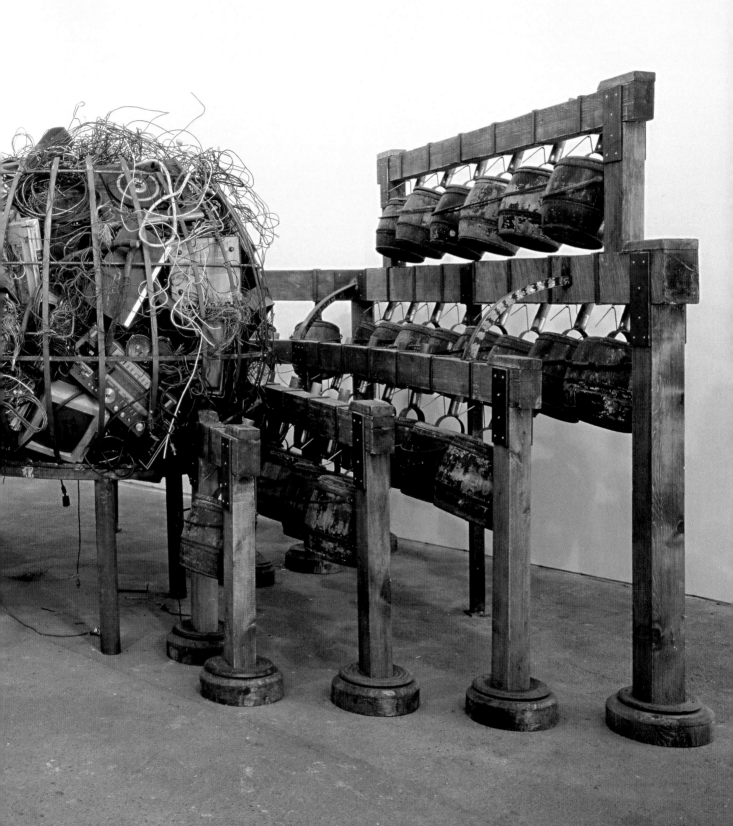

Daily Incantations, 1996
wood, metal, chamber pots, electrical appliances,
television, radios, and electrical cable
7 ft. 6 in. x 23 ft. x 11 ft. 6 in. (230 x 700 x 350 cm)
The Dakis Joannou Collection, Athens

Essays

There is no longer a tripartite division between a field of reality (the world) and a field of representation (the book) and a field of subjectivity (the author). Rather, an assemblage establishes connections between certain multiplicities drawn from each of these orders, so that a book has no sequel nor the world as its object nor one or several authors as its subject. In short, we think that one cannot write sufficiently in the name of an outside. The outside has no image, no signification, no subjectivity. The book as assemblage with the outside, against the book as image of the world.
—Gilles Deleuze and Félix Guattari, *A Thousand Plateaus*, 1980

The fiction is already there. The writer's task is to invent the reality.
—J.G. Ballard, *Crash*, 1973

At the end of one millennium and the beginning of another, and across a broad spectrum of cultural practices, the concerns of a generation of artists revolve around a meaningful discussion of the real. The forces driving this interrogation are difficult to isolate, for they encompass the large circumstances of everyday experience, but they are intrinsically related to the unremitting advances in new media technology that we witness today; and that technology is itself the main engine of a new, globalized form of capitalism that has resulted in an unmooring of the traditionally dominant coordinates by which we build identity and self. The common patterns that we use to negotiate daily life are constantly disrupted and called upon to adjust to new cognitive models. This process of adjustment is not a simple matter of absorbing new information into an already existing and stable framework or world view; rather, our experience of time, space, and even of ourselves and of each other—that is to say, the very core of our existence—is being rapidly changed both internally and externally by new ways of being and of seeing that are radically altering observed "reality."

Characteristic of life in this technologically driven era (in the West in particular) is the coexistence of multiple, disjunctive, and even antagonistic categories of space and time.[1] There is the material world, with its physical geography, discrete objects, fixed physiological subjects, and sense of a linear, chronological order of time that would allow for a progressive, causal model of history; and there is the digitally fabricated and deterritorialized world of new technologies, immaterial life-worlds, geographically remote yet technologically contiguous communities, and disembodied beings whose temporal experience is accelerated and instantaneous in the extreme. We exist at the crossroads between these two worlds, in an "essentially heterogeneous reality"[2] that constantly asks us to negotiate a terrain among familiar and newly emergent, actual and virtual, and local and global life-worlds.

Such ongoing transformations in the experiential world obviously have an impact on the human subject, forcing a constant "reinvention of subjective experience."[3] A commonly held consciousness today weaves together a mix of familiar and newly

1. This was made clear to me in reading the works of Jonathan Crary, Saskia Sassen, and Barbara Maria Stafford. See Crary, "Visual Technologies and the Dispersal of Perception," *Jurassic Technologies Revenant: 10th Biennale of Sydney*, exh. cat. (Sydney: Biennale of Sydney, 1996), pp. 17–26, and "Critical Reflections," *Artforum* 32, no. 6 (February 1994): 58–59, 103; Sassen, "Revisiting the Edge," *Microspace/Global Time: An Architectural Manifesto*, exh. cat. (Los Angeles: MAK Center for Art and Architecture, 1999); and Stafford, *Good Looking: Essays on the Virtue of Images* (Cambridge, Mass.: The MIT Press, 1996).

2. U. Weinreich, quoted in Gilles Deleuze and Félix Guattari, *A Thousand Plateaus: Capitalism and Schizophrenia*, trans. Brian Massumi (Minneapolis and London: University of Minnesota Press, 1987), p. 7.

3. Crary, "Olafur Eliasson: Visionary Events," *Olafur Eliasson*, exh. cat. (Basel: Kunsthalle Basel, 1997), n.p.

emergent, actual and virtual, local and global—and also of fiction and reality. Within and around these forces the individual subject is inserted, invented, and invents in turn. Our means of perception, sensory apprehension, meaning-formation, and creative response are relentlessly reshaped by this coexistence of different and constantly evolving orders of experience. Indeed, not only is the "digital era" continuously reconfiguring our modes of conveying and perceiving reality (thus regularly casting into doubt what we may think of as authentic and truthful), but reality itself is more and more constituted in and by technological imagery.

The consequences of this are too numerous and far-ranging to summarize here. One significant symptom, however, is the consistent "undermining of any stable subjective relation" to methods of either perception or cognition, to either object or idea, and the consequent "experience of a certain groundlessness."[4] We experience, in other words, the effects of a distancing from the real—from both self and world. This kind of distancing is the condition of living in an advanced capitalist society situated in an era of heightened technological mediation. The sense of living vicariously rather than viscerally, in a dispersed and fleeting environment rather than a stable one, has been accompanied by intimations of experiential impoverishment, and of a dwindling of control over one's life and destiny—and also, just as important, by an urgent desire to increase one's ability to act upon and influence one's life. The works in the *Carnegie International* owe much of their motivating force to this latter response to our present-day condition.

The artworks in this exhibition present a crucial question: What becomes of the self in the face of a reality that is perpetually subjected to the dynamic emergence of new relations, and to the dissolution and reconfiguration of older models? The works that artists are producing today speak in sometimes eager, sometimes wary terms of the pressures of present-day experience, to which they respond with different interrogations of our relation to reality. Art today possesses not so much a similarity of style as a shared focus, a philosophical investigation centered precisely on what constitutes the real—"authenticity," "truth," "certitude"—at a moment when the real is not secured, and does not, and perhaps cannot and should not, command a cohesive discourse.

The pictorial languages in this exhibition are on the surface diverse in the extreme, yet they center on a conceptually oriented realism that recognizes the impossibility of rendering "reality" directly yet refuses to cede this crucial task. They are not concerned with a mimetic framework or literal transcription of reality, or with an anthropology of it;[5] rather, they correspond to or coincide with it in intense and innovative ways. This has of course been true before in art's investigation of reality, and particularly at moments such as the present, when daily life is being transformed at an aggressive pace,[6] causing us to address both the constitution of that life and our subjective experience of it with ever greater urgency. Further, this epistemological approach, while always present

4. Crary, "Capital Effects," *October* 56 (Spring 1991): 128.

5. It should also be said that the focus of this exhibition is neither the abject and melancholic "return of the real" that was fairly specific to United States and European art practice in the early-to-mid-1990s, nor the psychologically oriented "new neurotic realism" current in England.

6. Indeed, the art of today can be seen as renewing modern art's long-standing efforts to respond to a culture of constant innovation and dislocation. European art of the early twentieth century (for example Cubism and Futurism), we know, reacted to conditions of radical speed, movement, and technological change that then seemed unprecedented. The inventions of that period generally had to do with expanding the potentials of the corporeal body; the computer-based innovation we are seeing today has the quality or at least the appearance of symbiotic fusion with the interior mind.

May 1997
Bienal de la Habana, Cuba
Fortaleza de la Cabaña

Wm Kentridge.

May 1997
Bienal de la Habana, Cuba
William Kentridge

August 4-8, 1997
Bellagio, Italy
Rockefeller Conference

October 1997
Johannesburg Biennale

October 1997
Johannesburg Biennale 10

October 1997
Johannesburg Biennale
Susanne Ghez

October 1997
Johannesburg
Goodman Gallery

October 1997
Istanbul Biennial
Rosa Martinez + Fulya Erdemci

November 1997
Prague, Czech Republic
Tomas Pospiszyl

November 30, 1997
Czech Republic

December 8, 1997
Adam Szymczyk
and Andrzej Przywara

Wysokie Mazowieckie, Poland

Lynn Corbett
December 1997

December 10, 1997
Berlin, Germany
Olafur Eliasson studio

December 1997
Berlin, Germany
Thomas Demand studio visit

January 1998
members of DCA Foundation
Denmark

January 1998
Glasgow, Scotland
Toby Webster + Susanne Ghez

January 26, 1998
Wall of Willie Doherty's studio
Derry, N. Ireland

January 27, 1998
Willie Doherty
Derry, N. Ireland

Kodak PREMIUM PROCESSING

Kodachrome FILM

2

January 31, 1998
London
Chris Ofili studio visit

7

in art, is not always at its forefront; in recent years, for example, it has been subdued by narrower (which is not to say insignificant) formal, theoretical, and sociopolitical concerns that themselves fed current preoccupations.

Finally, artworks are first and foremost materially based, experiential forms that make their impact on the level of affect; and within this overriding principle, one can detect in this exhibition three general strategies for conveying the contemporary condition and its focus on the real. Present here are radical acts of phenomenology that seize the viewer on an immediate "real" level, welcoming interaction and influence to the point where the bounds between subject and object are loosened, even made to dissolve. Also in evidence are instances of emphatic materialism that intensify everyday reality, in the process invoking or perhaps restoring a provocative attentiveness on the viewer's part. Third, manifest as well is a deliberate slippage between reality and fiction, putting the real into question through a deliberate "declination" and "deviation,"[7] often of the subtlest order, from which the viewer can return to the real with greater awareness. In other words, the works in this exhibition are constantly testing the real and its conventions, not to reconnect viewer and artist to some essential, authentic, or original vision or root condition but, on the contrary, to present reality in all its impurity, multiplicity, contingency, and intense presentness.

Perhaps the most telling characteristic shared by these works is their call for an actively engaged spectator. They enlist the beholder as accomplice in the aesthetic functioning of the work of art on heightened intellectual, somatic, and poetic grounds. It is this process of encounter and negotiation, rather than any settled endpoint of such a process, that the works compel, and it is in the collaboration with the spectator that their deeper meaning—their ethical charge, even—is revealed.[8] For in staving off the moment of closure, in opening up and extending the pathway leading from phenomenon to interpretation to (deferred) final definition, these pieces create for the subject a "space of *trans-action* from which one can begin again … the collaborative work of aesthetic invention, play, and transformation."[9] This "in-between" space is the crucial space for many artists today—the space of process, creativity, and agency they wish to inhabit, and the arena they wish their audiences to inhabit as well.

To allow the individual to intervene—whether on imaginary or physical grounds—is to open the work up to multiple avenues of interpretation that necessarily if provisionally resist and transgress a prescribed order. This strategy returns to the subject the ability to bypass predetermined designations and mediations, and points to a more expansive model for being in the world. In answering the crucial question of how to elicit new meaning-formations within our present circumstances, artists posit the central place of the subjective: the participation of the individual leads to reflection, self-examination, and even reinvention. Such a movement is predicated upon the full engagement of artist *and* spectator, and on the ability of artist and spectator together to produce affect and meaning. Affording instances of intellectual freedom and experiential

7. On these procedures see Deleuze and Guattari, *A Thousand Plateaus*, p. 489.

8. As Jean Fisher writes, "Where art is attentive to reception—to how the receiver inhabits the structure of language itself—it approaches [a] kind of ethical responsibility." Fisher, "Art's Caress," *Beyond Ethics and Aesthetics*, ed. Ine Gevers and Jeanne van Heeswijk (Amsterdam: Sun Press, 1997), p. 164.

9. Fisher, "The Syncretic Turn: Cross-Cultural Practices in the Age of Multiculturalism," *New Histories*, exh. cat. (Boston: The Institute of Contemporary Art, 1996), p. 38.

plenitude, these artworks provoke modes of self-awareness and action that counter the diminishment of self in our advanced technological culture. With these works, the human desire for unmediated experience "takes the form of a belief in productivism, for what is never mediated … is the idea that meaning lies not in objects but in the practice or theory of production to which they all refer … the emphasis is not on work but on a *practice*."[10] Thus the "real" that these works put forth is a real that is grounded not in certainty but in *agency*.

Vehicles of consciousness as much as objects of aesthetic and intellectual strength and beauty, these works propose and foster acts of the imagination that return to the viewer the ability to identify, to creatively associate, to empathize[11]—in other words, to undertake the movement toward meaning that is at the core of subjective experience, even as it has been deeply disrupted by our current social dispensation. Herein lies the works' ideological dimension, for they call on their viewer to "live out politically, in other words, with all the force of his or her desire."[12] What is ultimately at stake is the extension of individual human agency and private thought. It should be clarified, however, that although these works announce the necessity of the subject as agent, they cannot accomplish that goal by themselves. In what for the time being can only be a utopian gesture, they seek an activation of the imaginative faculties that will return their viewers/participants to themselves as changed and less docile members of the world community, having experienced the "insight with a gasp" that derives "from such intensely concentrated psychobiological experiences of unity in multiplicity"[13] as are offered by the artworks in this exhibition.

Among the diverse approaches to conceptually oriented realism in this exhibition are those that immerse us in a more concentratedly corporeal realm than is offered by visual engagement alone. The surge of art that uses time, sound, smell, movement, and spatiality as primary media is evidence of a commitment to the real. **Olafur Eliasson**'s installation is one of a number in this exhibition that support a body-centered experience dedicated to the extension of human sensory faculties, involving visual apprehension in concert with impressions of temperature, material texture, noise, and weight. Eliasson's work is grounded in singular and evanescent natural elements: steam, ice, heat, moisture, light. But these "natural" elements are artificially induced by the artist, and their means of fabrication, usually simple and practical, is made overt, and develops in pragmatic response to the given parameters of the site. Eliasson deliberately seeks to interrupt any sense of an unmediated relationship to "nature" that would ally his work with the Northern Romantic tradition that is his heritage. Yet even as his work is materially grounded by its emphasis on physical phenomena experienced in real time, it carries an emotional charge—perhaps even with connotations of the sublime—that is embedded in the viewing subject. Participant, artist-created construct, and environment together form a work located between nature and culture, and on a scale unique to each viewer.

10. Norman Bryson and Jeremy Gilbert-Rolfe, "XLVII Venice Biennale," *art/text* no. 59 (November/January 1997): 34.

11. Deleuze and Guattari describe *Einfühlung*, "empathy," as "the feeling that unites representation with a subject." *A Thousand Plateaus*, p. 498.

12. Ibid., p. 13.

13. Stafford, *Good Looking*, p. 208.

Ernesto Neto's work likewise solicits a heightened level of somatic participation. Neto's emphasis on a performing body is a descendant of Brazil's Neo-Concrete movement of the 1950s and 1960s, as consolidated in the work of Lygia Clark and Hélio Oiticica. Those artists' works, made, like Neto's, of modest materials, required physical activation by the spectator; and Neto's large, membranelike compartment, made of stretched translucent fabric often anchored by aromatic herbs and spices, similarly takes on its meaning in direct relation to the participant's touch: it comes to fruition in a reciprocal interaction between object and subject. The spectator's journeys through the sculpture's passages directly affect its composition, and there ensues a loosening of the separation between viewer and artwork, and the promise of a kind of experiential plenitude that is at once intimate (since the fabric indexes clothing and therefore corporeality) and social (through the public quality of the architectonic structure in which the fabric is shaped).

The body in all its vulnerability is recalled in **Ann Hamilton**'s *welle*, a wall that weeps barely visible beads of water, as if it were less an architectural enclosure than a functioning body disconcertingly enveloping its viewer. Hamilton has often been drawn to consider the complex functions of boundaries—the ways in which boundaries not only separate but join—and has used such membranes as conceptual devices for upsetting the old dichotomies of inside/outside, and human/nonhuman. Her interest in boundaries may have been stimulated by her training in textiles. Her earliest works were constructions that served as second skins for the body, the skin being the primal boundary between self and world: "I went from creating skins and suits for the body to treating the walls of a room as a skin."[14] Hamilton has consistently transformed the enclosing architecture of her chosen sites into vast, animated, epidermal sheaths that reawaken the viewer to otherwise conventional surrounds.

Suchan Kinoshita's work is located at the permeable boundary between art and theater, locations straddled by the viewer, who experiences a piece rich in sensory experience yet fragile in constitution. Kinoshita has previously given overlooked or unwieldy spaces new dimensions by manipulating them through unconventional materials. A student of experimental theater, she gently choreographs the visitor's movement through a series of interactions or "intermezzi" with different media that allow for tactile experiences and diverse points of view. Visitors are invited, one at a time, to occupy raw wooden "loggias" built for private meditation or activity. In engaging with Kinoshita's piece, the visitor employs faculties other than vision: movement and stillness, sound and silence, offer an immersive aesthetic that is constituted by the viewer's singular and constantly changing impressions.

The desire for an intensive and extensive engagement with the visible world appears in a different way in projected video environments, wherein viewers are not assigned the traditionally fixed point of view on which artworks constructed in solely visual terms so often converge, but are instead invited to become enveloped

14. Ann Hamilton, in Hugh M. Davies and Lynda Forsha, "A Conversation with Ann Hamilton," *Ann Hamilton*, exh. cat. (La Jolla: San Diego Museum of Contemporary Art, 1991), p. 64.

by, to circulate in, and to impact upon a multipartite installation corresponding to their own immediate experience. Besides, there is hardly a more accurate aesthetic correlate to the present condition in which many of us find ourselves, living simultaneously in actual and digital space. Video environments reflect our contemporary condition as both corporeally and virtually embedded: the spectator as sentient being is enfolded in a space whose sound, often exaggerated visual scale, physical proximity, and architectonic shell command a heightened material and even sculptural intensity. At the same time, the surrounding imagery is generally intangible and diffuse. Older and newer forms of visual manifestation coexist unreconciled, allowing the viewer neither complete integration nor complete autonomy; these video environments constitute transitional spaces for a transitional moment.

Diana Thater's installations involving multiple video screens and monitors create multifaceted spaces that physically and emotionally assimilate those who enter them. Their architectonic scale puts one "in" rather than "in front of" a work of art, and as one walks around the room, one both "interrupts" the piece—crossing the video projectors' beams, casting shadows—and becomes an active part of it. Thater's work foregrounds its own means of production, self-reflexively exposing its technical equipment, the style in which the images have been shot, and the images' surface quality. Further, Thater often washes her work in a palette characteristic of video, the red, green, and blue hues that together form the video spectrum, and from which the other colors within the video projection are made. Allowing the viewer neither passivity nor unmediated immersion, superimposing the electronic and the architectural, Thater asks us consciously to suture the virtual and the material, the real and the fictive, focusing all the while on images of trained animals—themselves symbols of an acculturated nature riven by technology.

Jane and Louise Wilson's *Gamma* consists of two split-screen images projected simultaneously into opposite corners of a gallery to create an enveloping, indeed claustrophobic spatial constriction. The cinema-scale video installations of this artist team (the Wilsons are identical twins) focus on institutional architecture and the collective fears and phobias it can carry. The Wilsons are interested in how power is made physically manifest in architectural design, and they aim both to demystify bureaucratic architecture and to underscore its oppressive presence. *Gamma* was filmed at Greenham Common, an American military base in Berkshire, England, that housed cruise missiles during the Cold War. Decommissioned in 1992, the base now lies deserted. Without altering its interiors, the Wilsons located inherently strange elements of the base (outscale charts, outdated equipment) to produce images both documentary and surreal, and a corresponding tension between the real and the fictive. As the camera roves through a labyrinth of abandoned rooms, revealing among their former functions "Decontamination Chamber," "Command Center," and "No Alone Zone," it evokes the "banality of evil," and the sense of oppression, paranoia,

and terror imparted by the stuff of quotidian military reality and the prospect of nuclear war. The visual vocabulary of *Gamma* reveals a close acquaintance with Cold War–period Hollywood film noir and its threatening atmosphere of suspense. Add to this the work's references to TV melodrama, news video, and surveillance footage, as well as film techniques ranging from formal wide-angle shots to forays with a hand-held camera, and the viewer is sent into a disorienting yet intensely absorbing realm.

An examination of power, surveillance, and paranoia also appears in the work of **Ann-Sofi Sidén**, whose films, performances, and video sculptures focus on narratives of control. Sidén's works feature grainy black-and-white surveillance videos of diverse activities, their monitors ensconced within units that bear a debt to Minimalist sculpture. Her seemingly unedited footage is in fact a compilation of live and prerecorded, real and artificial scenarios; in them, reality and fiction merge, as the viewer tries to link disparate narratives into a logical whole. That impulse on the viewer's part, of course, reflects a desire to understand, to impose control, and Sidén's film *QM, I think I call her QM* revolves around a similar force. A female psychiatrist (her character based on a real and paranoid doctor) discovers a mud-covered being, QM (played by the artist herself), in her apartment and becomes obsessed with this creature, who refuses to be either identified or dominated. The QM character has been embodied by Sidén in previous works, including performances, since the late 1980s. While she is a complete fabrication, the artist has created a comprehensive biographical history for her that feeds from both fact and fiction.

Sidén's work is one of a number in the exhibition that fabricate a complete, almost-normal universe closely aligned with reality itself. Many contemporary artworks evince a total immersion in a life-world that they produce with breathtaking thoroughness, provoking an intensified participation by viewers who are asked to become directly involved in them on a physical and emotional level. Whether in the plastic arts or on film or video, these works inscribe—through their insistent material appeal—a world that is at once a continuation of reality and unlike it, however subtly so. It is not so much that real life is critiqued (as in certain artworks of the 1980s) as that a painstaking construction of some aspect or aspects of real life is actively and laboriously undertaken. Artists of the 1990s grew up with mediation, quotation, and recycling, both in the work of the preceding generation of artists and in the larger world, and they see these practices as normative, not menacing. What they are after is not so much "insight" or "essence" as an inundating felt presence that will viscerally instantiate reality and meaning for the viewer. Without being autobiographical or narcissistic, these works are direct and personal; in their individuated practices, each artist is constructing a "real" of a kind—personal, social, metaphorical. The works can be seen as literal, not in their visual accuracy but in a sheer materiality that compounds and complicates reality. The results are not only technical but also metaphysical tours de force, executed with earnest conviction and intensity.

The fourth of five ongoing installments in **Matthew Barney**'s epic cycle of *Cremaster* films, *Cremaster 2* revolves around the life of Gary Gilmore (played by Barney himself), executed in Utah in 1977 for murder, and the subject of Norman Mailer's novelistic biography *The Executioner's Song*. Shot in the stark landscapes of Canadian glacier fields and Utah's Bonneville Salt Flats, Barney's elliptical narrative and extravagant mise-en-scène move back and forth in time, from the 1890s—when Gilmore's grandmother Fay is said within the family to have met the great escape artist Harry Houdini and conceived Gary's father—to the 1970s.[15] Like Houdini's own life and work, Barney's operatic cycle constitutes an allegory of escape from standards and checks, whether those checks be social constraints, the techniques of traditional storytelling, the categories of sexual differentiation, or the inherent limitations of the human body. His work involves a constant effort to break through, to arrive at a self-definition that eludes easy categorization by generating instead a vocabulary of permanent metamorphosis and transformation. Barney's grand and saturated vision gains its force in part as a physically and emotionally willed creation of the artist, a self-sustaining cosmology into which we are inexorably drawn.

A sense of a sated replicant universe, resulting from a total involvement, even an overexertion, on the artist's part, is also evident in **Gregor Schneider**'s project *Haus ur*. Since 1985, Schneider has been layering rooms inside the existing rooms of his outwardly normal-looking house near Cologne, Germany, so that his living quarters have become progressively tighter with each construction. For the *Carnegie International*, five rooms in Schneider's home—coffee room, bedroom, kitchen, closet, and toilet—have been dismantled, shipped, and reconstructed in the gallery. From inside the work, the viewer cannot distinguish between the original house and Schneider's additions; the original structure has disappeared under the artist's constructed layers, which, however, keep the interiors of the rooms fundamentally unchanged. Schneider's strategy of doubling a preexisting model is a recurring feature in the art of today, and speaks to a widespread tactic of hiding an extravagantly laborious construction process. In Schneider's case, one exits the installation and is confronted with its exoskeleton, as well as with a video documenting the labyrinthine psychogeography of Schneider's living space. Here the environment's intensely artificial nature becomes evident.

Equally the result of a densely fabricated and comprehensive vision, the work of **Bodys Isek Kingelez** takes concrete form as a sprawling sculpture modeled on the artist's hometown of Kinshasa, in the Democratic Republic of Congo. All manner of found materials are pressed into the service of a colorful utopian vision that takes its inspiration as much from extant architecture as from the artist's private lexicon. This aspect of description of the actual world is what distinguishes Kingelez's piece from fantasy or sentimental kitsch. Neither a model for proposed buildings nor an exact copy of existing ones, *Ville Fantôme* instead evolves in parallel to the world to which

15. Harry Houdini, a long-standing inspiration for Matthew Barney, is played in *Cremaster 2* by Norman Mailer, author of *The Executioner's Song*.

it refers, and to which it is joined indexically by visual references and by materials—bottle caps, corrugated cardboard, tinfoil—taken directly from Kingelez's environs. The methodology and pictorial language of *Ville Fantôme*, like the work's real-life urban counterpart, seem to be in a state of perpetual construction, collapse, and reconstitution. Yet *Ville Fantôme* carries the traditional inferences of the architectural model: it appears to be a replica of something extant, or else of something that could exist. As such, this meticulously fabricated and clearly artificial universe invokes an uncannily real geography.

"Everyone is welcome! If you want to be an artist, join our company!" So reads a billboard in Franz Kafka's picaresque novel *Amerika*, in which the protagonist attends an employment recruiting center of gargantuan proportions and, after a long struggle to assimilate into a series of absurd bureaucratic structures, finally lands a job. Both Kafka's novel and the late **Martin Kippenberger**'s *Happy End of Franz Kafka's "Amerika"* are raffish parables of the tyranny of social administration, in both cases conveyed through an audacious surrealism grounded in an "excess of the real"[16] and specifically in a vocabulary of judgment and prosecution that stands for "the obscene figure of a superegoic law."[17] *The Happy End* consists of scores of tables and chairs set up in a "sports arena," readied for the "game" of the interview process. But Kippenberger subverts the bureaucratic machine through a deliberate stylistic barbarism, using ungainly and unwanted tables and chairs that lend the work a tenderness and humor, undermining the cynicism it expresses about the public sphere. Like Kafka before him, Kippenberger was both satirist and allegorist of an intolerable truth: the power of the social order to negate individual human will.

Hanne Darboven employs a similarly overwhelming pictorial language in *Leben, leben/Life, living*, a suite of 2,782 typed and handwritten pages of "daily writing" that contains four different calculations for counting the years 1900 to 1999. Also included are two dollhouses from Darboven's extensive collection of popular artifacts, as well as photographs of the dollhouses, which are incorporated into the grid of writing. The subject of a century-long period of historical time is thus compounded by another continuum: that of the artist's lived time spent in the persistent daily task of bringing her work to fruition. In undertaking this task, and in giving it this rendered form, Darboven manifests a will to live in the present tense. Working with real time—both historical time and the time of the work's production—she extends and personalizes duration. Physically registered in the repetitive penned markings of her hand, and made literal by the enormous physical presence of the artwork as installed, time in effect becomes three-dimensional space, thereby gaining dense and concrete volume.

A plethora of objects go into **Mark Dion**'s pseudo-scientific installations, which often take the practices of the natural history museum as a point of departure. Dion enacts "a portion of the museum's task of collecting, displaying, and archivally classifying,"[18] and makes clear how subjective, personal, and arbitrary scientific methodology can be.

16. Slavoj Žižek, *Looking Awry: An Introduction to Jacques Lacan through Popular Culture* (Cambridge, Mass.: The MIT Press, 1991), p. 41.

17. Ibid., p. 18.

18. Mark Dion, quoted in James Meyer, *What Happened to the Institutional Critique?*, exh. cat. (New York: American Fine Arts, Co., Colin De Land Fine Art, 1993), p. 16.

To the history of the institutional critique that began in the 1960s and early 1970s with investigations of different fields and branches of knowledge, Dion adds an element of fantasy: his pseudo-documentary stance, his exaggerated language of "objective" presentative display, actually layers truths and falsehoods, history and fiction. Juxtaposing unrelated objects through a logic of the artist's own, Dion's allegorical universes are informed by the *Wunderkammer*, or "cabinet of wonders," of the late sixteenth and seventeenth centuries, the museum's precursor and the source and inspiration for Dion's bricolage principle of composition. Dion renders what Barbara Maria Stafford calls "a dream of connectedness, the encyclopedic will to comprehend remote or far-fetched things by bringing them within the intimate grasp of our very being."[19] In their sheer excess, his installations assert an inviolable presence and density that insert the viewer into solidity.

In works of accumulation like Dion's, presence thickens and slows. In **Alex Katz**'s paintings, on the other hand, the here-and-now snaps into focus, precisely captured in the light and atmosphere of an instant.[20] With each thoughtful step this artist takes, the composition is radically refined and pared down. Singular aspects of actual phenomena are subjected to a bold cropping of all unnecessary detail and incident. The paint surface—applied in a deft wet-on-wet technique evincing a spontaneous and fluid brushwork—retains the directness of the initial sensory impression, "that immediate sensation you see before you focus."[21] The expansive scale of Katz's vistas engulfs us in an ocular absorption further encouraged by an often close-up vantage point that places us well inside the brilliant hues of fall leaves, or the evening weather on a city street. In each case we are also given a physical record of attentiveness in the form of visibly broad mark-making, and it is here that we perceive the central paradox of Katz's enterprise: his ability to both convey an image and expose the direct sensual reality of its pictorial means, simultaneously and in equal measure. It is this riveting dichotomy—a perfectly balanced fluctuation between keen representation and formal abstraction, realism and artifice—that makes Katz's works so striking. His fusion of these polar opposites into something like an "abstract realism" is the source of his painting's finely strung tension.

William Kentridge's films, or kineticized drawings, likewise result from an arduous and painstaking process, whereby a single drawing receives hundreds of markings, erasures, additions, and emendations, its every interim stage preserved as a photographed frame or cel in an animated film.[22] On film, Kentridge's drawings register as a mental and physical force field, the concrete embodiment of an intellect and a hand at work. His annulments and adjustments within each drawing function as integral visual devices that are both compositional and symbolic, for the awareness of the activity of art-making that they induce is coextensive with an unblinking meditation on the bitter political history of South Africa, Kentridge's home. The physical process of erasure, then, is also representative of the deliberate acts of personal and social

19. Stafford, *Good Looking*, p. 205.

20. Alex Katz achieves this effect, paradoxically, through a complex and time-honored process involving preparatory sketches that lead to scaled-up charcoal drawings, which are in turn transferred by a prick-and-pounce method to canvas.

21. Katz, quoted in Ann Landi, "Innocent Perceptions," *Artnews* 97 no. 4 (April 1998): 170.

22. In traditional animation, hundreds of individual renderings are ribboned together to create a smooth film narrative. Kentridge, on the other hand, works the same few drawings again and again (the final "residue" of a ten-minute film is an average of twenty drawings), and leaves clearly visible the halting unfurling of his methodology.

effacement dictated by the apartheid state; and the sense of contingency inherent in a constant process of emendation echoes the trauma suffered by the entire society to which Kentridge belongs. In Kentridge's *Stereoscope*, the character of Soho Eckstein, a pinstripe-suited businessman modeled on Kentridge's grandfather, stands as a mute and anguished witness to South Africa's still-divided condition.

A correlative of the labor-intensive aspect of Kentridge's work is its laying bare of the process by which it comes to fruition. This is true of much of the art in the *Carnegie International*. Indeed, a fundamental characteristic of most of the artworks on view is their willful exposure of the means of their fabrication. Varied though their methodologies be, many of the artists here share a commitment to a transparent structure that is intrinsic to the work's content. On close inspection, an artwork that appears meticulously rendered is seen to be willfully flawed, welcoming artifice and fiction. The unconcealed fabrication of the works paradoxically assists us toward a more emphatic experience of them. Put another way, their realism lies less in their accurate rendering of the world than in their deliberate and stubborn literalness—which arises precisely in the spaces of fissures, rifts, and ruptures.

This pictorial strategy insists in a number of ways on our attentive engagement. A demystifying approach, in which images self-reflexively expose their own construction and interrupt their own absorption, it stands in direct opposition to the high resolution and seamlessness of the mass media. By undermining their own authority, artworks that follow this strategy simultaneously demand critical observation, as opposed to the passive reception encouraged by the information industry.[23] Further, the indication of the artist's exacting involvement in the work's production—via the calculated disclosure of material fabrication—has the effect of intensifying our own perception as well; by extension, we too become immersed in a complex approach to image-making. As the work never quite stabilizes, neither, by extension, does the viewer, who instead must actively engage in suturing the image together from its constituent parts. As such, the works resonate precisely because they seem to exist in a perpetual state of becoming— exactly the condition that enlivens them, that lends them a sense of absolute presence.

Such slippages and slidings as are visible in works that reveal their seams point to a visual language that is utterly of the present moment. This language deviates subtly from the world specifically in order to return to it with greater sharpness and clarity. Formal and technical operations appearing over and again in this exhibition include doubling, splitting, refracting, extending, reversing, displacing—all economical devices with which to unmoor experience and subsequently to retell and renew it. Translation in and of itself becomes a primary practice, and an explicit subject capable of generating powerful meaning. In this case the artwork does not transcribe the world so much as it exists in parallel to the world, distinguishing itself through the deliberate preservation of a diminutive distance. Here "reality" is located precisely

23. "The key to today's universe of simulacra, in which the Real is less and less distinguishable from its imaginary simulation, resides in the retreat of 'symbolic efficiency.'" Žižek, "Is It Possible to Traverse the Fantasy in Cyberspace?," *The Žižek Reader*, ed. Elizabeth Wright and Edmond Wright (Oxford: Blackwell Publishers, Ltd., 1999), p. 112.

in the imaginary, in the space of translation (and deliberate mistranslation), understood not as a secondary act or interim operation[24] but as a process through which artwork and viewer arrive at some deeper "truth"—albeit a constructed one. That truth is generated in the uneasy but productive coexistence of the real and the imaginary. Suspended between actual and symbolic space, works in the *Carnegie International* occupy a third terrain of fertile and radical indeterminacy. In many instances the real and the imaginary oscillate, trade places, and finally enmesh themselves in each other. In situating themselves between reality and fiction, in occupying a realm in-between, these works emphasize both the contingent nature of reality itself and the tenuous yet compelling reality of the imaginary, thus demonstrating that meaning is at once unstable and deeply desired.

Gabriel Orozco's work exemplifies the possibilities within this productive and subversive zone. *Ping Pond Table* takes its vocabulary from the ordinary game-table with which we are all familiar, yet the table has been altered through a simple compositional doubling (echoed in the organic patterns of the water lilies at the work's center) and a fusion with another pleasurable form (the pond in which the lilies float). The result reawakens a fresh consideration of everyday experience.[25] While *Ping Pond Table* is of course formed from a number of predetermined elements, both its meaning and its spatial organization are subject to unpredictable and indefinite variation when literally put into play by the viewer/participant. Orozco welcomes the dynamic interjection of the mobile body, which animates and extends the work's actual and emotional parameters, and simultaneously reveals the work's constant and intended instability. Lacking any rules by which to interact with the work, the spectator enters the elastic geography of the game experience, with its immediate emotional enjoyment and its creation of social encounters. Emphasizing the interdependency of viewer and object, Orozco prompts a profound and pleasurable absorption of the spectator into the act of making.

"Play with it, please. Have fun. Give yourself that freedom. Put my creativity into question, minimize the preciousness of the piece."[26] An openness to the participation of any and all viewers, who may subject a work to potentially endless reconfiguration, is a primary characteristic of the art of the late **Felix Gonzalez-Torres**. Willingly, even happily exposed by the artist to varying contexts and (re)interpretations, his work proceeds from his fervent desire for dialogue and community. He invited us to take part in the metaphorical and literal evolution of his work's meaning, and our participation grants it a kind of perpetually renewed life and relevance. Open to being variably and endlessly reproduced, Gonzalez-Torres's work is in a sense physically unassailable, an important condition for an artist who was deeply attuned to the ephemerality of life. Gonzalez-Torres's generosity extended to his understanding that his own life-after-death would continue to change in the hands of others: hence the owner of *Untitled*, a personal chronology in the form of a frieze, can add to it significant moments related to the artist's life.

24. "Translating is not a simple act ... a series of rich and complex operations is necessary.... Neither is translation a secondary act." Deleuze and Guattari, *A Thousand Plateaus*, p. 486.

25. Gabriel Orozco has spoken about wanting in his work "to make something present again." The artist, in conversation with the author, May 1998.

26. Felix Gonzalez-Torres, quoted in Lewis Baltz, "(sans titre), Felix Gonzalez-Torres," *L'Architecture d'Aujourd'hui* no. 306 (September 1996): 15.

In **Roman Signer**'s "action-sculptures,"[27] everyday objects—helicopter, boot, kayak, rocket—are subjected to meticulously calibrated and soberly executed operations that release energies here natural, there induced by explosives, setting the objects' physical properties into play and unleashing an unpredictable and momentary vision that is cartoonlike in its gravity-defying and often menacing effects. "I must confront the transitory," Signer remarks. "Perhaps it is a feeling that I carry within me for tragedy, for the absurd, the senseless and the useless."[28] Signer's artless video documentations of his sculpturally oriented events lend them a rational, even scientific air, and a veneer of observed truth; they anchor the artist's examinations of phenomena, chaos, and imagination in a format traditionally assigned to proven, quantifiable facts. Signer brings the methods of reasoned thought, logical calculation, and disciplined organization to bear on fundamentally aimless processes that let intellectual sparks fly while offering both a release from and an assault on an overly regulated daily existence.

"I no longer see a film, but experience a transcription. It is a different level of perception, a more subjective one."[29] Translation lies at the core of **Pierre Huyghe**'s project, and is particularly evident in his series of multiprojection videos entitled *L'Ellipse*. As previously exhibited, *L'Ellipse* consists of an extended panoramic screen bearing three projections shown in sequence from left to right. The left and right ends of the screen display two successive scenes, separated by a jump cut, from a preexisting film; the center screen displays an episode joining the two sequences, using the film's original actor but created by Huyghe. By introducing a newly recorded, real-time sequence—in which the main character looks visibly older yet still recalls his youthful celluloid self—Huyghe arrives at a quizzical and touching juncture where art and life, fiction and reality, and past and present intersect. Huyghe's interjection thus physically and conceptually uncouples the original film from its storyline and retroactively enfolds it into a new metanarrative that short-circuits time, reveals the subject as vulnerable and unstable, and doubly inscribes film and reality.

Like Huyghe's *L'Ellipse*, **Thomas Demand**'s photographs subtly untether and reinscribe their source, in this case photographs culled from the mass media, of visually indifferent sites. In Demand's hands these pictures reveal a compelling and sometimes troubling cultural charge. While his large, epic-scale photographs resemble such mass-media images, they actually show three-dimensional, life-sized environments built in the privacy of his studio, not for public exhibition but solely for the purpose of being reconstituted as photographic images. Upon close inspection, apparently immaculate window shades, tables, and chairs expose their folds and seams to reveal themselves as painstakingly constructed from cardboard and colored paper. In a final inversion, Demand knowingly uses the traditional role of photography as a faithful transcriber of the visible world to throw his subject's indisputable artificiality into doubt. Each of his images is consistently one or more steps removed from reality, putting into play a continuous series of slippages among referents, such that the very idea of an original recedes completely.

27. Roman Signer describes his own work as "aktion/skulpture." See Kristine Stiles, "The Sound of One Bomb Clapping," *Roman Signer: Works*, exh. cat. (Philadelphia: The Galleries at Moore, Moore College of Art and Design, 1996).

28. Signer, quoted in Gerhard Mack, "Roman Signer," *Kritisches Lexikon der Gegenwartskunst* no. 30 (1995): 15.

29. Pierre Huyghe, quoted in "Pierre Huyghe on His Work," *Europarte, 47th Venice Biennale*, exh. cat. (Venice: Arsenale Editrice, 1997), p. 32.

Sam Taylor-Wood's pieces likewise encourage their own symbolic dissolution, interrupting any unproblematized reading by commingling multiple orders of experience. The meanings of her choreographed tableaux derive precisely from the interface or rupture between image and soundtrack, internal and external worlds. Taylor-Wood's audio-photographic series *Five Revolutionary Seconds* takes its title from the five seconds required for the artist's camera to rotate and capture in one continuous swoop a 360-degree image of a carefully staged scene. Within panoptic views of plush interiors, a loose grouping of socially and psychically incompatible human types expresses a range of amplified states, from indifference to lethargy to anguish. Unsettling the image further is an audio recording of sounds and conversational fragments taped during the photo shoot; this informal banter contradicts the amalgam of emotional isolation and physical proximity that seems to be the lot of the figures pictured. In its complex artificial structure, its extravagant settings and sentiments, and, most tellingly, its dynamically distorted space, Taylor-Wood's work revisits the vocabulary of the Baroque, in which the raw and the fantastic are knowingly fused.

A somewhat jarring amalgam of opposites informs **John Currin**'s pale nudes, in which the high and the low uncannily cohere. Currin's figures exhibit the distended anatomies and distorted proportions of Northern Renaissance and early Mannerist figuration, but their poses are closer to the pin-up than to any art-historical figure, and their faces are modern, lifted from such banal sources as old *Cosmopolitan* magazine covers. This perverse ménage of influences makes for a "realist drag"[30] style that synchronizes renderings both precise and artificial. Currin's virtuoso technique echoes Northern Renaissance art: the impeccable surfaces of his paintings are built up from multiple layers of opaque monochrome paint sealed with glazes, resulting in enamellike grounds and deep tonalities. Centrally placed on the picture plane are one or more bodies ranging from fleshy to skinny, from youthful to middle-aged. Refined but denatured and marked by time-induced flaws, Currin's figures may intimate misogyny, but more than this they counter the effect of the erotic that is the traditional domain of the nude.

The cut-paper silhouette and the epic cyclorama—both popular nineteenth-century art forms—are used by **Kara Walker** to altogether personal ends in her mural-sized installations examining the history of race relations in the United States. Walker creates a type of contemporary history painting out of near-life-sized cameos cut from black paper and arranged in a narrative frieze cycle against a white wall. Her formal methodology feeds her trenchant subject matter: the combination of black contours and white ground, and the reduction of figures to their emblematic profiles, are like visual equivalents of the act of stereotyping at the core of Walker's narrative.[31] Working with racial stereotypes drawn from antebellum caricatures, slave narratives, and "other sorts of 'truthful' forms of historical fiction,"[32] Walker uses an iconography that is transgressive on all fronts—sexually explicit, often cruel and violent, scatological and

30. John Currin, quoted in Keith Seward, "Boomerang," *John Currin*, exh. cat. (Limoges: F.R.A.C. Limousin, 1995), p. 38.

31. "The silhouette says a lot with very little information, but that's also what the stereotype does. So I saw the silhouette and the stereotype as linked." Kara Walker, in "An Interview with Kara Walker," *Kara Walker: Upon My Many Masters— An Outline*, exh. brochure (San Francisco: San Francisco Museum of Modern Art, 1997), n.p.

32. Walker, in "An Interview with Kara Walker," *Capp Street Project: Kara Walker*, exh. brochure (Oakland: California College of Arts and Crafts, 1999), n.p.

December 1, 1998
Bienal de Lima

December 1, 1998
Bienal de Lima

December 5, 1998
Bogota, Colombia
work by Felix Gonzalez-Torres

December 7, 1998
Mexico City
La Panaderia

December 8, 1998
Mexico City

December 15, 1998
Alex Katz paintings
Brooklyn warehouse

December 16, 1998
Alex Katz studio
New York

December 1998
Las Vegas

January 30, 1999
Chicago
Kerry James Marshall studio
RYTHM MASTR (in progress)

February 14, 1999
Madrid, Spain
Kendell Geers installation

February 16, 1999
Madrid (Casa de Americas)
José Antonio Hernández-Diez

February 17, 1999
London
Wilson twins + Grynsztejn sisters

February 20, 1999
Hamburg, Germany
Hanne Darboven's home

February 20, 1999
Hamburg, Germany
Hanne Darboven house/studio

February 20, 1999
Hamburg, Germany
Hanne Darboven house/studio

February 20, 1999
Deichtorhallen, Hamburg
Martin Kippenberger installation

February 20, 1999
Deichtorhallen, Hamburg
Martin Kippenberger installation

February 23, 1999
New York
Shirin Neshat studio

March 11, 1999
Pittsburgh
Janet Cardiff

March 11, 1999
Pittsburgh
Janet Cardiff

abject. In these simultaneously elegant and perverse vignettes, male and female, black and white, are victims and perpetrators in equal measure. Combining bawdy humor and sarcastic parody with scathing critique, Walker retells and takes fierce possession of a long and painful history of derogatory representation.

Probably no event, whether historical or mythic, has been depicted more often in Western art than the Crucifixion and its prelude and aftermath. Long after the majority of art's countless renderings of the Crucifixion story were produced, **Luc Tuymans**'s cycle *The Passion* explores how even the most profound experiences can be leached of precision and meaning in re-presentation. Each canvas in Tuymans's series is based on a photograph taken at a modern enactment of a Passion Play, an "authentic forgery"[33] at an irretrievable remove from its religious and historical origins. Tuymans evokes the sacred only to preclude it: the stark light in these works is not some divine radiance but a banal transcription of the glaring stage lighting that illuminated the actors. Modest in size and always painted in a single day, the paintings retain the croppings, the blurs and overexposures, and the neutral emphasis on all parts of the picture seen in the photographs that are their sources. Tuymans's pared-down compositions, muted colors, and deliberately scanty brushwork translate emotionally as expressing a palpable loss—perhaps of religious faith itself, perhaps of belief in the efficacy of painting, perhaps of hope for a primary experience in a constantly mediated world.

Edward Ruscha deliberately choreographs a collision of different orders of experience (visual, semantic, imaginary) in paintings that evince his signature style: two fields—one pictorial, one linguistic—intersect and cross-pollinate, such that nature becomes a conventional "sign" and language takes on a dimension of the physical world. *Artesia*, a canvas with the proportions of a drive-in-movie screen, casts a rugged snowscape against an inhospitably bright backdrop, overlaid by a grid of words belonging in typography and name to the everyday idiom of Los Angeles's road signage system, and receding, like an aerial sprawl, into perspectival distance. The striking discrepancy that Ruscha creates between image and language is a source of friction in his art: the word as outsized shape rubs against the word as conjurer of mental images, and against the visual image of a clichéd natural Sublime. In this way Ruscha gives graphic body to an extralinguistic state of cognitive dissonance— a "visual noise"[34]—that he defines as of the urban realm, and specifically of the psychic territory of Los Angeles. Literally as well as figuratively, he articulates that city's "cool" sensibility in all its sun-shot airbrushed clarity, its taste for immaculate finish and icy perfection of style.

Urban reality and mythology combine in **Kerry James Marshall**'s *RYTHM MASTR*, an inner-city tale in the form of a superhero comic printed on newspaper. *RYTHM MASTR* extends Marshall's conceptually powerful allegories of contemporary African-American culture in a new formal direction. Centered on his own neighborhood in the south side

33. Luc Tuymans describes his painting as "an authentic forgery" in "Juan Vicente Aliaga in Conversation with Luc Tuymans," *Luc Tuymans* (London: Phaidon Press, 1996), p. 8.

34. Edward Ruscha, quoted in Bernard Blistène, "Conversation with Ed Ruscha," in *Edward Ruscha*, exh. cat. (Rotterdam: Museum Boijmans Van Beuningen, 1990), p. 130.

of Chicago, it is a parable chronicling a dystopian yet hopeful universe—part imaginary, part topically concrete—at the thin edge of social, technological, and moral fault lines. The story follows the divergent paths taken by two young kids in the wake of a drive-by shooting, which escalates into a battle pitting superheroes—latter-day embodiments of ancient African archetypes—against the forces of cybertechnology. The comic strip form belies the profoundly serious issues raised by Marshall's allegory, which dramatizes the black urban community's complex and ongoing negotiation of its African heritage, uniquely difficult history, and present socioeconomic challenges. While staying close to the cruel realities of contemporary urban existence, Marshall's work also focuses upon the individual and collective acts that enable inner-city inhabitants to preserve their communities, their histories, and, more fundamentally, their self-respect. While devised to embody a deep sense of common humanity, *RYTHM MASTR* never loses sight of its specific context, made compellingly physical in installation: printed as newspaper comics pages, the work covers the vitrines of a museum gallery, echoing the papered storefront windows of failed urban centers, a visual code for an economically devastated core.

At the level of art-historical practice and precedent, the works in the *Carnegie International* have origins in recent modernist and postmodernist practice, and reconfigure earlier modes of institutional and multicultural critique. Most of the work in the exhibition reveals a debt to the reflexive means and emphasis on phenomenological and indexical inquiry seen in Minimalism and Post-Minimalism, which broke with the modernist focus on the autonomy of art while manifesting a concomitant awareness of the gallery framework and rejecting the modernist conception of the acontextual space. These tendencies, fed in the late 1970s and early 1980s by feminist, psychoanalytic, and postcolonial theory, led in the 1980s to a full-fledged postmodernism and in the early 1990s to multiculturalism, its primary characteristics a critique of "the institution" writ large[35] and an undermining of the dominant order.

Primarily a Euro-American aesthetic, "classic" postmodernism of the late 1970s to mid-1980s undertook a blistering critique of representation that also questioned conventional reality, primarily by "denaturalizing" the effects of our image-world. Many postmodern artists analyzed and deconstructed imagery culled from the storehouses of the media in order to reveal it as ideologically fabricated rather than given and "real." "Reality" as a consequence could be understood as socially constructed, and also as imposed upon individuals by institutionalized forms of power. Thus postmodern art was frequently put at the service of a critical stance toward this "reality" as a cultural product and a directed experience. Countering the seamless representations of the communications media, postmodernism was urgently dedicated to the effects of mass culture on our perception of reality, and its critical stance and strategic tools—its depiction of depictions, its laying bare of the process of meaning-production—are

35. "The 'institution' was widely interpreted to signify a dominant ideology, such as Modernism; an ever-present cultural order or standard, such as patriarchy; social structures and behavioral patterns, such as class and gender; cultural producers, such as the museum or the Media." Jan Avgikos, "Institutional Critique, Identity Politics, and Retro-Romanticism: Finding the Face in Sherman's Photographs," *Jürgen Klauke, Cindy Sherman*, exh. cat. (Munich: Cantz and Sammlung Goetz, 1994), p. 49.

still in evidence in art today. Broadly speaking, however, postmodernism ran into two corrosive impasses to which the works in the *Carnegie International* have reacted. Too often, postmodern works became polemical illustrations of theory, losing any capacity to communicate affectively, their primary content being not the experience of an image but its dissective analysis. Perhaps more significant was the postmodern position that there was no possibility of transcending or transgressing a mediated reality, which was seen as a "simulacrum" or field of referents that threatened not just to re-present but to replace our perception of the world and of ourselves, leading to a terminal isolation of the self.

The works in the *Carnegie International* are concerned less with the replacement of the real by its simulacrum and more with actively occupying the field between the real and its referent, that interim space between phenomena and interpretation where private introspection can still take place, before reality is constituted and fixed. In other words, the artists in this exhibition demonstrate that meaning can still be generated through making—that the image, precisely through its incompletion and open-endedness, may contain the capacity to reconnect rather than to reify. This stance—"what Heidegger called 'worldling'"[36]—maintains that reality is indeed a construct, but one that we have the freedom to alter and to see in multiple ways, manipulating its meanings to suit our private visions. Certainly these artists don't deny the possibility of alienation from daily reality. In fact, such alienation seems a prerequisite and starting point for their attempts to allow reality and fiction to coexist in the same visual field. Squarely situated between reality and reproduction, the works in the exhibition widen the sphere of both, and recover a connection between them.

Many of the artists here belong to a generation raised on postmodernism, and their anxiety over the mediation of reality is tempered by their assumption that the distance between reality and representation is irreconcilable.[37] No "task of mourning" for the real or first-degree referent is evident in these works, because the real is recognized as the result of a reciprocal exchange between subjective thought and the many constructions that constitute the world. Deconstruction has been followed by a turn toward re-construction, and production has taken precedence over re-production, spurred on by a consciousness that goes beyond polemical strategies. Despite their clear debt to postmodernism—particularly its questioning of authority and its destabilization of given realities—artists today resist its dissolution of reality into received imagery. Even when media-based imagery is the basis for an artwork, it is willfully reordered to articulate a personal vision and produce an affective experience that is "immediate not mediated."[38] The strategy points to a pronounced if subdued sense of authorship, a firm but discreet belief in subjectivity.

A parallel analysis of the workings of cultural power reached its saturation point in the early 1990s with multicultural practices that sought to expose and counter the dominant order's exclusion of subjectivities and realities different from its own.

36. Stuart Morgan, "Thomas Demand," *Frieze* no. 23 (Summer 1995): 71.

37. See Žižek, *Looking Awry*, p. 36.

38. Fisher, "Art's Caress," p. 166.

Multiculturalism, or "the cultural politics of difference,"[39] asserted realities in the plural: diverse and multiple experiences of individuals and cultures, located in or deriving from outside the "central" Western metropolises, outside a culture that had denied them legitimate avenues of voice and visibility. Informed in particular by feminist practice and by postcolonial theory, and opposed to modernism's ahistorical, universalizing tendencies, multiculturalism sought to dismantle conventional hierarchies and to insert into artistic discourse the specific texture of previously marginalized political, social, sexual, ethnic, and geographic "others." Cross-cultural dialogues were undertaken across a wealth of diverse, politically and socially grounded narratives that often bespoke a biographical bent, thus preparing the way for the current focus on subjectivity.

Yet while multiculturalism enabled insight into different histories and practices, and set the stage for meaningful dialogues that allowed us at least partially "to *see differently*,"[40] the strength of the work it produced was diminished by a reductive emphasis on quasi-ethnographic investigations that left little room for aesthetic and intellectual play or affective impact. The persistent focus on biography and lines of cultural origin paradoxically led to a self-induced ghettoization in which the artist was exclusively and perpetually "other," a condition that did not allow for individual and complex inspirations beyond and in excess of issues of identity, hybridity, and ethnicity. Further, instead of directing attention toward a truly pluralistic and decentralized cultural practice, multiculturalism in its emphasis on difference may have implicitly, if in an oppositional manner, reinforced a West-centric "master narrative" by unwittingly reproducing the binary mechanisms of self/other and center/periphery that it sought to disavow.

Art-making today has absorbed, retooled, and renewed the lessons of multiculturalism for the present.[41] Recognizing both the pitfalls and the potential of "othering," artists have moved "beyond the demand for assimilation, beyond absolutist notions of difference and identity, beyond … 'self and other,'"[42] and toward a polyphonic visual vocabulary that actively *produces* difference rather than simply prescribing it. The heterogeneous realities and sedimented imagery presented in this art cohabit yet remain discrete. Rather than deploring the loss of a "pure" or original ethnicity, or lamenting the imposition of a stronger symbolic order, artworks today propose to occupy a "scene of translations,"[43] a space in which multiple visual languages, including those of the dominant center, intersect and coexist incommensurably. Characteristic of this transcultural aesthetic is a positively unresolved and reciprocal exchange among impure meaning-constructions (including those of the West) that will not settle on one or another definition.

Significantly, non-Occidental societies have long employed dynamic tactics like these in their negotiations with the West.[44] Historically, resistance to colonization often took the form of a deliberate and critical misappropriation and manipulation of Western elements, a selective absorption of the colonial order in which the colonized

39. Cornel West, "The New Cultural Politics of Difference," *Out There: Marginalization and Contemporary Cultures*, ed. Russell Ferguson, Martha Gever, Trinh T. Min-ha, and West (New York: The New Museum of Contemporary Art, 1990), p. 19.

40. Fisher, "Hors d'oeuvre," *Cocido y Crudo*, exh. cat. (Madrid: Museo Nacional Centro de Arte Reina Sofía, 1994), p. 314.

41. If the most important contribution of multiculturalism has been to establish a political awareness of point of view— of who speaks and who remains voiceless—it could be argued that multicultural practices have informed the thrust toward engagement-oriented art, which offers one way in which the "other" is no longer mute.

42. Sarat Maharaj, "Perfidious Fidelity: The Untranslatability of the Other," in Fisher, ed., *Global Visions: Towards a New Internationalism in the Visual Arts* (London: Kala Press, 1994), p. 27.

43. Ibid., p. 28.

44. See in particular Homi K. Bhabha, "Of Mimicry and Man: The Ambivalence of Colonial Discourse" and "Signs Taken for Wonders," both in *The Location of Culture* (London and New York: Routledge Press, 1994).

culture did not renounce its own symbolic terms. The result today is a locally inflected "vernacular multinationalism"[45] grafting the local and the global. This language, visual and otherwise, must not be misread as degraded or derivative; on the contrary, it is in and of itself productive, dynamic, and deliberately mixed and multidimensional. The artworks it informs describe an evolving form of subjectivity that is replacing older conceptions of the "authentic" and "stable" self (itself now revealed as a fiction) in favor of a self that is inherently multivalent and contradictory.

The subject who is situated in an in-between space of negotiated borderlands and cultures is precisely the focus of **Shirin Neshat**, whose most recent work, a meditation on the condition of circulating between East and West, underscores rather than smooths over the distances and divisions between cultures. Neshat's photographs and video works have examined the excluded position of women in fundamentalist Islamic societies; her work both creates and recovers a symbolic space for such women, rendering them visible and audible through iconic imagery and powerful vocal soundtracks. Neshat's videos have taken the form of two simultaneous projections facing the viewer from opposite sides of a room, demanding a negotiation between images that references a negotiation between separate and differing yet interdependent psycho-geographic worlds. Physically and intellectually positioning the viewer in an interstitial space, between images of an imaginary and unrecoverable homeland and a present reality, Neshat's structural configuration describes a fundamental condition in our hypermobile era of voluntary and involuntary migration.

In **José Antonio Hernández-Diez**'s *El Ceibó* (The Sideboard), a videotaped image shows the artist obsessively packing, unpacking, and repacking, in a ritual of dispossession and exile that reflects the present-day unreliability of the intimate domestic realm. The video projection, whose dimensions reference the artist's recumbent height, is ensconced within a generic cabinet. This fusion of corporeality with a household object links Hernández-Diez's work to a Surrealist tradition that had a strong influence in Latin America, and whose tactics include the use of a highly personal iconography and a grafting of dissimilar components, often at an inflated scale. A sculpture by Hernández-Diez in the form of an enlarged dish drainer, ornamented with acrylic fingernails cut to the artist's height, takes on resonant connotations in light of his Venezuelan roots: a prosaic emblem of cleanliness, the work is redolent with the Christian rite of ablution, and therefore with the erasure not only of dirt but of all the "sin" that a Catholic culture conventionally wishes to expunge, including the sexuality connoted by the fake fingernails. Hernández-Diez's work exposes, challenges, and undermines the strict constructions of sexuality and gender that underpin the abiding values of a religious and patriarchal social order.

Formally speaking, the multinational aesthetic manifests itself in the kind of contemporary bricolage seen in the paintings of **Chris Ofili**. Here, raw elements drawn from a vast range of Western and non-Western sources operate both independently

45. Thanks to Kendell Geers for recommending the term "multinationalism," which implicates both multicultural practices and, more uneasily, the "multinational" corporation, an economic parallel to the cultural global/local practices outlined here.

and as part of a larger field to constitute a single image. Ofili's multivalent forms are arranged in a cut-and-mix, syncopated rhythm recalling the sampling and recycling techniques of hip-hop music, a primary inspiration of his. While Ofili's canvases are influenced by African aesthetics (particularly cave paintings containing repetitive dot patterning, which he observed on a visit to Zimbabwe in 1992), Ofili is more interested in the exaggerated "Afro-kitsch" of black popular culture and in deliberately misquoting "African" materials—to wit, elephant dung, which is employed in traditional African sculpture but which Ofili obtains from the London zoo and uses as decorative feet to hold up his canvases. Ofili thus directs the viewer's attention away from the matter of cultural origins and toward contemporary black urban experience in a way that disputes identity stereotypes.

Kendell Geers similarly employs recycling techniques in a contestatory manner, fully aware that the recycling of objects and images is a survival strategy in the so-called "Third World," including his native South Africa. Geers's work finds a compositional equivalent in popular music: he was specifically influenced by 1980s techno, with its focus on elsewhere discredited elements such as noise and feedback, and on the looping of material "stolen" from street culture. Geers applies these techniques to his own raw material, clips culled from commercial Hollywood movies and reconstituted in sculptural environments that aggressively foreground the physical aspects of the mass media: television monitors, VCRs, cables, and exposed wires are scattered in such a way as to recall process art, here invested with subjective emotion and politics. Geers is an Afrikaner, and his direct lineage traverses colonization, oppression, officially dictated violence, resistance (in the form of political activism), and the conversion of an entire society from one reality (the reality of apartheid) to another. Keenly aware of the contingent nature of authority, Geers has devised a critical practice that examines the deleterious effects of dominant commercial imagery on the imagination, and prompts the viewer beyond the passive absorption of an otherwise uninterrupted flow of technology.

The grafting of the local and the global, and of tradition and modernity, finds a poignant representation in **Chen Zhen**'s *Daily Incantations*. One hundred and one chamber pots are arranged on a tiered wooden rack based on a Chinese bell instrument from the Bronze Age. Emanating from the chamber pots is a meditative sound—the sound of their being washed clean, a morning ritual in Chen's native Shanghai that is vanishing in the wake of industrial development. At the work's center, a large sphere of electronic debris evokes the increased presence of Western technology in Chinese culture. We also hear the sound of readings from Mao Zedong's *Red Book*, a reference to Chen's childhood, when such readings were a daily communal rite meant to "cleanse the soul." These dual incantations have less to do with the relations between East and West than with China's internal tensions between ancient traditions and present pressures; what is interesting to the artist is "to expose various relationships and contradictions between tradition and reality."[46]

46. Chen Zhen, quoted in Hou Hanru, "Entropy: Chinese Artists, Western Art Institutions," in Fisher, ed., *Global Visions*, p. 85.

Chen's work, "rooted in the dialectics of Chinese philosophical ideas of the world, is also directed towards the development of international communications and, finally, towards revealing the truth that the future world order will be born out of a certain entropic rule; that a new internationalism will replace the existing West-centric domination."[47] There is no question that current art production evinces internationalist strains, manifested in a visual repertoire that is shared worldwide, derived from common references and mutual influences due in great part to a pervasive information technology, an escalating global economy, and increased travel among artists, many of whom live outside their native culture. This situation reflects and depends upon an economic multinationalism that often veils its maintenance of traditional hegemonies and socioeconomic disparities.[48] Works in the exhibition sound a note of caution against any traffic in a "global" visual vocabulary that inadvertently gives itself over to West-centric value systems, particularly when images themselves have emerged as the ideal commodity of late capitalism—nothing travels, is consumed, and turns over faster than visual spectacle. This means that artists have to be particularly astute in countermanding the "master narrative" of globalized production, or at least to be highly conscious accomplices to it, awake to how the shifting conditions of global techno-economics shape subjectivity and ideology.

Is it conceivable to imagine a transnational vocabulary that can both circumvent an undifferentiated "international visual esperanto"[49] and resist the dominant rationale of late capital? Artworks in this exhibition oppose the idea of an international "trans-avant-garde" by honing in on the principal contradiction emerging in the new world-space of global capitalism: its opposite tendency toward localization.[50] The "abstract" arena of late capital is reterritorialized from within by enduring ties to vernacular history, immediate environment, and subjective experience. The artists in this exhibition pay constant attention to the linkage of the local and the personal, at all levels, to global processes. They weave lived, "local" concerns into an "international" arena, creating a strategic transnational forum made up of a "multiplicity of 'locals,'"[51] an in-between space of vernacular and global practice. Globalism for these artists is "based on a recognition of difference rather than an assumption of sameness"[52]: whereas the "internationalism" of the earlier twentieth century suggested a universal identity crossing national boundaries, with little regard for the specifics of place and context, current internationalist strains propose a syncretism of local and global expression. This grafting of the local and the global appears across an increasingly decentered and thriving art community encompassing regions formerly considered, at least in the West, to be on the margins: Latin America, Eastern Europe, the Middle East, Scandinavia.

Nahum Tevet's *A Page from a Catalogue* holds the local and the global in symbolic tension. Its sculptural language of commercial materials (such as plywood) and stripped-down geometric shapes derives from Minimalism, and, in Tevet's native Israel,

47. Ibid., p. 87.

48. It should not be ignored that the local/global synergy evident in art-making today has an uncanny macro-economic parallel in the "global localization" marketing strategies employed by transnational corporations like Sony and Coca-Cola since the late 1970s. It should also be noted, as Sassen writes in the present volume, that Western-derived "globalization" does not impact equally or merge smoothly with the wide array of specific cultural, political, and economic realities that it crosses world-wide. Differing life-worlds undertake varying degrees of technological assimilation in all directions, and mobilization is often the privileged outcome of economic access.

49. Maharaj, "Perfidious Fidelity," p. 34.

50. At its worst, this tendency results in contestatory enclaves defending essentialized notions of nation, race, religion, and cultural identity, which, at their worst in turn, give way to acts of "ethnic cleansing" and rash fundamentalism such as we have recently witnessed in many parts of the world.

51. Sassen, "Revisiting the Edge," p. 9.

52. Thomas McEvilley, "Tracing the Indian Diaspora," *Art in America* 86 no. 10 (October 1998): 76.

53. Deleuze and Guattari,
A Thousand Plateaus, p. 499.

metonymically relates to an entire modernist heritage. Tevet's work resonates with
the Bauhaus spirit that emigrated from Europe to Israel and elsewhere earlier in the
twentieth century and subsequently adapted to local conditions. Significantly, Tevet's
experience is deeply informed by Israeli modernism's ideological counterpart, Zionism;
he was raised on a kibbutz, a Zionist settlement model that also reflects modernist
utopian ideas of social harmony and communal identity. Today the kibbutz system
founders under socioeconomic and political strains, and Tevet's sculpture, made,
like the kibbutz, from independent parts that accrue into a greater whole, is shot through
with vulnerability in its seemingly precarious deployment. This pulls his work away
from any visionary language and into a less idealized zone, one that manifests the
profound ambivalence toward the consequences of nationhood felt by the current
generation of Israeli artists.

It is **Jeff Wall**'s abiding interest to force contemporary capitalism to appear in
his work in its embedded forms, and to join it to its individual human agents. Wall
recasts telling moments of urban life in the heightened language of a Western pictorial
tradition that is as much artful allegory as pointed reportage. He presents his large
high-resolution photographs as back-lit Cibachrome transparencies set in the kinds of
cases associated with advertising display. Yet while he may employ devices of visual
persuasion familiar to us from advertising and movies, he does so not to conjure dream
images of escapist desire but to lay bare, critically and vividly, the all-too-real under-
side of our late industrial society. Wall's newest piece, in progress as of this writing,
is set in the Mies van der Rohe pavilion in Barcelona, Spain, an archetypal model
for twentieth-century Western domestic architecture. Into this spatial doctrine of a "uni-
versally" applicable route to a "better life" Wall inserts the normally unacknowledged
social and economic support that such an idiom requires to sustain itself, in the form
of a cleaning man—by extension, the representative of a vast fringe work force that
buoys a "global" language.

There are, of course, enormous benefits in the globalizing process, including the
recognition of alternative identities and image manifestations that can and do under-
mine homogenizing forces. An important outcome of global electronic networks such
as the Internet, for example, is the creation of a worldwide virtual grid of specialized
micro-communities based on convivial alliances and interests, communities that are
exhibiting and developing new ways of "inhabiting" the world online, simultaneously,
in real time and space. **Sarah Sze**'s sculptures demonstrate a treatment of space that
shares characteristics with the networks of the World Wide Web, being extraordinarily
complex, nonhierarchical, decentralized, and constituted from discrete core elements
that are used in additive fashion, piece by successive piece, to seemingly infinite
ends. Sze's labyrinthine assemblages are formed out of interlinked paraphernalia—
the household bric-a-brac of domestic life—whose "streamlining, spiraling, zig-
zagging, snaking, feverish line of variation"[53] becomes inseparable from a sense

March 13, 1999 New York City
Ada + Alex Katz, Richard Armstrong
tree models for painting

March 24, 1999
Andy Warhol Museum, Pittsburgh
Takashi Murakami

Chris Rauhoff
March 24, 1999

March 26, 1999
Pittsburgh
Kerry James Marshall

Kara Walker
Oakland, California
April 2, 1999

Alyson Baker
Olafur Eliasson
April 29, 1999

May 3, 1999
New York
Matthew Barney studio

May 3, 1999
New York
John Currin studio

May 5, 1999
Mark Dion
Carnegie Museum of Natural History

June 1999

Venice Biennale
Ann Hamilton installation

June 6, 1999
CI99/00 advisory committee
Porto, Portugal

of acceleration and speed. Yet the work maintains a tie to human scale through its commonplace materials—matchsticks, straws, thumbtacks—and its evident and laborious patchwork technique. Sze's visual vocabulary remains locally independent even as it is immersed in an ambient whole whose macrostructural parallel is hypermobile electronic space.

Ever attuned to the way two-dimensional flat surfaces are received in the world, **Laura Owens** derives the formal inspiration for her paintings partly from computer graphics, which generate three-dimensional illusion from unmodulated spatial structures and uninflected, inorganic colors. Much in the way that icons sit on a computer screen, Owens's precisely defined shapes occupy an open field of sharply delineated color. While her skin-thin surfaces and flattened figure-ground vocabulary owe a clear debt to mid-century Color Field painting, her compositions may equally derive from computer-generated drawings; if so, their transference to canvas retains the screen's crisp pastel palette. The aphysicality of Owens's painting is countermanded, however, by her strong emphasis on surface material and outsize scale. Her canvases include thick passages of impastoed paint squeezed directly from the tube, introducing an "expressive" facture, and they often physically engage their architectural surrounds—a diptych may be installed, for example, with the panels directly facing each other in the space, and an aggressively tall painting may almost brush the ceiling.

Takashi Murakami's sculptures and paintings brazenly straddle plastic and cyber realms, for they derive as much from Japan's *otaku* (geek) subculture of animation art as from that nation's time-honored pictorial traditions. Murakami's life-sized polychrome cyborgs, or human machines, are meticulously crafted sculptures inspired by the unofficial and sometimes hard-core computer-image offshoots of the *anime* (animated film) and *manga* (comic book) industries. He conjoins the visual terms of cybervision with the imagery of traditional Japanese art, especially in his mural-sized paintings and wall works.[54] The aesthetic continuity between nineteenth-century Japanese works such as those of Katsushika Hokusai (whose stylized woodcut prints are well-known to Westerners) and Murakami's postmodern, post-Pop counterparts[55] is grounded in their radical distortion of nature—an emphasis on decoration and surface, line and expanse, over volume—that values artificial construction and dramatic impact above accurate rendering of the outside world. Combined with a technical attention to detail and an elegant and precise craftsmanship, this continuity renders Murakami's vision historic and current at once.

Present-day experiences of deterritorialized cyberspaces, hypermobile economics, and unprecedented emigration and immigration (all fundamental aspects of globalization[56]) define both our larger world and an evolving kinesthetic consciousness particular to artists, who often must travel to work on-site at the ever increasing number of international exhibitions such as this one. These peripatetic conditions have inevitably led to a focus on nomadism itself as a subject and strategy in art.[57]

54. Significantly, Takashi Murakami received the first doctorate in *Nihon-ga* (literally, Japanese-style painting) from Tokyo's prestigious National University of Fine Arts and Music. *Nihon-ga* is an officially sanctioned genre that combines traditional Japanese techniques with Western painting practices.

55. I am indebted to Midori Matsui for this observation. Murakami himself has lectured on the tie he perceives between premodern and postmodern expressions of Japanese popular imagination.

56. See Sassen, "The State and the New Power of Geography," *Losing Control? Sovereignty in an Age of Globalization* (New York: Columbia University Press, 1995).

57. See Meyer, "Nomads," *Parkett* 49 (1997): 205–9, and Miwon Kwon, "One Place after Another: Notes on Site Specificity," *October* 80 (Spring 1997): 85–110.

Movement through space is a primary element of **Janet Cardiff**'s museum "audio walks," in which the viewer/listener dons a Walkman and headphones bearing the voice of the artist/narrator, and is led by that voice along a route through the museum building. As the viewer/listener perambulates the physical site, spaces and incidents in the present overlap in the imagination with a hyperrealistic "soundscape" conjured by Cardiff's voice. Her work thus exists at the intersection between physical and imagined space, real and fictive experience. Cardiff's work is performed and completed through the viewer's peregrinations and projections into space, creating an altogether novel form of "site-specific" art that engages its context in an aggressive yet ephemeral way. Generating "a nomadic narrative," the artist transforms the site "from a physical location—grounded, fixed, actual—to a discursive vector—ungrounded, fluid, virtual."[58]

Markéta Othová's suites of images diagram a lyrical essay on nomadism, charting her travels between her native Prague and cities beyond. Each of Othová's images reaches beyond its visual and formal appeal to address photography's pictorial genres (the landscape, the still life) and specific properties—as when, for example, it focuses on sources of light, that essential component in the production of the photograph. If it is the photograph's essential character to picture something that is no longer, Othová amplifies this attribute by focusing on things in motion or in the process of eradication, that is, in the process of no longer being where or how they are pictured. Transitory sights glimpsed from moving trains or while walking appear over and again as entries and exits into a still, unpeopled world that seems accessible yet withdrawn. The atmosphere that consistently engages the artist in these images seems situated just this side of an event.

Franz Ackermann also creates subjective geographies, rendered as small-scale gouaches that function as intimate journals of his transient existence. Drawn as he travels for months at a time to locations throughout the world, and ever alert to a sense of place, Ackermann's "mental maps" combine actual locations with dynamic abstractions that suggest the sensorial immediacy, chaotic atmosphere, and mutating heterogeneous urban sprawl that are his subject matter. Impressions of objects and sensations swim in fluid, shifting space, oscillating between the macroscopic and the microscopic in an exemplary presentation of "haptic" space—"the space of contemporary movement, of capital," the primary aspect of which "is that its orientations, landmarks, and linkages are in continuous variation."[59] Emotionally specific rather than physically accurate, Ackermann's miniature improvisations are the efforts of a willfully nomadic mind: no diasporic sense of exile or longing for home is evident in these works, which, to the contrary, espouse an endless passage and a deterritorialized invention.

Unlike Ackermann's border-crossing journeys, **Willie Doherty**'s works are squarely situated at or in a border zone. Structurally and thematically, they render an interspace that constantly troubles any clear division or resolution between opposing viewpoints, between nature and culture, self and other. *Somewhere Else* has been exhibited as a

58. Kwon, "One Place after Another," p. 95.

59. Deleuze and Guattari, *A Thousand Plateaus*, p. 493.

large, free-standing, V-shaped construction, each of its four surfaces receiving a tall, floor-bound projected video image. The open-book construction necessarily prevents simultaneous access to the entire work, demonstrating in powerful sculptural fashion the near-impossibility of occupying more than one point of view at the same time, whether physically or, by extension, personally or politically. Doherty, who was born and raised in Derry—a hotbed of "The Troubles," the civil strife of Northern Ireland over the past thirty years—understands, from a perspective both political and deeply personal, the reality and potentially violent consequences of divergent, irreconcilable, and coexisting vantage points. He addresses his country's complex history with a persuasive visual poetry informed by the language of film noir, camera surveillance, tourist advertising, and in particular by visual devices used in TV crime-scene docudramas for conveying the "real" (the shaky handheld camera image being a prime example). But Doherty uses such techniques to foreground the ways in which the media pretend to imagistic credibility and thereby construct and influence our perception of places, people, and events. His film techniques are brought to bear on borderlands in his immediate environs: bucolic landscapes riven through by the vestiges of military demarcations, corroded urban peripheries, the seashore lapping at land's edge. Added to *Somewhere Else* is a disembodied voice, which, while acting as a mark of immediate human presence, cannot be properly located in space and, like the viewer wanting to see Doherty's work all at once, is given the impossible task of being "a man in two places at the same time."

60. Stafford, *Good Looking*, p. 10.

The interspace described by Doherty's installation is finally the location to which all of the works in the *Carnegie International* to some extent refer—at the living edge of the physical and the digital, of a disembodied and a haptic self, of representation and abstraction, of the real and the fictive, all within an actively generated in-between. Like experience itself, art today is built around a series of coexisting and incommensurate oppositions that demarcate the territory and the terms of larger ideological debates: the virtual versus the material, the global versus the local, fiction versus reality. Over and again, works in this exhibition are phenomenologically based and rely on the spectator's psychosomatic response; they construct emphatic total worlds while exposing their means of fabrication; and they deliberately reveal rifts in their narrative and formal structures. Such methods create a region of intense formal and emotional indeterminacy, one that will not favor any one medium or narrative and that defers any culmination or end.

This aesthetic is also and at the same time an epistemology and an ethical stance. Constantly in formation, its refusal to synthesize into a unified whole or absolute "truth" is coextensive with the circumscribed dimension of "universals" at the present time, and by extension has its human correlative in "a 'weakening' of immutable or Heideggerian Being, then giving shape to metamorphic Becoming."[60] It is this unfixed

and sedimented Becoming that is encouraged by the "open works"[61] in the exhibition, works that insist on our corporeal and emotional experience as the ground on which meaning must be formed. As such, these works argue for a contemporary cultural identity that refuses to proclaim an irreducible wholeness or indivisible origin, manifesting instead the vulnerability of a personal, durable self located at the very threshold of diverse subjecthoods.

Objects soliciting a shared vacillation and fleeting integration with the subject impel human choice. One must actively extend oneself intellectually, psychologically, emotionally. In the process, the artwork, the viewer, and authentic experience — reality itself in fact—are potentially transformed. "Art, if it is anything at all, must be considered as both an aesthetic and ethical *practice of making and remaking reality* by both artist and viewer."[62] Much has been said to the effect that art production today lacks an ideological backbone, but this argument badly misinterprets the subtle yet no less emphatic position that many contemporary works occupy and urge. What may at first seem an absence of the overtly political instead is revealed as a nuanced and subversive political stance, one that does not so much demonstrate or illustrate theory or politics as enact them in and through the work. If broad and generous in their "message," these works are no less engaged with specific issues of identity, community, and the world. While deliberately antimonumental, they are far from benign. They are, finally, the aesthetic outgrowth of a deeply personal mode of being in the world, an outward vision that comes into immediate focus in each present instant of the spectator's viewing. From phenomenology to critique to engagement: for both artist and viewer, to stay in translation is to free the continued workings of the imagination.

I have come to the end of this apologia for the novel as a vast net. Someone might object that the more the work tends toward the multiplication of possibilities, the further it departs from that unicum which is the self of the writer, his inner sincerity and the discovery of his own truth. But I would answer: Who are we, who is each one of us, if not a combinatoria of experiences, information, books we have read, things imagined? Each life is an encyclopedia, a library, an inventory of objects, a series of styles, and everything can be constantly shuffled and reordered in every way conceivable.

But perhaps the answer that stands closest to my heart is something else: Think what it would be to have a work conceived from outside the self, a work that would let us escape the limited perspective of the individual ego, not only to enter into selves like our own but to give speech to that which has no language?
—Italo Calvino, Six Memos for the Next Millennium, 1985

61. The "open work" is Umberto Eco's term for an artwork that emphasizes the interactive role of the reader/listener/viewer in the work's interpretation, thus opening the artwork to a multiplicity of possible orders. See Eco, *The Open Work*, trans. Anna Cancogni, with an introduction by David Robey (Cambridge, Mass.: Harvard University Press, 1989).

62. Fisher, "Hors d'oeuvre," p. 315.

Electronic Attractions, Resistant Reveries/Jonathan Crary

A major international art exhibition at the fading edge of the millennium might reasonably be expected to reveal vivid evidence or even prophetic hints of broader cultural transformations. As a panorama of current artmaking, such an exhibition might offer the possibility of considering the *conditions of possibility* for aesthetic and cultural experimentation at this moment of both symbolic and actual transition. Of course the most compelling and unsettling artwork will not announce these conditions in any direct or reflective way. Rather, it will disclose the terms of its own self-constitution through its apparent nonsynchronicity, its disconnection from the dominant characterization (or mythology) of our own present.

One of the most pervasive ideological constructions currently operative is that an unprecedented historical shift has recently occurred with remarkable suddenness, ushering in an era of globalization, of universal communication and connectivity. In one sense, this techno-economic fantasy—the vision of a "wired world"—took shape alongside the "collapse" of communism and of an East-West system, and promoted the notion that the end of the twentieth century marked the decisive triumph of a totalizing free market, with its promises of growth, prosperity, and the Westernization of the planet. But self-congratulatory accounts of this supposedly revolutionary transformation simultaneously had to reassure that on another level, nothing had changed—that despite sweeping systemic, institutional, and technological reconfigurations, human life and experience could flow on within a fundamental continuity and sameness.

Contemporary actuality, however, is clearly much closer to the inverse of this general narrative. The seamlessly wired world is not in place, and probably never will be, but at the same time there *has* been an enormous set of derangements in the makeup of individual affective, perceptual, and cognitive experience, challenging any easy assumption of cultural continuity between the present moment and several decades ago. Perhaps we have reached a threshold beyond which it is no longer a question of challenges to traditional habits, responses, and emotions, but of a point (partly generational) at which that older field of meanings has moved beyond recovery or even clear recall.

At the start of the 1990s it was fashionable to set globalization outside of the older myths of "monoculture" or homogeneity, proclaiming instead the advent of an era of generalized communication in which a decentered field of newly empowered voices (genders, ethnicities, nationalisms, identities, races, classes) would replace the master discourses of an earlier modern age. But even if an exclusionary and hierarchical model of control over information and communication is defunct, the monological power of the global marketplace is far more overwhelming than any of what Jean-François Lyotard referred to as the "grand narratives" of religion, the state, and human rationality. Globalization has produced a bizarre mix: on the one hand, the universalism of capitalist commodity culture, on the other, a debilitating array of political and social particularisms. It is a mix at least superficially manifested in our repeated recognition

that groups as dissimilar as Rwandan Hutus, fringe right-wing North Americans, Sudanese rebels, Guatemalan schoolchildren, Kosovar refugees, and Chinese demonstrators against NATO are all penetrated by a common field of habitual wants constructed around the same banal products and brands: Nike T-shirts, Sony Discman CD players, Reebok shoes, videocassettes of the latest Jean-Claude Van Damme movie. The uniform compulsions of global consumerism easily coexist with a polyphony of voices, a mosaic of otherwise utterly noncommunicating spheres of experience.

One of the crucial paradoxes of "globalization," then, is this: the greater the technological capacity for connection, for speed, for exchange and circulation of information, the more fragmented and compartmentalized the world becomes. Most of our Enlightenment intellectual heritage would have encouraged us to believe otherwise; universal access to knowledge and tools of communication, we might have thought, should be the basis for supranational conditions of freedom and participatory democracy. But—and this is especially significant from the more circumscribed standpoint of the visual arts—the spread of new communication networks is not generating a global community with a shared set of aesthetic and perceptual foundations. Instead there has been a proliferation of relatively self-sufficient microworlds of affect, meaning, and experience, among which intelligible exchange is less and less possible. The unfathomable amount of "information" available today works powerfully against the possibility or even the ideal of commonly shared knowledge. Instead, electronically accessible data can be deployed in the service of anything—of any point of view, regardless of politics or pathology. It is a generalized epistemological crisis, within which some of our most important contemporary artists are rethinking the nature of "research" and experimenting with the assemblage of novel informational artifacts. Devising various strategies of materializing "knowledge" through concrete procedures of bricolage, they are testing out provisional and pragmatic models of collective truths, and proposing ways of activating collective memory within a culture dependent on historical amnesia. This is a far cry from the Baudrillardism of the 1980s, the Reagan-Thatcher era, when it was fashionable to present virtuoso demonstrations of simulation as an endless chain, in a cynical play of signs and images that supposedly no longer referred to anything.

As recent critics have insisted, "globalization" is a misleading term in that it seems to connote a sense of spatiality or territory, albeit on a large scale.[1] But as we know, the operation of global capitalism is predicated on the irrelevance of territory. Marx foresaw this as early as the 1850s, when he wrote that the essence of capitalism was "the annihilation of space by time" and a striving "to drive beyond every spatial barrier."[2] Today his insight is realized: for the first time in history there has been a delinking of economic circulation from physical space, as abstracted forms of wealth gain a mobility and fluidity unrelated to what we used to think of as location. This should not lead us to hyperbolic assertions about the disappearance of space, the ubiquity of

1. See, for example, Zygmunt Bauman, *Globalization: The Human Consequences* (New York: Columbia University Press, 1998).

2. Karl Marx, *Grundrisse*, 1857, trans. Martin Nicolaus (New York: Random House, 1973), p. 524.

instantaneous speed, and so on. We must begin to understand the strange kinds of dislocations and adjacencies that now constitute subjective experience. Unavoidably, our lives are divided between two essentially incompatible milieus: on the one hand, an interface with the spaceless electronic worlds of contemporary technological culture, and on the other, the extensive terrain on which our bodies are situated.

Technological prostheses have obviously taken many forms throughout history, but never before have they involved such a powerful set of imperatives to permanently "inhabit" a "world" that is fundamentally uninhabitable except on a phantasmic level. Because of the absolute priority granted to the operations of economic exchange, the privilege accorded to its digital domains is unassailable. We are only in the first stages of the depreciation and disparagement of a "brick and mortar" world, yet both the tangible "real" world and our own corporal existence already seem progressively more dilapidated in comparison with the infinite phantasmagoria of images and data available online. The entropy and decay of our physical surroundings, and the cosmetic and genetic deficiencies of our own bodies (especially their aging and mortality), are permanent humiliations in the face of dematerialized digital phenomena. It is of course entirely logical that immense corporate industries are now trading relentlessly upon the fragility of the body to expand a central arena of consumption: bio-engineering, prosthetic surgery, psychochemicals for endless emotional needs (e.g., an antishyness drug now in trials), antiaging procedures, and the patenting and commercialization of the human genome, to name a few.

These are the issues out of which artists and others are currently inventing countermodels of the body that affirm its political volatility and might work against its fraudulent domestication. But the paradigm shift that they are addressing is not analogous to previous historical transformations. It is, for just one instance, far more rapid. The rise of typographic culture, by comparison, did not occur immediately after the invention of the printing press and movable type in the fifteenth century; it took place slowly, over several hundred years, its effects, in terms of an extensive diffusion across a social field, only coming fully into place in the late eighteenth or early nineteenth century. More significant, though, and even perhaps *most* significant, what we are witnessing is not so much a change in technological conceptions, from one dominant arrangement of machinic systems to another, as the emergence of an unprecedented dynamic of continual innovation and obsolescence. It is not as if we were in a transitional period of adjustment to a new set of tools that will all seem quite mundane in another generation, as the telephone and radio do now. For the vast majority of people, our perceptual and cognitive relationship to communication and information technology is and will continue to be estranged, because the velocity at which new products emerge, and at which reconfigurations of technological systems take place, precludes the possibility of ever becoming "familiar" with a given arrangement. What we have familiarly referred to as photography, film, video, television,

for example, no longer have relatively stable identities, but are subject to frequent mutations as part of larger technological transformations. Whatever is currently touted as "essential" to our practical needs is always already disquietingly close to the precipice of obsolescence. Life becomes an anxiety-filled sequence of replacements and upgrades. Given the impossibility of meaningfully integrating technological tools into a coherent field of creative activity, it becomes important to invent provisional and flexible strategies of adaptation and imagination outside of the enforced rhythms of high-tech consumption. Perception itself is so closely aligned with these rhythms that its primary characteristic is its continual permutation.

3. Guy Debord, *The Society of the Spectacle* (New York: Zone Books, 1994), p. 137.

Yet within these processes of continual reorganization and innovation, certain features remain relatively stable. Following Michel Foucault, it is still in some ways useful to characterize certain aspects of contemporary technological culture as "disciplinary" institutions and practices. Foucault's panoptic model of society, in which the subject is an object of research and surveillance, certainly has contemporary relevance. At the same time, it is important to recognize major reconfigurations of those mechanisms. Foucault himself makes clear that if the disciplinary society was originally constituted around procedures through which the body was literally confined, physically isolated and regimented, or set in place at work, these were but the first relatively crude experiments in an ongoing process of refinement. A notion of the productive, consuming, observing subject is part of a development in which an *internalization* of disciplinary imperatives occurs, in which the individual is made more directly responsible for his or her own efficient, productive, or profitable deployment within various social arrangements.

Related to Foucault's particular account of Western modernization is Guy Debord's theorization of a "society of the spectacle." For many, Debord's work and Foucault's might seem remote from each other, and certainly the two stood for very different kinds of thinking, of critique, and of political intervention. Foucault in fact dismissed the idea of the spectacle—yet there are salient points of overlap between his social model and Debord's. For rather than emphasizing the effects and power of the mass media and their visual imagery, Debord insists that spectacle is essentially the development of a technology of *separation*. It is the consequence of capitalism's inevitable "restructuring of society without community."[3] Debord's account of spectacle as multiple strategies of isolation is in many ways congruent with those Foucault outlines in *Discipline and Punish*: each account describes the production of docile subjects, or more specifically the reduction of the body as a political force. Max Weber's earlier description of "the inner isolation of the individual" as a key component of capitalist modernity stands behind both of these thinkers. But equally important, both Debord and Foucault outline diffuse mechanisms of power through which imperatives of normalization or conformity permeate most layers of social activity and become subjectively internalized.

It is in this sense that the management of perception through the television set or the computer monitor (and also, for that matter, through early forms of mass culture in the late nineteenth century) has little to do with the visual contents of their screens and far more with a larger management of the individual. Spectacle is fundamentally concerned not with a *looking* at images but rather with the construction of states of mind and conduct that individuate, immobilize, and separate subjects, even within a world in which flux and circulation are primary. That is, the involvement of the individual in attentive perception becomes crucial to the operation of power, which now can take a noncoercive form. This is why it is not inappropriate to conflate many seemingly different optical or technological objects currently produced: they are similarly about arrangements of bodies in space, techniques of isolation, cellurization, and above all separation. Spectacle is not an optics but an architecture of power. Television and the personal computer, even as they mutate toward a single machinic functioning, deploy antinomadic procedures that effect partitioning and sedentarization, rendering bodies simultaneously controllable and useful, even as they simulate the illusion of choice and interactivity.

One of the most compelling historical models for assessing the various composite entities that human beings and machines make up appears in the work of Gilles Deleuze and Félix Guattari, who distinguish several dominant historical models of how human beings have interfaced or been "subjected to machines or machinic systems." Industrial capitalism, particularly in the nineteenth century, was one phase, in which a human being (or worker) was linked to a machine as an exterior object. More recently, however, with cybernetic and informational machines, "The relation between human and machine is based on internal, mutual communication, and no longer on usage or action."[4] Deleuze has proposed that the last two decades have seen a modification of Foucault's disciplinary societies into "societies of control," in which the combination of a global market, information technology, and the irresistible imperative of "communication" produces continuous and unbounded effects of control.[5] Dr. Eric Schmidt, chairman of the software corporation Novell, recently insisted that the twenty-first century would inaugurate the "attention economy," and that economic success on the Internet will be about controlling and maximizing the number of "eyeballs" online.[6] But however we label such historical shifts or social transformations within the last century, perception continues to be a crucial component of the subjects produced for a wide range of social and technical systems, even as it simultaneously continues to be a potential site of breakdown and crisis in terms of these machines' efficient operation.

It is becoming clearer that a potent conjunction of panoptic techniques and attentive imperatives continues to function reciprocally in many social locations. The computer monitor (whether desktop, laptop, or palm size) can stand for the effective fusion of surveillance and spectacle, as the screen is both viewed and capable of

4. Gilles Deleuze and Félix Guattari, *A Thousand Plateaus: Capitalism and Schizophrenia,* trans. Brian Massumi (Minneapolis and London: University of Minnesota Press, 1987), p. 458.

5. See Deleuze's essays "Control and Becoming" and "Postscript on Control Societies" in his *Negotiations 1972–1990,* trans. Martin Joughin (New York: Columbia University Press, 1995), pp. 169–82.

6. See Christa Degnan, "Novell's Schmidt Outlines 'DigitalMe' Technology," *PC Week Online,* March 22, 1999.

monitoring, recording, and cross-referencing attentive behavior in terms of productivity, or even, through the tracking of eye movement, of the accumulation of data on specific paths, durations, and fixations of visual interest in relation to a sequence of images and information. At the same time, vast digital "archives" are being assembled that record and analyze one's activities and itineraries in cyberspace. Individual life in front of all kinds of screens is increasingly part of a continuous process of feedback and adjustment within what Foucault calls a "network of permanent observation."[7] Film theorist D.N. Rodowick amplifies on this: "The goals of interactive computing that are in the vanguard of research on new electronic media, while genuinely utopian, must nonetheless be questioned. For the dream of the individual's absolute control over information is simultaneously the potentiality for absolute surveillance and the reification of private experience."[8]

For every improvement in the techniques for controlling an observer there are parallel shifts in the shapes of inattention, distraction, and various states of "absent-mindedness." There is a continual emergence of new thresholds at which an otherwise institutionally competent subjectivity veers into something dispersed, unfocused, and nonproductive—into forms of what we could call passive noncompliance. These experiences hint at a wide range of noninstrumental and deviant interfaces. Using the example of television, Guattari suggests some of the heterogeneity of individual experience:

> When I watch television, I exist at the intersection 1) of a perpetual fascination provoked by the screen's luminous animation which borders on the hypnotic 2) of a captive relation with the narrative content of the program, associated with a lateral awareness of surrounding events—water boiling on the stove, a child's cry, the telephone . . . 3) of a world of phantasms occupying my daydreams. My feeling of personal identity is thus pulled in different directions. How can I maintain a relative sense of unicity, despite the diversity of components of subjectivation that pass through me? It's a question of the refrain that fixes me in front of the screen.[9]

Since so many forms of institutionally modeled perception, beginning in the early twentieth century, have entailed cognitively "processing" heterogenous stimuli (whether as film, radio, television, cyberspace), the swerves into inattentiveness increasingly have produced alternate experiences of dissociation, of temporalities that are not just dissimilar but fundamentally incompatible with normative institutional arrangements. The daydream, which is an integral part of a continuum of attention, has always been a crucial but indeterminate part of the politics of everyday life. In the twentieth century, as Christian Metz and others have argued, both film and television have entered into a "functional competition" with daydream;[10] but although its history will never be formally written, the daydream nonetheless remains a stubborn domain

7. Michel Foucault, *Discipline and Punish: The Birth of the Prison*, trans. Alan Sheridan (New York: Pantheon, 1977), p. 295.

8. D.N. Rodowick, "Reading the Figural," *Camera Obscura* 24 (September 1990): 11–46.

9. Guattari, *Chaosmos: An Ethico-Aesthetic Paradigm*, trans. Paul Bains and Julian Pefanis (Bloomington: Indiana University Press, 1995), pp. 16–17.

10. See Christian Metz, *The Imaginary Signifier*, trans. Celia Britton et al. (Bloomington: Indiana University Press, 1982), pp. 135–37.

of resistance that exists within any system of routinization or coercion. Similarly, disciplinary patterns of vision based on imperatives of recognition, identity, and stabilization are never fully separate from nomadic models of cognitive flux that allow the generation of novelty, difference, and instability.

One central feature of many contemporary technological arrangements, however, is the imposition of a permanent low-level attentiveness that is maintained to varying degrees throughout large expanses of waking life. The later nineteenth century saw the onset of a relentless colonization of "free" or leisure time. This program was initially rather scattered and partial in its effects, and the breaks and intervals within it were conducive to oscillations between spectacular attentiveness and the free play of subjective absorptions of many kinds. But now, at the end of the twentieth century, the loosely connected machinic network for electronic work, communication, consumption, and recreation has not only demolished what little had remained of the distinction between leisure and labor but has come, in large arenas of Western social life, to determine how temporality is inhabited. New information and telematic systems simulate the possibility of meanderings and drift, but in fact they constitute modes of sedentarization and separation, the flow of stimuli and the rhythm of response producing an unprecedented mixture of diffuse attentiveness and quasi-automatism that can be maintained for remarkably long periods of time. In these technological environments, it may not even be meaningful to distinguish between conscious attention to one's actions and mechanical autoregulated patterns. Over thirty years ago, Arthur Koestler could describe the "dimming of awareness" produced by repetitive experiences within homogenous sensory milieus: "Automatized routines are self-regulating in the sense that their strategy is automatically guided by feedbacks from their environments, without the necessity of referring decisions to higher levels. They operate by closed feedback loops."[11] But what once might have been called reverie now most often takes place in full alignment with preset rhythms, events, and speeds, all of which affirm the irrelevance of whatever is not integrable or compatible with their formats.

It is pointless to lament what Paul Virilio describes as "the disintegration of direct perception," or what Italo Calvino calls the loss of our capacity "for bringing visions into focus with our eyes shut."[12] But it is equally self-defeating to uncritically celebrate or acquiesce to the dominant technological modalities available today. It is no coincidence that the majority of attempts at website- or computer-graphics-based art have been dull and inconsequential, for in most cases this art has not even begun to understand the inseparability of machines from larger social and psychic circuitry. Now the question is how and whether such alternate modes as trance, distraction, and daydream can flourish within the interstices of these circuits. It is particularly important to determine what creative possibilities can be generated amid electronic forms of boredom, habit, and addiction, for this densely sedimented, patchwork fabric of contemporary experience is the basis for much significant art practice today.

11. Arthur Koestler, *The Ghost in the Machine* (New York: Macmillan, 1967), p. 207.

12. Paul Virilio, *The Vision Machine*, trans. Julie Rose (Bloomington: Indiana University Press, 1994), p. 16; Italo Calvino, *Six Memos for the Next Millennium* (Cambridge, Mass.: Harvard University Press, 1988), p. 92.

Many of the artists in this exhibition have supplied us with singular diagrams of that terrain, as have artists in other media: I think, for example, of the novels of Kobo Abe, J.G. Ballard, and Thomas Pynchon's *Vineland*, and of films such as Chris Marker's *Sans Soleil*, Andrei Tarkovsky's *Stalker*, Wim Wenders's *Until the End of the World*, and David Cronenberg's *Videodrome*. More specifically we can point to an irreducible mix of continuity and disjunction in the way our absorption into disembodied technological environments is immediately adjacent to the materiality and intersubjectivity of "real," lived, Euclidean space. Especially revealing are those now common transitional moments when, for example, one turns off a computer after having been online, or immersed in any digital ambience, for an extended period. There is a brief interval before the world fully recomposes itself, when one's immediate surroundings, usually a room and its contents, seem both vague and oppressive in their actuality, their heaviness, their vulnerability to decay, their obdurate resistance to being clicked away in an instant. This interval also vividly reveals the disparity between one's sense of limitless "connectedness" while online and a stark intuition of the enduring fact of one's subjective isolation and contingent physiological existence. But it is only out of this kind of apprehension that experiments and operations within and on the world can take place, without technological delusions and without nostalgia for an older model of "authentic" experience and objects.

It is almost hard to remember those extravagant portrayals, from as recently as eight or nine years ago, in which "cyberspace" was widely associated with hallucinatory and psychedelic experience. One encountered assertions that cyberspace would allow "people to get ecstatic with each other," or that it would enable them to enter a panhuman "infinity of space and eternity of light."[13] Now, virtual reality and cyberspace have suffered the fate of 3D movies and holograms. The cretinous banality of most online "life" is all too evident, and the idea that the word "interactive" once connoted empowerment or joy seems merely peculiar. Cyberspace was supposedly going to provide the resources to reinvent the self and its relation to the world. Instead it has provided a vast reinvention of shopping. The goal of remaking the self and its world, though, is historically durable; the task now, for artists and others, is to discover the disparate tools, the vacant sites, and the unforeseen processes through which this aim can at least be imagined and anticipated.

13. Nichole Stenger, "Mind Is a Leaking Rainbow," in Michael Benedikt, ed., *Cyberspace: First Steps* (Cambridge, Mass.: The MIT Press, 1991), p. 151.

Conversation Pieces/Jean Fisher

Thinking otherwise than he thinks, he thinks in such a way that the Other might come to thought, as approach and response.

—Maurice Blanchot, *The Writing of the Disaster*, 1986

1. Fredric Jameson, "Post-modernism, or the Cultural Logic of Late Capitalism," excerpts reprinted in *Post-modernism: A Reader*, ed. and introduced by Thomas Docherty (New York: Harvester Wheatsheaf, 1993), pp. 85–88.

Prologue

Toward the end of the tenth century, the European peasantry was subjected to a severe breakdown in the structure of medieval society: poverty and famine, uncontrolled rape and pillage by robber barons, and plague and pestilence, including a hallucination sickness (ergotism) caused by eating bread made from fungus-contaminated grain. Taken altogether, these afflictions may have been responsible for the pyrotechnic visions of hell that began to appear around that time. If we introduce "banality" into this catalogue of terrors we might wonder what was new at the end of the second millennium, not only because the word "banal" once referred to feudal servitude—and there is nothing more banal than a life governed by poverty and insecurity—but also because it means the trivialization of life. Banality dulls the imagination and weakens a sense of human agency and ethical responsibility to one's fellows.

The peasantry of the first millennium remade their world through the inspiration of religion—not through the Papacy, itself corrupt and divided, but through the monastic orders, which galvanized local imaginations into rebuilding ethical communities. For the medieval world, it was theological discourse that provided the horizon of mean-ing and the blueprint for ethical conduct. But Western societies today are composed of heterogeneous constituencies and competing realities, whose beliefs and values may be not only incompatible but also irreconcilable. They are essentially bereft of any consensual founding principle (which, in the past, was God, science, or even capitalism) that would guarantee cohesion and justice—including a sense of reality, without which we lose sight of ourselves as active agents in making ethical decisions.

According to the postmodernist critique of life under global capitalism that emerged in the 1980s, the corporate control of codes of image production had undermined our ability to distinguish the real from its simulacra. Thoroughly embedded in global consumerism, we had become so inextricably entangled in its networks of mediated realities that, as Fredric Jameson famously said, to create a critical distance from it was near impossible, and moral denunciations of its totalitarian tendencies had hence become futile.[1] Ethical practice itself came to be seen as a redundant residue of Enlight-enment humanism. To be sure, if an ethics is possible, it cannot be left to the mercy of *interests*, whether on the level of the self-sufficient individual, the community, or the nation-state. In the first instance, an individual consciousness is ultimately concerned with its own needs and desires; in the second, communities increasingly lack any responsible relation with their neighbors, so that to surrender ethics to them risks the kind of xenophobic tribalism that we have witnessed in recent years; and in the third, the state is complicit with multinational corporatism, an alliance that weakens

its responsibility to its citizenry (beyond its concern for the efficiency of worker production). And yet, without some kind of ethical obligation and accountability to one another, the forces of injustice and exploitation go unchecked, and what has so far counted as "human" begins to fragment into so many abstract zeros and ones to be recombined into whatever configuration the faceless Programmer chooses.

In the 1980s, aesthetic practice appeared as by no means exempt from the futility of engaging in any directly oppositional debate, for the system had already absorbed and disarmed the languages of an overtly politicized art. This being the case, the question was: Even if it were possible now to invent counter-hegemonic practices, what forms could they possibly take? During the 1990s, however, it seems to me that a resistance has emerged to this ethical ennui and negative appraisal of artistic agency, due in part to the influence of a critical mass of cultural producers who have entered the privileged Euro-American centers from the "outside." These artists have their own stories to tell about the ongoing experience of racist and gender stereotyping, colonial exploitation, and economic and cultural marginalization. The Author of the West's Master Narrative may have lost his credibility, but authors of micro-narratives are presenting realities that are worlds away from official culture's narcosis in the timeless inertia of the imaginary. These in themselves have demanded an ethical response from the West.

This path of resistance has not been without problems: a lack of interpretative tools, and also of the will to understand, on the part of Western critics has allowed an exoticization and commodification of the cultural other while also leading to a certain globalization of art language, following the West's demand for cultural translatability. Yet a number of debates have reopened: What constitutes a life experience and art's relation to it? How do we approach the work of others? And, once again, what is the accountability of the self to others in the world?

About Experience

Writing after the disaster of World War I, Walter Benjamin was moved to note that in a world of communication devoted to transmitted information, "It is as if something that seemed inalienable to us, the securest among our possessions, were taken from us: the ability to exchange experiences." "Every morning brings us the news of the globe, and yet we are poor in noteworthy stories. This is because no event any longer comes to us without already being shot through with explanation."[2] Following Benjamin, the Italian philosopher Giorgio Agamben adds that today the "destruction of experience no longer necessitates a catastrophe, and that humdrum life in any city will do.... This does not mean that today there are no more experiences, but they are enacted outside the individual," who "merely observes them."[3] But if everything consisted of mediated experience,[4] already encoded and interpreted, there would be no space for imagination, for the reinvention and transformation of existence, and we would truly be locked into totalitarianism.

2. Walter Benjamin, "The Storyteller," in *Illuminations*, trans. Harry Zohn (New York: Schocken Books, 1969), pp. 83, 89.

3. Giorgio Agamben, *Infancy and History*, trans. Liz Heron (London: Verso, 1993), pp. 13–14.

4. The word "experience" is used in two senses here: first, traditional common sense or know-how, whose repetition provides continuity; and second, that which arises as a new event.

Agamben argues that "experience" of the kind one might "have" is to be found first and foremost in human "infancy," understood not as a state of prelinguistic innocence but as an emergence from the "babble of nature," which is "pure language," into discourse. That is, experience is found in the difference between the two discontinuous limits of language that Emile Benveniste called the "semiotic" and the "semantic," sign system and discourse.[5] Such experience cannot be thought *a priori*; it arrives unannounced, as it were, as "wordless" gesture, a rhythmic syncope or missed beat, an eclipse of reason, and therefore cannot belong to the realm of the speaking subject—that "I" of the enunciation, who is always constituted within the discursive field. This would seem commensurate with what Michel de Certeau calls a "non-discursive practice," something not conscious of itself and therefore a "'remainder' constituted by the part of human experience that has not been tamed and symbolized in language."[6] Certeau finds such "remainders" in everyday life. Arguing that consumerism, for example, may not be as passive as is generally thought, he suggests that consumers often select mediated codes and reuse them for their own ends, subverting those intended by producers (a practice of self-empowerment familiar in the history of the disenfranchised under colonial rule). Such a practice mobilizes language into new configurations, thereby putting into play creative agency and a locally viable ethics, but it exists outside theoretical thought. There is clearly an analogy here with the kind of ethico-poetic art practice that refuses to offer up a familiar prepackaged "experience" but shimmers in the space of the as-yet-to-be-narrated.

Among the artists whose work might be said to operate in this spatio-temporal interval is Gabriel Orozco, whose work of the early 1990s is playful in a sense that I would ascribe to Agamben's "infancy." This art concerns the performance of human work upon the raw material of the world, fashioning it into simple configurations: the impressions of hands on a lump of clay (*Mis manos son mi corazón* [My hands are my heart], 1990); a ball of Plasticine, its weight equivalent to that of the artist's body

(*Piedra que cede* [Yielding stone], 1992); the elliptical tracks made by bicycle wheels through puddles (*La extensión de reflejo* [Extension of reflection], 1993). *Piedra* is rolled out into the world, with which it then has a "conversation," it has "experiences," their history being written in the impressions and debris of the street that are embedded in its surface. Also typical of the artist's working process at this time are subtle adjustments to the spatiotemporal organization of the local environment, like the discarded oranges placed singly on the cleared tables of an empty street market (*Turista maluco* [Crazy tourist], 1991), momentarily changing the world without imposing an authorial signature. In other words, like child's play, Orozco's process appeared not to involve *a priori* judgments but to respond to the material conditions at hand.

Gabriel Orozco
Horses Running Endlessly, 1995
wood
Collection of Elayne and Marvin Mordes, Baltimore, Maryland

5. "The semiotic marks a property of language, the semantic results from the speaker's enactment of language. The semiotic sign exists in itself, founding the reality of language, but it has no specific application; the sentence, which expresses the semantic, can only be specific." Agamben, *Infancy and History*, p. 54.

6. Michel de Certeau, *The Practice of Everyday Life*, trans. Steven F. Rendall (Berkeley: University of California Press, 1984), p. 61.

Orozco's subsequent work includes sculpture based on games themselves, particularly those that require an interaction of players. Any game may be likened to language and the rules of grammar: it is a self-enclosed world—a miniature *habitus*[7]— of fixed moves and rituals of conduct, but their expression is open to inventive play. While Orozco's "games" allude to the "real" world, however, they are not coincidental with it, and no expected rule applies. *Horses Running Endlessly* (1995), for instance, presents a wooden chessboard in which there are four times the usual number of squares; those squares come in three colors, not two; and the only pieces are knights. The knight's move is unerringly oblique; it transgresses the logic of linear progression, deferring its own advance at every turn. One might say that *Horses Running Endlessly* suspends us in a perpetual state of play. This is also true of *Oval Billiard Table* (1996), which provides us with two white balls and a third, red ball that is suspended like a pendulum from the ceiling, so that cueing a white ball at it causes it to swing in wild ellipses beyond the table's limits. There are furthermore no pockets, so that there is no goal whose achievement would finish the game—this game too has no end. If these works seem like an oblique Borgesian parody of the "real," they can also be construed as a political commentary on social structures and hierarchies and the absurdity of the rules that govern them, but there is a deeper significance in the experience of ritual and play that they offer: if ritual concerns repetition as a means of securing human stability, play opens the imagination to the infinite, but it is the limits these two practices impose on each other that prevent humankind from falling into either totalitarian stagnation or anarchy.

7. *Habitus* is Pierre Bourdieu's term for the set of "dispositions" that generate practices and agents within a given field of cultural production. See Bourdieu, *The Field of Cultural Production*, ed. and with an introduction by Randall Johnson (Cambridge: Polity Press, 1993).

About Totality and Infinity

It is an old aesthetic argument that there are two basic principles of conceiving an art object (or a text or exhibition). The first is as a totality: an object is circumscribed by a singular point of view or discursive framework, which represents a pregiven set of values and whose meaning can be grasped as a finite whole. This is an art of pleasure, like a good novel or Hollywood movie, and its plot has a satisfying resolution. It is, quite simply, *explanatory*.

Edward Ruscha
Damage, 1964
oil on canvas
72 x 67 in.
Collection of Alford House/
Anderson Fine Arts Center,
Anderson, Indiana

The work of Edward Ruscha is a good example of the second principle: the work that cannot be understood "at a glance" as a totality. Meaning is not proffered from some authoritative, connoisseurial, or idealized vantage point, but has to be constructed in the mind of each viewer in his or her spatiotemporal and mental trajectory through the work. Essentially this kind of art presents a choreographic space open to the viewer's work of transformation. Since each viewer construes meaning from the relation between what the work presents and his or her own histories and experiences, there can be no definitive meaning. Among viewers sharing a similar *habitus*, of course, the possibilities of meaning cannot be infinite either; but the work nevertheless has the potential of indefinite extension, since in each viewer it provokes a new pattern of readings.

We have, then, two forms of practice that may, rather crudely, be characterized as "closed" and "open," "representation" and "presentation," "manipulation" and "communication." It is not the intention here to make a value judgment between them, since each performs a useful function, but rather to point out the different ethico-poetic experiences they offer. Representation tends toward the didactic and abstract; its meaning is apparently not dependent on any particular context or experience of time or space, because it seems to be self-contained. If it has a moral tone, it imposes that tone through its closed system. Presentation, on the other hand, is like the performance of speech itself. Where meaning is not given, the viewer must, as Norman Bryson puts it, "pull the image into its own orbit of tacit knowledge, taking it as provo-cation to perform an act of interpretation which is strictly speaking an improvisation, a minutely localized reaction that cannot—impossible dream of the stereotype—be programmed in advance."[8] In the choreographic space of art, meaning is contingent upon the "here and now" of its relation with the viewer as a spatiotemporal event.

I believe this is what Adrian Piper means by the "indexical present," a term she employs in writing on the use in art of a direct mode of viewer address articulated around "I" and "you."[9] In this way the viewer is confronted "face to face" with an inescapable other, the experience of which is intended to expose and cut through those prejudices and dogmas of received opinion that cast a shadow between self and other. Caught in the emotional and logical disjunctions arising between the transmitted reality of the artist and her incantation of stereotypical racist and sexist positions, the viewer is forced to make an ethical evaluation of his or her own position.

Piper's indexical present is analogous to Emmanuel Levinas's notion of the "face to face." Levinas counterposes two ways of relating to the world: as a totality, through an effort of rational and systematic ordering; and as the idea of infinity, which is the self's internal recognition of what is transcendent to it—the existence of more than it can contain. Levinas argues that the concept of totality has dominated Western philosophy, and is predicated on assumptions that truth is synonymous with vision— the "panoramic view" that assimilates, possesses, and grounds knowledge in objectivity, and dismisses other knowledges to the realm of the "subjective" and "irrational" (seeing is believing). For Levinas, however, "The idea of infinity is the mind before it lends itself to the distinction between what it discovers by itself and what it receives from opinion."[10] And, "The idea of infinity implies a soul capable of containing more than it can draw from itself. It designates an interior being that is capable of a relation with the exterior, and does not take its own interiority for the totality of being."[11] Infinity (or "exteriority") is not a representation; it does not first exist, then reveal itself, but is produced in the "face to face" relationship between the self and the other, in response to and acceptance of the other's absolute alterity.

Levinas's debate concerns the search for an ethical relationship between self and other, one in which the self perceives the other neither as an extension of the self

8. Norman Bryson, *Vision and Painting: The Logic of the Gaze* (London: Macmillan, 1983), p. 154.

9. Adrian Piper, "Xenophobia and the Indexical Present," in *Out of Order, Out of Sight*, vol. 1: *Selected Writings in Meta-Art 1968–1992* (Cambridge, Mass., and London: The MIT Press, 1996), pp. 245–54. Piper, of course, is an artist as well as a philosopher and writer, and the idea of the "indexical present" has a direct bearing on her own artwork.

10. Emmanuel Levinas, *Totality and Infinity: An Essay on Exteriority*, trans. Alphonso Lingis (Pittsburgh: Duquesne University Press, 1969), p. 25.

11. Ibid., p. 180.

nor as a threat to be assimilated and possessed. Any attempt to assimilate the other to the terms of the self necessarily robs it of what makes it other. Self and other are not reducible to each other, nor do they exist in a symmetrical or oppositional relation. At the same time, to open oneself to the other would not be to lose oneself, since there would no longer be a consciousness capable of responding or evaluating meaning. For Levinas the infinity of otherness is exemplified by the expression of the other's face, whose meaning for the self cannot be a question of prior knowledge but must be deciphered in each instant of the encounter. It is this *responsibility* toward the other, answering her demand for a conversation, as it were, that constitutes ethics: there can be no ethics outside a relation with an other. Fundamentally, meaning does not originate from one's own subjectivity but as a response to the other.

This is the exemplary lesson of the work of Willie Doherty, whose images deceptively reflect the banal, commonplace "experiences" of the everyday—a featureless path among scrub vegetation typical of the outskirts of a city, an anonymous bend in a road, an "ordinary" face—but are also grounded in the historical specificity of his home environment in Northern Ireland. Beginning from the local, the work nonetheless speaks generally about our experience in language; and in this sense Doherty is a masterful "storyteller." Despite his manipulation of familiar codes of film noir, photography, and reportage, his images lack identifiable coordinates, so that their meanings are unlocatable. Texts applied to photographs or voice-overs to videos appear to provide "location" (they allude to the mythologized stereotypes that infect utterances about sectarian violence and Northern Irish identities), and yet, paradoxically, they tend to reinforce the dislocation of the images, since it becomes apparent that one's interpretation of them is inextricably tied to ideology. The text "floats" on the image but cannot anchor it.

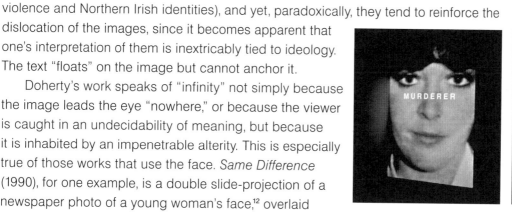

Doherty's work speaks of "infinity" not simply because the image leads the eye "nowhere," or because the viewer is caught in an undecidability of meaning, but because it is inhabited by an impenetrable alterity. This is especially true of those works that use the face. *Same Difference* (1990), for one example, is a double slide-projection of a newspaper photo of a young woman's face,[12] overlaid by a continuous and double cycle of words conventionally used by Ulster Loyalists and by the British news media to describe the "Irish terrorist," and also by Irish Republicanism to describe IRA personnel as "volunteers." It is impossible, however, for the viewer to assimilate the woman to either of these roles, precisely because, although the inscriptions are literally "written on the face," they are not in fact recoverable *from* the face itself. To be believed, they have to be taken "on faith"—but faith is not the domain of reality or truth. Following Levinas, we are drawn to the uniqueness of this particular face, and the appeal of her impenetrable otherness overrides the

12. The woman is not anonymous; she is Donna Maguire, who was arrested in 1992 by the Dutch authorities on suspicion of being an "IRA terrorist."

Willie Doherty
Same Difference, 1990
slide and text installation
Art Council Collection,
Hayward Gallery, London

meanings imposed by the text. Here, too, we can see how, as the title *Same Difference* suggests, the linguistic binaries "self" and "other," "same" and "different," must finally collapse into each other in their fundamental indeterminacy, whereas alterity as a sense of the "infinite" belongs to a unique and immeasurable order of experience.

About Ethical Agency

We do not need to be reminded at this point that our senses of selfhood and meaning are not generated internally, from a sovereign self, but are the effect of a continuous negotiation with others and the world. What is at stake here, however, is precisely our equivocation between the real and the imaginary—between what can be understood from "immediate experience" and what from the veil of ready-made interpretations that interpolates itself between self and life, self and self. Mikhail Bakhtin believed that art was responsible to life, and in emphasizing less the relations between self and other than the relations between acts performed in the world, his thought presupposes a *sociality*, which, in turn, opens a way of considering the ethical role of the artist and the work of art.[13]

Bakhtin's concern is with the untranslatable chasm between the uniqueness of one's own experience as performed act and its representation in the world of culture—simply, between subjective and objective experience. His solution to this dilemma is to propose an evaluation that is *narrated* in the process of performing each act. That is, the remaking of the world does not occur through following prescribed rules, but through the ethical decisions that have to be made in negotiating everyday experiences, and through creative activity. Here "totality" reappears, not as a closed system of knowledge but as a "unity" (uniqueness) of the world of events in which we all participate through the acts that each of us performs. All acts, all experiences, carry an "emotional-volitional tone" that expresses the uniqueness of the event, a tone that is not a "passive psychic reaction" but an ethically answerable "*movement* of consciousness."[14] For Bakhtin this ethical answerability is intrinsic to the artistic process: as the artist engages with life, so the work of art is answerable to life. Thus for Bakhtin it is our answerability to our own acts that constitutes an ethical practice, and to abdicate one's unique responsibility as one confronts the dictates of institutional structures is to become a "pretender"—which is the problem of agency we face at this end of the twentieth century.

Like Levinas, Bakhtin speaks of the absolute separation of self and other, but it is a separation in which the self recognizes its formative debt and ongoing obligation to others: "To live from within myself, from my own unique place in Being, does not yet mean at all that I live only for my own sake."[15] Bakhtin's self is unique insofar as it exists continuously within unrepeatable moments of life that are specific to it and to its perspective on the world. But the self can have only a partial view of itself, and it is the gift of the other to offer it a more complete context. Likewise, while artistic

13. See Mikhail Bakhtin, *Toward a Philosophy of the Act*, trans. Vadim Liapunov (Austin: University of Texas Press, 1993).

14. Ibid., p. 36.

15. Ibid., p. 48.

activity produces a subject, neither the activity nor the artist is autonomous, since both move outward toward the consciousness of the other who gives them value.

16. Ibid., p. 47.

A common thread running through these accounts is the desire for narration, for the telling of one's own stories as distinct from those manipulated and imposed by the forces of ideology, or structured by the media from appearances. As Bakhtin said, "The unique place from which I act is structured through categories of space and time, value and meaning";[16] my subjectivity is not fixed but is continuously being formed through the history of my encounters with others in the world, which provide my ethical ground. According to the authors presented here, for this to work entails listening and responding directly to the other and his or her experiences, not to ideological interests that condition our prejudices and attitudes. This is not an easy task. Bakhtin, for instance, working in a modernist ethos, did not envision the more recent understanding of the extent to which we are not free agents but are bound to abstract systems of communications that make us less able to make decisions about the truth of events. This does not mean, however, that his proposals have no value for us. Decisions ultimately have to be made, and ethical responsibilities assumed, if we are not to regress from the more humane of the ideals of the Enlightenment back into the Dark Ages of the first millennium. If artistic practices have a role here, it is to unpick the languages of habitual discourse, to present us with other ways of seeing, other stories that offer different insights into the experience of the world, so that we can begin again the task of remaking it.

The Global City: The Denationalizing of Time and Space/Saskia Sassen

The experience of the global is partial. The global is not an all-encompassing umbrella; the multiple processes that constitute it inhabit and shape specific, rather than universal, economic, political, cultural, and subjective structures. In so doing, they produce new spatialities and temporalities, coexisting with yet distinct from the master temporality and spatiality of the "national." In the interplay of their difference, strategic openings have emerged. Such openings are especially evident in sites where these intersecting temporalities and spatialities assume thick and consequential forms. Among these sites is the global city.

The global city is a border zone where the old spatialities and temporalities of the national and the new ones of the global digital age engage. Out of their juxtaposition comes the possibility of a whole series of new economic and cultural projects. But there are other, smaller sites, too, where the juxtapositions of spatialities and temporalities are likely to be thick, charged. One question that comes to mind is whether art, in some of its instantiations, can represent such a microsite of juxtapositions, and one that captures a key dynamic of our current transition.

Here I explore some of these issues by emphasizing the locational and institutional embeddedness of economic globalization, and by arguing that the combination of this embeddedness with the specificity of globalization entails a partial unbundling of what historically have been constructed as national spatialities and temporalities. This unbundling of the national produces openings for other dynamics and actors besides the national state to emerge in the international arena. Do we see here the formation of a new politics?

The Spatialities and Temporalities of the Global

The insertion of the global in an overwhelmingly nationalized institutional world engenders a partial unbundling of that national order. It is partial because the geography of economic globalization is neither diffuse nor all encompassing; it is strategic.[1] Further, it is partial in the sense that national space was probably never a unitary condition, even though institutionally constructed as such. One way of conceptualizing this insertion of the global in the national is as a partial and incipient "denationalization."[2]

The process of denationalization I am seeking to specify here cannot be reduced to a geographic conception, as was the notion in the heads of the generals who fought the wars for nationalizing territory in earlier centuries. Instead, this is a highly specialized and strategic denationalizing of specific institutional arenas. Manhattan and the City of London are the equivalent of free trade zones when it comes to finance, but it is not Manhattan as a geographic entity, with all its layers of activity and regulation, that is a free trade zone; it is a specialized functional or institutional realm located in Manhattan that becomes denationalized. This institutional realm, then, is disproportionately concentrated in global cities. And this has the effect of reterritorializing even the most globalized, digitalized, and partly dematerialized industries and markets.

1. The literature disagrees on this point. Some authors see globalization as a universal and universalizing condition, especially in the sphere of consumption. In my own research I have tended to focus on the operations necessary for the management and coordination of the global economy as well as those that organize and appropriate profit.

2. See Saskia Sassen, *Losing Control? Sovereignty in an Age of Globalization*, the 1995 Columbia University Leonard Hastings Schoff Memorial Lectures (New York: Columbia University Press, 1996), chapter 1.

But this reterritorializing has its own conditionality—a complex and dynamic interaction with national state authority. The strategic spaces in which global processes are embedded are often national; the mechanisms through which new legal forms, necessary for globalization, are implemented are often part of state institutions; the infrastructure that makes possible the hypermobility of financial capital at the global scale is embedded in national territories. Thus one way of conceiving of these inevitable negotiations with the national is in terms of this partial and strategic dynamic of denationalization. Taking the specificity of a national/local setting as a starting point makes it possible to capture the many, particular trajectories through which the insertion of the global materializes in different institutional orders within different national states, the multiple forms it assumes, and the multiple cross-border networks that are thereby constituted. Dynamic processes and border zones emerge in the juxtapositions of the national and the global thus understood.[3]

From this perspective, to understand the spatiality of economic globalization only in terms of hypermobility and space/time compression—the dominant markers in today's conceptualization—is inadequate. If hypermobility and space/time compression are to exist, they need to be produced, and their production requires vast concentrations of very material and not-so-mobile facilities and infrastructures. They also need to be managed and serviced, and this requires mostly place-bound labor pools of both skilled and low-wage workers. The global city is emblematic here, with its vast concentrations of hypermobile, dematerialized financial instruments and the enormous concentrations of material and place-bound resources that it takes to make those instruments circulate around the globe in a second. It is precisely the combination of the spatial dispersal of numerous economic activities with telematic global integration that has contributed to a strategic role for major cities in the current phase of the world economy.[4]

Even the vast new economic topography that is being implemented through electronic space is one moment, one fragment, of an even vaster economic chain that is in good part embedded in nonelectronic spaces. The most advanced information-industries, such as finance, are installed only partly in electronic space; so are the industries that produce digital products, such as software. The growing digitalization of economic activities has not eliminated the need for major international business and financial centers and all the material resources they concentrate, from state-of-the-art telematics infrastructure to brain talent. We tend to operate in topographies that weave between actual and digital space. Even as we are increasingly relocating activities to digital spaces, and locating digital capacities in the human body, there is no purely virtual firm or human being.

Yet, complex as these dynamics of newly produced and newly unbundled spatialities are, they are not enough to specify the processes that constitute economic globalization. The strategic economic projects of globalization have emerged in the

3. See Sassen, "Spatialities and Temporalities of the Global," forthcoming in *Public Culture*, Millennium Issue on Globalization, 2000.

4. See, e.g., Paul L. Knox and Peter J. Taylor, eds., *World Cities in a World-System* (Cambridge: at the University Press, 1995); Michael A. Cohen, Blair A. Ruble, Joseph S. Tulchin, and Allison M. Garland, eds., *Preparing for the Urban Future: Global Pressures and Local Forces* (Washington, D.C.: Woodrow Wilson Center Press [distributed by The Johns Hopkins University Press], 1996); and Richard Stren, "The Studies of Cities: Popular Perceptions, Academic Disciplines, and Emerging Agendas," in ibid., pp. 392–420.

play between two master/monster temporalities, within which we exist and transact (and enact all kinds of microtemporalities). One of these is a collapsing temporality: that of the national state as a historic institution. This master temporality is often thought of as historic time. The other is a new temporality, that of economic globalization. In the intersection of these two coexisting temporalities we see the formation of new economic dynamics and opportunities that drive and constitute economic globalization and can be thought of as partly denationalized temporalities.

Elsewhere I have argued that what we could think of as the dominant narrative or mainstream account of economic globalization is a *narrative of eviction*.[5] Key concepts in the dominant accounts of globalization, the information economy, and telematics all suggest that place no longer matters, and that the only type of worker who matters is the highly educated professional. This account privileges the capability for global transmission over the concentrations of built infrastructure that make transmission possible; information outputs over the workers producing those outputs, from specialists to secretaries; and the new transnational corporate culture over the multiplicity of cultural environments, including reterritorialized immigrant cultures, within which many of the "other" jobs of the global information economy take place. In brief, the dominant narrative concerns itself with the upper circuits of capital, not the lower ones, and with the global capacities of major economic actors, not the infrastructure of facilities and jobs underlying those capacities. This narrow focus has the effect of evicting from the account the *place*-boundedness of significant components of the global information economy, and the fact that a far broader range of types of urban spaces is involved than some of the master images suggest.[6]

Insofar as an economic analysis of the global city recovers the broad array of jobs and work cultures that are part of the global economy but typically not marked as such, it allows us to examine the possibility of a new politics involving the disadvantaged actors operating in this new transnational economic geography. This politics of the disadvantaged lies at the intersection of disadvantage and economic participation in the global economy, specifically by those who hold the "other" jobs in the global economy—from factory workers in export-processing zones to cleaners on Wall Street. The centrality of place in global processes engenders a transnational economic and political opening in the formation of new claims, and hence in the constitution of entitlements, notably rights to place, and, at the limit, in the constitution of "citizenship."[7] The city has indeed emerged as a site for new claims—by global capital, certainly, which uses the city as an "organizational commodity," but also by disadvantaged sectors of the urban population, which, in large cities, is frequently as internationalized a presence as capital is. The denationalizing of urban space, and the formation of new claims centered in denationalized actors and involving contestation, raise the question, Whose city is it?

5. See Sassen, *Globalization and Its Discontents* (New York: New Press, 1998), chapter 1.

6. See *The Journal of Urban Technology* 3 no. 1 (Fall 1995), a special issue entitled *Information Technologies and Inner-City Communities*, and A. D. King, ed., *Representing the City: Ethnicity, Capital and Culture in the 21st Century* (London: Macmillan, 1996).

7. See Joan Copjec and Michael Sorkin, *Giving Ground* (London: Verso, 1999), and *Social Justice* 20 nos. 3–4 (Fall–Winter 1993), a special issue entitled *Global Crisis, Local Struggles*.

I see this as a type of political opening that contains both unifying capacities across national boundaries and sharpening conflicts within such boundaries. Global capital and the new immigrant work force are two major transnationalized categories that both have unifying properties internally and find themselves in contestation with each other inside global cities.

Revisiting the Edge: Global Span and Sited Materialities

The partial unbundling of the national through the insertion of the global within it produces a rescaling of old hierarchies running from the local, the regional, the national, on to the global. Going to the next scale in terms of size is no longer how integration is achieved. The local now transacts directly with the global; the global installs itself in locals, and is itself constituted through a multiplicity of locals.[8]

The distinction between the global and the local needs to be rethought, notably the assumption of the global as universal and the necessity of proximity in the constitution of the local. For example, both international professionals and immigrant workers operate today in contexts that are at the same time local and global. The new professionals of finance are members of a cross-border culture that is in many ways embedded in a global network of "local" places—a set of particular international financial centers, with much circulation of people, information, and capital among them. As financial centers, furthermore, London, New York, Zurich, Amsterdam, Frankfurt, and so on are all part of an international yet very localized work subculture. We see proximity here, but a proximity not confined to territorial space; rather, it is a partly deterritorialized form of proximity containing multiple territorial moments. And many immigrants will tend to be part of a cross-border network that connects specific localities—their new communities and their localities of origin in home countries. Although in a manner different from the financiers, they nonetheless also have the experience of deterritorialized local cultures, not predicated on locational proximity.

One way of reading this is as a tearing away of the "context" or "surrounding" and its replacement with the fact of the global. The strategic operation is not the search for a connection with the context or surrounding. It is, rather, installation in a strategic cross-border geography constituted through multiple locals. The spatiality thus produced can be thought of as a cross-border network of specific sites embedded partly in the national but constituted through spatial and temporal practices that distinguish these sites from others, notably those of the national as historically constructed.[9]

Two points come to mind.

First, global cities structure a zone that can span the globe, and do so in a second, but it is a zone embedded in specific sites and juxtaposed with older temporalities and spatialities. In the case of the research I have done on the new interface economies that dominate the global city, I find that it is precisely this juxtaposing that produces the global city.

8. I also see this in the political realm, particularly in the kind of "global" politics attributed to the Internet. I think of such a politics, rather, as a multiplicity of localized operations, but with a difference: they are part of the global network that is the Internet. This produces a "knowing" that re-marks the local. See Sassen, "Electronic Space and Power," in *Globalization and Its Discontents*, and Arjun Appadurai, *Modernity at Large* (Minneapolis: University of Minnesota Press, 1996).

9. We can think of the global economy, then, as materializing in a worldwide grid of strategic places, uppermost among which are global cities. We can think of this global grid as constituting a new economic geography of centrality, one that cuts across national boundaries and across the old North-South divide. A key aspect of the spatialization of global economic processes which I cannot develop here is digital space; see Florian Rotzer, *Die Telepolis: Urbanitat im digitalen Zeitalter* (Mannheim: Bollmann, 1995); and *Futur Antérieur* vols. 30–32, special issue entitled *La Ville-Monde Aujourd'hui: Entre Virtualité et Ancrage*, ed. Thierry Pillon and Anne Querrien (Paris: L'Harmattan, 1995).

I would be interested in understanding whether the microenvironments represented by certain kinds of art, for instance digitally produced environments or objects, involve a similar dynamic of what appear as opposites but are in fact mutually imbricated. Such microenvironments might present themselves as self-contained settings made possible by digital capacities, yet they may well respond precisely to the features of the nondigital condition, and in this sense be engendered, ironically, by what they are not.

Financial capital illustrates the more general point I am trying to make. I have argued elsewhere that the ascendance of financial capital, and its capacity to subject other forms of capital (for example manufacturing capital) to its modes, has to do with the coexistence of the different temporalities (much shorter for finance than for other forms of capital) and spatialities of finance (the hypermobility of finance's dematerialized outputs). Without the other forms of capital, finance by itself, with all its speeds, could not do much.[10] How would this type of juxtaposition of differences work out in the microenvironments of certain forms of art? It seems to me such environments might be subject to the same tension between global span and sited materialities. If certain art projects negotiate the relationship between the almost limitless freedom (so to speak) of their forms and the constraints of the materials that might go into their execution, there may be interesting conceptual resonances here with the tension present in the digital between what is experienced as limitless, dematerialized capacity and the sited materialities that are also part of digital art.

Second, although the new spatial and temporal zone that is being structured spans the globe, it is inhabited and constituted by multiple units or locals—it is not just a flow of transactions, or one large encompassing system. The global city is a function of a global network; there is no such thing as a single global city, as you might have had with the empires of old, each with its capital. This network is constituted in terms of hyperconcentrated nodes of activities and resources. What connects the nodes is dematerialized digital capacity; but the nodes incorporate enormous amounts and types of sited materialities.

This means that we need to decode what is local (or national?) in such locals, or in what has historically been constructed as local, because sited in a place. And it means specifying the nature of the new territorial and institutional conditionalities of the local—of that which is present in a place—in a global and digital era.

These issues raise a question about how an edge works, about the presence or absence of intersections between different environments, about what happens to contextuality. The orientation of these local environments is simultaneously inward and toward the global. The intensity of each environment's internal transactions is such as to override most considerations of the broader locality or context within which that environment exists. The new networked subeconomy of the global city occupies a strategic geography that is partly deterritorialized, that cuts across borders, and that

10. See Cynthia Davidson, ed., *Anytime* (New York: Anyone Corporation, 1999).

connects a variety of points on the globe. It occupies only a fraction of its "local" setting; its boundaries are not those of the city where it is partly located, let alone those of the "neighborhood."[11]

How this would work for certain forms of art is not clear to me; but it is possible that the issue of the edge, the surrounding, the locus, also holds for art that is marked by the intensity of its internal transactions and its cross-border, transnational rather than contextual orientation.

Unbundlings and New Openings

The unbundling of the national, and the specific dynamics of denationalization as instantiated in the global city, have contributed in creating operational and conceptual openings for other actors and subjects. The ascendance of a large variety of nonstate actors in the international arena signals the expansion of an international civil society. This is clearly a contested space, particularly when we consider, for example, the logic of the capital market—profitability at all costs—against that of the regime of human rights. But it does represent a space in which other actors can gain visibility, as individuals and as collectives, and can emerge from the invisibility of aggregate membership in a nation-state.

There are two strategic dynamics I am isolating here: first, the incipient denationalizing of specific types of national settings, particularly global cities; and second, the formation of conceptual and operational openings for actors other than the national state in cross-border political dynamics. The role of the new global corporate actors is clear here, but there is also a space for collectivities whose experience of membership has not been fully subsumed under nationhood in its modern conception, e.g. minorities, immigrants, first-nation people, women, and many others.

The large city of today emerges as a strategic site for these new types of operations. It is one of the nexuses in which new claims materialize and assume concrete forms. The loss of power at the national level produces the possibility for new forms of power and politics at the subnational level. As container of social process and power, the national is cracked; and this cracked casing opens up possibilities for a geography of politics that would link subnational spaces. Cities are foremost in this new geography.

11. On another, larger scale, in my research on global cities I found rather clearly that these cities develop a stronger orientation toward the global markets than to their hinterlands. In doing so they override a key proposition in the literature of urban systems, to wit, that cities and urban systems integrate and articulate national territory. See Sassen, *Cities in a World Economy* (Thousand Oaks, Ca.: Pine Forge/ Sage, forthcoming in 2000), pp. 1–31.

Fantasy between Real and Reality/Slavoj Žižek

01

The mad circulation of capital described by Marx is a solipsistic monster—self-enhancing, self-engendering, self-fecundating, traveling a path that reaches its peak in the metareflexive futures speculations of today. But to claim that this specter, indifferent to any human or environmental concern, is an ideological abstraction is far too simplistic. One should never forget that behind it are real people and natural materials, on whose productive capacities and resources the circulation of capital is based and on which it feeds, like a gigantic parasite. It is not just an "abstraction" existing only in a financial speculator's misperception of social reality; rather, it is "real," in the precise sense that it determines the structures of real social processes. The fates of whole classes and sometimes of whole countries may be decided by the speculative dance of capital, which pursues its goal of profit in blithe indifference to its effects on social reality. Therein resides its fundamental systemic violence, which is much more uncanny than the direct, social and ideological violence of the precapitalist period. The violence of capitalism is no longer attributable to concrete individuals and their "evil" intentions; it is "objective," systemic, anonymous. Here we should recall Etienne Balibar's distinction between two opposite but complementary modes of violence in today's world: the "ultraobjective" ("structural") violence that is inherent in the social conditions of global capitalism (the "automatic" creation of excluded, disposable individuals, from the homeless to the unemployed), and the "ultrasubjective" violence of newly emerging ethnic and religious (in short, racist) "fundamentalisms," a second "excessive" and "groundless" violence that is a counterpart to the first.[1]

Here we encounter the Lacanian difference between reality and the Real: "reality" is the social reality of actual people involved in personal interactions and productive processes, while the Real is the inexorable, "abstract," spectral logic of capital, which determines what goes on in that social reality. Is this not truer than ever today? Do not phenomena usually designated as those of "virtual capitalism" (futures trades, and similar, abstract financial speculations) point toward the reign of "real abstraction" at its purest, a purity much more radical than in Marx's time? In this sense capitalism, utilitarian and despiritualized, stands for the reign of abstract Universality. We catch a glimpse of the hidden truth of this abstract Universality when we glance at its material remnants: its graveyards of outdated or used machines, its piled mountains of used cars and computers, the famous airplane resting-place in the Mojave Desert. In these ever-growing piles of dysfunctional "stuff," which cannot but strike us with their inert, useless presence, we can, as it were, perceive the capitalist drive at rest.

1. See Etienne Balibar, "La Violence: Idealité et cruauté," *La Crainte des masses* (Paris: Galilée, 1997).

02

Is this fantasmatic spectrality (as opposed to social reality) effectively identical to the (Lacanian) Real? Eric Santner's discussion of the Freudian figure of Moses is exemplary here.[2] What is traumatic about this figure—and by extension about the Jewish break with the pagan religion of One Nature, a religion in which a multitude of deities could coexist—is not simply monotheism's repression of pagan enjoyment (sacred orgies, images) but the excessive and subsequently disavowed violence in this gesture of repressing the pagan universe and imposing the universal rule of the One Law. The "repressed" in Jewish monotheism, in other words, is not the wealth of pagan deities and sacred orgies but its own installing gesture, i.e., to use the standard terms, the crime that founds the Rule of Law itself, the violent gesture that brings about a regime which will retroactively criminalize this gesture itself. Referring to a well-known paradox—"There are no cannibals in our tribe, we ate the last one yesterday"—Santner conceives Moses as the exemplary figure of such a last cannibal who abolishes the condition of cannibalism. (The figure of Jesus, by contrast, becomes the last meal, the last victim to be slaughtered and eaten; here Santner follows René Girard, who conceived the victim Christ as the sacrifice to end all sacrifices.)

Now Santner introduces a key distinction, between symbolic history—the set of explicit mythical narratives and ideological and ethical prescriptions that constitute a community's tradition, what Hegel would have called its "ethical substance"—and this history's obscene Other, the unacknowledgeable, "spectral," fantasmatic secret history that effectively sustains the explicit symbolic tradition but must be foreclosed if that tradition is to remain operative. (What Freud endeavors to reconstitute in *Moses and Monotheism*—the story of Moses's murder, etc.—is just such a spectral history haunting Jewish religious tradition.) Santner's formulation immediately recalls Lacan's definition of the "Real as Impossible," from his *Encore* seminar. For Santner, the spectral fantasmatic history tells the story of a traumatic event that "continues not to take place," that cannot be inscribed within precisely the symbolic space that its intervention brought about; or as Lacan would have put it, the spectral traumatic event "*ne cesse pas de ne pas s'écrire*," doesn't stop *not* being written, doesn't cease *not* to inscribe itself.[3] And of course it is precisely as such—as nonexistent—that it continues to *insist*, i.e., that its spectral presence continues to haunt the living. One becomes a full member of a community not simply by identifying with its explicit symbolic tradition but when, and only when, one also assumes the spectral dimension through which that tradition is sustained—the undead ghosts that haunt the living, the secret history of traumatic fantasies transmitted "between the lines," through the explicit tradition's lacks and distortions. Jewish lore contains the well-known story of a rabbi telling a young pupil the legend of a Jewish prophet to whom a divine vision appears. When the youngster eagerly asks, "Is this true? Did it really happen?," the rabbi answers, "It probably didn't really happen, but it *is* true."[4] In the same way, the

2. See Eric Santner, "Traumatic Revelations: Freud's Moses and the Origins of Anti-Semitism," in Renata Salecl, ed., *The Impasse of Sexual Difference* (Durham, N.C.: Duke University Press, forthcoming).

3. Jacques Lacan, *Seminar XX: Encore* (New York: W.W. Norton, 1998), p. 59.

4. I owe this story to George Rosenwald, University of Michigan, Ann Arbor.

murder of the primordial father and other Freudian myths are in a way *more real than reality.* Of course they "didn't really happen," but they are "true"—their spectral presence sustains the explicit symbolic tradition.

Here, referring to Ian Hacking's recent work,[5] Santner draws a fine line of separation from the standard notion of the change in the narrative network that allows us to tell the coherent story of our past. For Santner, when we change from one narrative register to another in a way that allows us to "rewrite the past," the newly emergent "descriptive vocabulary" must foreclose or repress the traumatic excess of its own violent imposition. The line between the old and the new discursive regime is a "vanishing mediator," and it is precisely insofar as this "vanishing mediator" remains nonintegrated, excluded, that it continues to haunt "actual" history as its spectral Other Scene. This foreclosed ("primordially repressed") myth, which grounds the rule of Logos, is thus not simply a past event but a permanent spectral presence, an undead ghost that must constantly *insist* if the present symbolic frame is to remain operative.

5. Ian Hacking, *Rewriting the Soul* (Princeton: at the University Press, 1995).

6. Peter Hoeg, *The Woman and the Ape* (New York: Farrar Straus & Giroux, 1996).

03

One should not confound this "primordially repressed" myth (this "fundamental fantasy") with the multitude of inconsistent daydreams that always accompany our symbolic commitments, allowing us to endure them. Let us recall the example of ("straight") sexual relationship. The success of Peter Hoeg's novel *The Woman and the Ape*[6] signals the fantasy of sex with an animal as a full sexual relationship, and it is crucial that this animal is as a rule male. The animal in Hoeg's book is a male ape, which copulates with, and fully satisfies, a human woman. In the cyborg-sex fantasy, by contrast, for example the film *Blade Runner*, the cyborg is generally female—the fantasy is that of the Woman-Machine. Do not these stories materialize two standard vulgar daydreams: that of a woman who wants a strong animal partner, a potent "beast," rather than a hysterical and impotent male weakling, and that of a man who wants not a living woman but a female "doll," perfectly programmed to meet his desires? To penetrate the underlying "fundamental fantasy," what we should do is stage these two fantasies together, imagining a male ape copulating with a female cyborg. This unbearable ideal is the fantasmatic support for the "normal" couple of a man and woman copulating. The need for this redoubling, the need for this fantasmatic supplement to accompany the "straight" sexual act as a spectral shadow, is yet another proof that "there is no sexual relationship."

Do we not see something quite similar in the superb final scene of the recent Hollywood film *My Best Friend's Wedding*? It is the scene of the wedding itself—the wedding of Cameron Diaz. Julia Roberts—the "best friend" who, throughout the movie, has tried to abort this marriage in order to win back Diaz's bridegroom, her former boyfriend—resigns herself to her loss and accepts the proposal of her gay

friend Rupert Everett, with whom she performs a passionate dance in front of all the guests. In fact Roberts and Everett become the true couple, whom we are to oppose to the real, "official" couple of Diaz and her bridegroom, engaged in a full, "straight" relationship. What is crucial here is that Roberts and Everett are not engaged in an actual sexual relationship; yet although they are just staging a spectacle, although they are *performing a fake appearance*, their performance is in a way *more real* than the common, ordinary reality of the other couple, with their "actual sex." In short, the dance of Roberts and Everett is *sublime* in the Kantian sense: what they stage, what appears—*shines through*—their act, is the fantasy, the impossible utopian dream, of the ultimate "perfect couple." The other, "actual" couple will never come close to this. Again: the gesture of Roberts and Everett stages the impossible fantasy whose specter accompanies and redoubles the gesture of the "true" couple—and the paradox is that they can do this precisely because they are not an "actual" couple, precisely because their different sexual orientations ensure that their relationship will never be consummated.

04

The lesson of all this is that, in the opposition between fantasy and reality, the Real is on the side of fantasy. Nowhere is this clearer than in a familiar movie procedure reflecting censorship rules such as the Hayes Code: at the end of the film, when the catastrophe is at its peak, we are returned to "normal" everyday reality, retroactively transposing everything that has gone before into a nightmarish dream. To avoid the standard examples, from Robert Wiene's *Cabinet of Dr. Caligari* to Fritz Lang's *Woman in the Window*, let us turn to Robert Siodmak's relatively little-known film *The Strange Affair of Uncle Harry* (1945). An online movie guide describes the film as "OK for children," but the "key words" used to characterize its plot are "incest, kill, romance, schemer, sister"—an excellent example of an "innocent" reading coexisting with unsettling undertones.

Even more than *Woman in the Window*, *Uncle Harry* plays on the paradoxes of desire and its realization. John Quincy, a middle-aged unmarried fabric designer (played, in a superb case of anticasting, by the sinister George Sanders), lives a dull life with his two domineering unmarried sisters, the older Hester and the younger Lettie, who take care of him in their family manor in New Hampshire. He meets a visiting fashion expert from New York, Deborah Brown; their friendship soon becomes love, and he asks her to marry him. When Deborah is introduced to John's family and the sisters are told of their engagement, Hester is happy for her brother, but Lettie is violently jealous, and feigns a heart attack. Frustrated and angry at this attempt to spoil his happiness, John tries to murder Lettie by poisoning her drink; a mistake occurs, however, and it is Hester who drinks from the cup, and dies. Then, although

Lettie knows the poison was meant for her, she takes the blame for the murder and is condemned to death. Even when John publicly announces his guilt, she refuses to corroborate his account—because she knows that her death will stop him from marrying Deborah. "I'll give you what you always wanted," she tells him, "your freedom from me!" In this way, she knows, she will put him forever in her debt, since now he owes her his freedom. By taking the guilt upon herself and letting him live, she makes his life a living death. In short, Lettie takes John's desire to kill her upon herself; she frustrates his desire by fulfilling it.

At the film's end, however, John wakes from sleep, and discovers that this entire catastrophic situation in which he has poisoned his sister has been a dream. What has woken him is the arrival of Deborah, and he happily elopes with her to New York, leaving his sisters behind.

The paradox of course is that this fictionalization of the murder, accepted by the movie-makers to mollify the censors, introduces an additional element of pathology: the film's final lesson is that "the most disturbed psyche in the film may actually have been that of the protagonist."[7] Instead of simply confronting his sister like a mature adult, John dreams an elaborate poisoning scheme. Does this not reveal his "profound guilt over his sexual attraction to her"?[8] In other words, this retroactive fictionalization engages the subject who generates it much more fundamentally than if the film had had him really poison his sister. Had the film dealt with a "real life" murder, it would ultimately have shown John as the victim of an externally imposed situation (the unfortunate fact of having a possessive and dominating sister), on which it would have been possible for him (and for us, the spectators) to put the blame. Instead, the fictionalization of the murder anchors the narrative much more strongly in John's own libidinal tendencies. For surely the underlying premise of the fictionalization device is that John himself has a privileged, intimate relationship with Lettie; that Lettie's dominating role in his life in some way satisfies his libidinal needs; and that his aggressive acting-out in the dream (his attempt to murder her) is directed at the Real of his own unacknowledged "passionate attachment." He dreams of the failed murder, then, and of his subsequent, permanent psychic attachment to Lettie, to avoid the "happy" prospect, rejected by his unconscious, of abandoning his incestuous link with her and marrying Deborah. And when, at the film's end, he awakens, he does so to escape the horrible prospect of the realization of his unconscious desire in all its fundamental ambiguity.

05

At a different level, Santner's argument evokes the Holocaust, the event that set in motion the entire, explicit contemporary discussion of ethics but simultaneously continues to haunt us as a spectral entity that cannot be fully accounted for, cannot

7. *Film Noir*, ed. Alain Silver and Elizabeth Ward (London: Secker and Warburg, 1980), p. 297.

8. Ibid., p. 298.

be integrated into our social reality, even if we know (almost) everything about it at the level of historical fact. Yet are we not confusing here two modalities of the trauma that is impossible for us to integrate into our symbolic universe: the fantasmatic narrative of a spectral event that "did not really happen" (like the Freudian myth of the primordial parricide) and the traces of an event that definitely *did* happen but was too traumatic to be integrated into historical memory, so that we cannot register it as neutral, "objective" observers and accept it as a part of our past reality? Is there something "spectral" about the Holocaust not because its status is fantasmatic but because of its very *excess* of reality?[9] It is crucial to distinguish here between the fantasmatic spectral narrative and the Real itself. One should never forget that the foreclosed traumatic narrative of the crime or transgression comes as it were after the (f)act, that it is in itself a lure, a "primordial lie" (a "passionate attachment," to use Judith Butler's term[10]) that must deceive the subject in order to provide the fantasmatic foundation of his or her being.

Which notion of truth, then, does this notion of the Real involve? Let us take an exercise of antideconstructionist historicism at its best, Marc Vernet's rejection of the concept of film noir.[11] In a detailed analysis, Vernet demonstrates that all of the constituting features of the genre as commonly defined ("expressionist" chiaroscuro lighting, askew camera angles, the paranoid universe of the hard-boiled novel, the elevation of corruption to a cosmic metaphysical principle embodied in the femme fatale, etc.), as well as the explanations given for them (the threat posed to the patriarchal phallic regime by the social impact of World War II, etc.), are simply false. What Vernet does for noir is something similar to what the late François Furet did for the French Revolution in historiography: he turns an Event into a non-Event, a false hypostasis involving a series of misrecognitions of a complex, concrete historical situation. Film noir is not a category of Hollywood cinema, but a category of the criticism and history of cinema—a category that could only have emerged in France, and only just after World War II, when the French gaze was subject to a particular set of limitations and misapprehensions (ignorance of what had come before in Hollywood, the tension of the ideological situation in France at the time, etc.).

This analysis is sharpened when we take into account the fact that post-Structuralist deconstruction (the standard theoretical foundation of Anglo-Saxon writing on film noir) has in a way exactly the same status as film noir itself per Vernet: in the same way that American noir doesn't exist (in itself, in America), since it was invented for and by the French gaze, post-Structuralist deconstruction doesn't exist (in itself, in France), since it was invented in the United States, for and by the American academic gaze, which of course has its own constitutive limitations. The prefix "post-" in "post-Structuralism" is a reflexive determination in the Hegelian sense of the term: although it seems to designate a property of its object—a change, a cut, in the orientation of French intellectual thought—it actually refers to the gaze of the subject

9. Isn't the recent impasse over Binjamin Wilkomirski's *Fragments: Memories of a Wartime Childhood* (New York: Schocken Books, 1996) exemplary of this ambiguity of the Real? The book was assumed to narrate the authentic, blurred memories of the author, who, as a three-to-four-year-old child, had been imprisoned in Majdanek. It turned out to be a fiction. Apart from the standard question of literary manipulation, are we aware to what extent this "fake" reveals the fantasmatic investment and *jouissance* operative in even the most painful and extreme conditions?

10. See Judith Butler, *The Psychic Life of Power: Theories in Subjection* (Stanford: at the University Press, 1997).

11. Marc Vernet, "*Film Noir* on the Edge of Doom," in Joan Copjec, ed., *Shades of Noir* (London: Verso, 1993), pp. 1–31.

perceiving it, in that "post" really means "things that went on in French theory after the American (or German) gaze perceived them." "Structuralism" *tout court*, meanwhile, designates French theory "in itself," before the foreign gaze took note of it. So that "post-Structuralism" is Structuralism from the moment it was noted by the foreign gaze. In short, an entity like "post-Structuralist deconstruction" (a term not used in France) comes into existence only under a gaze unaware of the details of the French philosophical scene.

The concept of film noir posits a unity in American cinema that did not exist "in itself." Ignorant of the ideological tradition of American individualist populism, and misperceiving Hollywood films through an existentialist lens, the French gaze mistook the cynical-pessimist-fatalist stance of the noir hero for a socially critical attitude. In the same way, the foreign gaze unites authors (Jacques Derrida, Gilles Deleuze, Michel Foucault, Jean-François Lyotard...) who in France are simply not perceived as part of the same episteme. It inscribes these authors into a unified field of radical cultural criticism, conferring on them a feminist, etc., critical social stance that is for the most part absent in France itself.[12] Just as film noir is a category not of American cinema but primarily of French film criticism and (later) of the historiography of cinema, "post-Structuralist deconstruction" is not a category of French philosophy but primarily a category of the American (mis)reception of French authors designated as such. And when we are reading what is arguably the paradigmatic example and topic of deconstructionist theory as applied to cinema, that is, the analysis of the way the figure of the femme fatale in film noir reflects an ambiguous male reaction to a threat to the patriarchal phallic order, we effectively have a nonexistent theoretical position analyzing a nonexistent cinematic genre.

Is this conclusion effectively incontrovertible, however, even if we concede that, at the level of data, Vernet is right? Cannot the unreal produce real results, and in effect have a reality of its own? Although Vernet undermines a lot of standard noir theory (for example the rather crude notion that the noir universe reflects a paranoiac male reaction to the threat to the phallic regime embodied in the femme fatale), an enigma remains: the mysterious efficiency and persistence of the noir notion. The more Vernet is right at the factual level, the more enigmatic and inexplicable become the extraordinary strength and longevity of this "illusory" notion of noir, which has haunted our imagination for decades. Perhaps, then, film noir is a *concept* in the Hegelian sense—something that cannot simply be explained and accounted for in terms of historical circumstances, conditions, and reactions, but that acts as a structuring principle, displaying dynamics of its own. As a concept, film noir would then be actual, a unique vision of the universe combining a multitude of elements into what Louis Althusser would have called an *articulation*. If the notion of noir does not empirically fit the multitude of noir films, instead of rejecting it we should risk the notorious Hegelian rejoinder, "So much the worse for reality!"

12. Typically, French "post-Structuralist" authors are often, together with the representatives of the Frankfurt School, labeled as part of "critical theory"—a classification unthinkable in France.

More precisely, we should look at the dialectic between a universal notion and its reality. There is a gap between the two, and this gap sparks a transformation of both. It is because real films never fit their notion that they constantly change, and this change imperceptibly transforms the notion, the standard by which they are measured: we pass from the hard-boiled-detective noir (the Dashiell Hammett/Raymond Chandler formula) to the persecuted-innocent-bystander noir (the Cornell Woolrich formula) to the sucker-caught-in-a-crime noir (the James Cain formula), etc., etc.

06

We now are tempted to designate these two foreign, askew, misrecognizing gazes whose points of view were nevertheless constitutive of their respective objects (film noir and post-Structuralist deconstruction) as exemplary cases of the so-called "drama of false appearances."[13] This is the drama in which the hero or heroine, whether through sexual behavior or through the appearance of some crime, is placed in a compromising situation: their action is observed by a character who sees it wrongly, reading illicit implications into innocent behavior. At the end, of course, the misunderstanding is cleared up and the heroes are absolved of any wrongdoing. The point is, however, that this game of false appearance *allows a censored thought to be articulated*. We viewers have the pleasure of imagining the hero or heroine enacting forbidden wishes, but we escape any penalty, since we know that despite false appearances, nothing has happened—the protagonists are innocent. The dirty imagination of the onlooker within the drama, who misreads an innocent sign or coincidence, is here the stand-in for our own "pleasurably aberrant viewing."[14] This is what Lacan had in mind when he claimed that truth has the structure of fiction— the suspension of *literal* truth opens up the way for the articulation of *libidinal* truth.

This situation is exemplarily staged in Ted Tetzlaff's film *The Window*, in which a small boy effectively sees a crime, but no one believes him. His parents even make him apologize to the murderers for spreading false rumors about them.[15] It is, however, Lillian Hellman's play *The Children's Hour*—filmed twice, both times by William Wyler—that offers perhaps the clearest, almost laboratory example of the drama of false appearances. As is well known, the first version (*These Three*, from 1936) provided the occasion for one of the great Goldwynisms: when Sam Goldwyn, the producer, was warned that the film involved lesbians, he supposedly replied, "That's okay, we'll turn them into Americans!" What then effectively happened was that the alleged lesbian affair around which the story turns was made into a standard heterosexual affair.

The film is set in a posh school for girls run by two friends, the austere and domineering Martha and the warm and affectionate Karen, who is in love with Joe, the local doctor. When Mary Tilford, a vicious preteen pupil, is censured by Martha for a

13. See Martha Wolfenstein and Nathan Leites, *Movies: A Psychological Study* (Glencoe, Ill.: The Free Press, 1950).

14. Richard Maltby, "'A Brief Romantic Interlude': Dick and Jane go to 3½ Seconds of the Classic Hollywood Cinema," in David Bordwell and Noel Carroll, eds., *Post-Theory* (Madison: University of Wisconsin Press, 1996), p. 455.

15. What we are dealing with here, of course, is the structure of the perplexed gaze that is generative of fantasy and sexuation (see chapter 5 of my book *The Ticklish Subject* [London: Verso, 1999]). This structure provides the general foundation of the pleasure involved in the act of seeing. There would be no movie spectator finding pleasure in watching the screen if the fundamental structure of subjectivity were not characterized by this impassive, fascinated, perplexed gaze.

misdeed, she retaliates by telling her grandmother that late one evening she has seen Joe and Martha (not Karen, Joe's fiancée) "carrying on" in a bedroom near the students' quarters. The grandmother believes her (especially after her lie is corroborated by Rosalie, a weak girl terrorized by Mary), removes her from the school, and advises all the other parents to do the same. The truth eventually comes out, but the damage has been done: the school is closed, and Joe loses his position at the hospital. Even the friendship between Karen and Martha comes to an end after Karen admits that she, too, has had her suspicions about Martha and Joe. Finally Joe leaves the country for a job in Vienna, where Karen later joins him.

The second version, from 1961, treats the play more faithfully: this time, when Mary retaliates against Martha, she tells her grandmother that it is Martha and Karen she has seen kissing and embracing. She implies that she does not fully understand what she has seen, but it must have been something "unnatural." After the parents remove their children from the school, leaving the two women alone in the large building, Martha realizes that she does in fact love Karen, in more than just a sisterly way; unable to bear the guilt she feels over this, she hangs herself. Mary's lie is ultimately exposed, but now it is far too late: in the film's final scene, Karen leaves Martha's funeral and walks proudly past Mary's grandmother, Joe, and all the other townspeople whom Mary had fooled.

This story turns around an evil onlooker (Mary) who, through her lie, unwittingly realizes an adult's unconscious desire. The paradox of course is that before Mary's accusation, Martha had not recognized her lesbian longings; it is only this external accusation that makes her aware of a disavowed, interior part of herself. The drama of false appearances is thus brought to its truth: the evil onlooker's "pleasurably aberrant viewing" externalizes what the falsely accused subject has repressed.

The interesting point is that although the second version of The Children's Hour undoes the distortion of censorship, the first version is as a rule considered superior to the 1961 remake, mainly because it abounds with repressed eroticism—an eroticism not between Martha and Joe, but between Martha and Karen. Although it is between Martha and Joe that the evil onlooker alleges an affair, Martha seems much more passionately attached to Karen—even more so than does Joe, with his rather conventional straight love. The key to the drama of false appearances, then, is that it makes less overlap with more. The standard procedure of censorship is not to show the prohibited event (the murder, the sex act) directly, but instead to show its reflection in the reactions of its witnesses; yet this deprivation opens up a space to be filled in by fantasmatic projections. It is possible, then, that the gaze that does not see clearly what is going on effectively sees more, not less.

In a homologous way, the notion of noir (or of post-Structuralist deconstruction, for that matter), even if it grew from a limited foreign perspective, exposes potentials in its object that are invisible to those directly engaged in that object. Herein resides

the ultimate dialectical paradox of truth and falsity: sometimes the aberrant view, mis-reading a situation from a limited perspective, can *on account of this very limitation* perceive the "repressed" potentials of the observed constellation. It is true that if we submit the movies usually designated as film noir to a close historical analysis, the concept of film noir loses its consistency, and disintegrates; but, paradoxically, we should nevertheless insist that there is truth on the level of the spectral (false) appearance of noir, if not on that of detailed historical knowledge. The effectiveness of this concept of noir is what today enables us to immediately identify as belonging to the genre the short scene from *The Lady in the Lake* that contains the simple line of dialogue with which the detective answers the question "But why did he kill her? Didn't he love her?" with a straight, "This is reason enough to kill."

Sometimes, furthermore, the external misperception exerts a productive influence on the misperceived "original" itself, forcing it to become aware of its own "repressed" truth. Arguably the French notion of noir had a strong influence on American movie-making, even if it was the result of a misperception. Might not the supreme example of this productivity of the external misperception be the American reception of Derrida, which, although it clearly *was* a misperception, surely exerted a retroactive productive influence on Derrida himself, forcing him to confront ethical and political issues more directly? Was not the American reception of Derrida in this sense a kind of *pharmakon*, a supplement to the "original" Derrida himself, distorting the original and at the same time keeping it alive? In short, would Derrida be still so much "alive" if we were to subtract from his work its American misperception?

Biographies & Bibliographies

Franz Ackermann/p.16
Born 1963, Neumarkt St. Veit, West Germany
Lives and works in Berlin

Franz Ackermann's paintings, gouaches, and installations have been included in group exhibitions in Europe and the United States since 1997, including *Time Out*, Kunsthalle Nürnberg, Nuremberg, and *Heaven*, P.S. 1 Contemporary Art Center, Long Island City, New York (1997); *Atlas Mapping*, Kunsthaus Bregenz (1998); and *Frieze*, Institute of Contemporary Art, Boston, Massachusetts, *Dream City*, Kunstverein München, Munich, and *go away: artists and travel*, Royal College of Art, London (1999). Since his first solo show in 1989, Ackermann's work has been presented in exhibitions at neugerriemschneider, Berlin (1994, 1996, 1998), Gavin Brown's enterprise, New York (1995, 1997), and at major venues in Germany, including Portikus Frankfurt am Main and Städtische Galerie Nordhorn (1997), Neuer Aachener Kunstverein, Aachen (1998), and Kasseler Kunstverein, Kassel (1999).

Education

1984–88 Akademie der Bildenden Künste, Munich

1989–91 Hochschule für bildende Künste, Hamburg

Selected Further Reading

Richie, Matthew. "Franz Ackermann, Manfred Pernice, Gregor Schneider: The New City." *art/text* no. 65 (May–July 1999): 72–74, cover.

Ackermann, Franz. "Wish You Were Here." *Frieze* 44 (January/February 1999): 37–38.

Portikus Frankfurt am Main, Germany. *Franz Ackermann: Mental Maps* (1997). Exhibition catalogue, text by Harald Fricke.

Städtische Galerie Nordhorn, Germany. *Unerwartet: Franz Ackermann* (1997). Exhibition catalogue.

Decter, Joshua. "Franz Ackermann: Thomas Solomon's Garage." *Artforum* 34, no. 3 (November 1995): 97–98.

Matthew Barney/p.18
Born 1967, San Francisco, California, U.S.A.
Lives and works in New York

Matthew Barney's work has been shown in many group exhibitions since 1990, including *documenta IX*, Kassel (1992); *45th Venice Biennale* (1993); *DASAMERICAS II*, Museu de Arte de São Paulo, *Biennial Exhibition*, Whitney Museum of American Art, New York, and *ARS '95*, Museum of Contemporary Art, Helsinki (1995); *Jurassic Technologies Revenant*, the 10th Biennale of Sydney (1996); *Biennale d'Art Contemporain de Lyon* and *"Rrose is a Rrose is a Rrose" Gender Performance in Photography*, Solomon R. Guggenheim Museum, New York, and Andy Warhol Museum, Pittsburgh, Pennsylvania (1997); and *Wounds: Between Democracy and Redemption in Contemporary Art*, Moderna Museet, Stockholm (1998). Solo exhibitions of Barney's work have been presented regularly since 1988. He had his first solo show with Barbara Gladstone Gallery in 1991, and his work has since been presented at venues including Tate Gallery, London, Fondation Cartier pour l'art contemporain, Paris, and Museum Boijmans Van Beuningen, Rotterdam (1995); CapcMusée d'art contemporain, Bordeaux, Kunsthalle Bern, and San Francisco Museum of Modern Art, California (1996); Portikus Frankfurt am Main and Kunsthalle, Vienna (1997); Fundació "la Caixa," Barcelona, and Regen Projects, Los Angeles (1998); and Kunstkanaal (television broadcast), Amsterdam (December 6, 1998) and Rotterdam (October 11, 1998). In 1993 Barney was awarded the Europa 2000 prize at the *45th Venice Biennale*; in 1996 he received the Hugo Boss Award, presented by the Solomon R. Guggenheim Museum, New York.

Education

1989 Yale University, New Haven, Connecticut, B.A.

Selected Further Reading

Siegel, Katy. "Nurture Boy." *Artforum* 37, no. 10 (summer 1999): 132–35.

Portikus Frankfurt am Main, Germany. *Matthew Barney: Cremaster 5* (1997). Exhibition catalogue.

Kunsthalle Wien, Austria, and Museum für Gegenwartskunst der Emanuel Hoffmann-Stiftung und der Öffendlichen Kunstsammlung Basel, Switzerland. *Matthew Barney: Cremaster 1* (1997). Exhibition catalogue.

Sammlung Goetz, Munich, Germany. *Matthew Barney–Tony Oursler–Jeff Wall* (1996). Exhibition catalogue, texts by Jerry Saltz and Thyrza Nichols Goodeve.

Fondation Cartier pour l'art contemporain, Paris, and Barbara Gladstone Gallery, New York. *Matthew Barney: Cremaster 4* (1995). Exhibition catalogue, text by James Lingwood.

Janet Cardiff/p.20
Born 1957, Brussels, Ontario, Canada
Lives and works in Lethbridge, Alberta, Canada

Janet Cardiff's audio-based installations have been presented in major international exhibitions and biennials, including *NowHere*, Louisiana Museum of Modern Art, Humlebæk (1996); *Sculpture. Projects in Münster 1997*, Westfälisches Landesmuseum (1997); *La Ville, le Jardin, la Mémoire—1998, 2000, 1999*, Académie de France, Villa Medici, Rome, *XXIV Bienal de São Paulo*, and *Wanås '98*, Knislinge (1998); and *6th International Istanbul Biennial* (1999). Additionally, Cardiff has participated in such important museum shows as *Present Tense: Nine Artists in the Nineties*, San Francisco Museum of Modern Art, California, and *Ear as Eye*, Los Angeles Contemporary Exhibitions (1997); *Voices*, Witte de With, Rotterdam, Miro Foundation, Barcelona, and Le Fresnoy, Tourcoing (1998); and *The Museum as Muse: Artists Reflect*, Museum of Modern Art, New York (1999). Solo exhibitions of her work have been presented since 1987, including shows at Edmonton Art Gallery, Alberta (1993); Power Plant Art Gallery, Toronto, and Randolph Street Gallery, Chicago (1994); Raum Aktueller Kunst, Vienna, Galerie Barbara Weiss, Berlin, and Morris-Healy Gallery, New York (1997); and an Artangel project at Whitechapel Library, London, and Kunstraum München, Munich (1998). In 1991 Cardiff was Artist in Residence at the Banff Centre for the Arts, Alberta.

Education

1980 Queen's University, Kingston, Ontario, B.F.A.

1983 University of Alberta, Edmonton, Alberta, M.V.A.

Selected Further Reading

Museum of Modern Art, New York. *The Museum as Muse: Artists Reflect* (1999). Exhibition catalogue, text by Kitty Scott.

Académie de France, Villa Medici, Rome. *Janet Cardiff, Villa Medici Walk* (1998). Exhibition brochure, texts by Sylvie Fortin and John Weber.

Westfälisches Landesmuseum, Münster, Germany. *Sculpture. Projects in Münster 1997* (1997). Exhibition catalogue, with "Walk Münster" by Janet Cardiff.

Drobnick, Jim. "Mock Excursions and Twisted Itineraries: Tour Guide Performances." *Parachute* 80 (October/December 1995): 31–37.

Edmonton Art Gallery, Alberta, Canada. *To Touch: An Installation by Janet Cardiff* (1993). Exhibition brochure, text by Kitty Scott.

John Currin/p.22
Born 1962, Boulder, Colorado, U.S.A.
Lives and works in New York

John Currin's paintings have been shown widely in group and solo exhibitions since 1989. Group shows have included *Wild Walls*, Stedelijk Museum, Amsterdam, and Institute of Contemporary Art, London (1995); *narcissism: Artists Reflect Themselves*, California Center for the Arts, Escondido (1996); *Projects 60: John Currin, Elizabeth Peyton, Luc Tuymans*, Museum of Modern Art, New York, and *Heart, Body, Mind, Soul: American Art in the 1990s* and *The Tate Gallery Selects: American Realities—Views from Abroad*, Whitney Museum of American Art, New York (1997); *Pop Surrealism*, Aldrich Museum of Contemporary Art, Ridgefield, Connecticut, and *Young Americans 2: New American Art*, Saatchi Gallery, London (1998); and *John Currin and Elizabeth Peyton*, Carpenter Center for the Visual Arts, Harvard University, Cambridge, Massachusetts, and *Examining Pictures: exhibiting paintings*, Whitechapel Art Gallery, London (1999). Solo exhibitions of Currin's paintings have been presented at Andrea Rosen Gallery, New York (1992, 1994, 1995, 1997); Fonds Régional d'Art Contemporain du Limousin, Limoges (1995); and Regen Projects, Los Angeles (1996, 1999).

Education

1984 Carnegie Mellon University, Pittsburgh, Pennsylvania, B.F.A.

1986 Yale University, New Haven, Connecticut, M.F.A.

Selected Further Reading

Schjeldahl, Peter. "The Elegant Scavenger." *The New Yorker*, 22 February and 1 March 1999, 174.

Knight, Christopher. "Young Artist Hobnobs with the Old Masters." *Los Angeles Times*, 15 February 1999, F16.

Museum of Modern Art, New York. *Projects 60: John Currin, Elizabeth Peyton, Luc Tuymans* (1997). Exhibition brochure, text by Laura Hoptman.

Fonds Régional d'Art Contemporain du Limousin, Limoges, France. *John Currin. Œuvres/Works: 1989–1995* (1995). Exhibition catalogue, texts by Frédéric Paul and Keith Seward.

Seward, Keith. "John Currin: The Weirdest of the Weird." *Flash Art* 28, no. 185 (November/December 1995): 78–80.

Hanne Darboven/p.24
Born 1941, Munich, Germany
Lives and works in Hamburg, Germany

Hanne Darboven has exhibited extensively for over thirty years, participating in many important international exhibitions, including *documenta 5* (1972), *documenta 6* (1977), *documenta 7* (1982), Kassel, and *40th Venice Biennale* (1982). Her work has also been presented in such major survey shows as *1965–1975: Reconsidering the Object of Art*, Museum of Contemporary Art, Los Angeles (1995); and *Die Epoche der Moderne: Kunst im 20. Jahrhundert*, Martin Gropius Bau, Berlin (1997). Darboven's first solo exhibition with Leo Castelli Gallery, New York, was in 1973. Recent solo exhibitions include *Hanne Darboven: Evolution Leibniz, 1986,* Sprengel Museum Hannover (1996); *Hanne Darboven: Kulturgeschichte, 1880–1983*, Dia Center for the Arts, New York (1996–97); *Hanne Darboven: Kinder dieser Welt*, Staatsgalerie Stuttgart (1997); *Stone of wisdom/ Stein der weisen 1996*, Sperone Westwater, New York (1998); and *Hanne Darboven: Menschen und Landschaften*, Hallen für Neue Kunst, Schaffhausen (1999).

Education

1965 Hochschule für bildende Künste, Hamburg

Selected Further Reading

Hallen für Neue Kunst, Schaffhausen, Germany. *Hanne Darboven: Menschen und Landschaften* (1999). Exhibition catalogue.

Dia Center for the Arts, New York. *Hanne Darboven: Kulturgeschichte 1880–1983* (1996). Exhibition brochure, text by Lynne Cooke.

Goethe-Institut, London, and Ostfildern, Germany. *Hanne Darboven. Konstruiert, Literarisch, Musikalisch/ Constructed, Literary, Musical: The Sculpting of Time* (1994). Exhibition catalogue, text by Ingrid Burgbacher-Krupka, including an interview with the artist.

Deichtorhallen Hamburg, Germany. *Hanne Darboven: Die Geflügelte Erde, Requiem* (1991). Exhibition catalogue.

Bruggen, Coosje van. "Today Crossed Out." In *Hanne Darboven: Urzeit/ Uhrzeit*. New York: Rizzoli International Publications, Inc., 1990.

Thomas Demand/p.26
Born 1964, Munich, West Germany
Lives and works in Berlin

Thomas Demand's photographs have been shown in group exhibitions for nearly a decade. Recent shows include *Ars Viva 1995*, Anhaltische Gemäldegalerie, Dessau (1995); *New Photography 12*, Museum of Modern Art, New York (1996); *Positionen Künstlerischer Photographie in Deutschland Seit 1945*, Martin Gropius Bau, Berlin, *Elsewhere*, Carnegie Museum of Art, Pittsburgh, Pennsylvania, and *Stills: Emerging Photography in the 1990s*, Walker Art Center, Minneapolis, Minnesota (1997); *être nature*, Fondation Cartier pour l'art contemporain, Paris (1998); and *Anarchitecture*, De Appel Foundation, Amsterdam, and *Grosse Illusionen: Thomas Demand, Andreas Gursky, Edward Ruscha*, Kunstmuseum Bonn and Museum of Contemporary Art, North Miami, Florida (1999). Solo exhibitions of his work have been presented since 1991, including shows at Victoria Miro Gallery, London (1995, 1997) and 303 Gallery, New York (1998), and museum exhibitions at Centre d'art contemporain de Vassivière en Limousin, Beaumont-du-lac (1997); Kunsthalle Zürich and Kunsthalle Bielefeld (1998); and Tate Gallery, London (1999).

Education

1987–89 Akademie der Bildenden Künste, Munich

1989–92 Kunstakademie Düsseldorf

1992 Cité des Arts, Paris

1993–94 Goldsmiths College, London, M.A.

1995 Rijksakademie van Beeldende Kunsten, Amsterdam

Selected Further Reading

Kunstmuseum Bonn and Museum of Contemporary Art, North Miami, Florida. *Grosse Illusionen: Thomas Demand, Andreas Gursky, Edward Ruscha* (1999). Exhibition catalogue, texts by Stefan Gronert, Diedrich Diederichsen, and Ralph Rugoff.

Tate Gallery, London. *Artnow 17: Thomas Demand* (1999). Exhibition brochure, text by Michela Parkin.

Kunsthalle Zürich, Switzerland, and Kunsthalle Bielefeld, Germany. *Thomas Demand* (1998). Exhibition catalogue, texts by Stuart Morgan and Bernhard Bürgi.

Galerie de l'ancienne Poste, Le Channel, and Centre d'art contemporain de Vassivière en Limousin, Beaumont-du-lac, France. *Thomas Demand* (1997). Exhibition catalogue, text by Joshua Decter.

Muniz, Vik, and Thomas Demand. "Notion of Space, A Conversation." *Blind Spot,* no. 8 (fall/winter 1996): 30–37.

Mark Dion/p.28
Born 1961, New Bedford, Massachusetts, U.S.A.
Lives and works in Beach Lake, Pennsylvania

Education

1982–84 School of Visual Arts, New York

1985 Whitney Museum of American Art Independent Study Program, New York

1985 University of Hartford, Connecticut

Selected Further Reading

Dion, Mark. *Archaeology.* London: Black Dog Publishing, 1999. Texts by Alex Coles, Emi Fontana, Robert Williams, Jonathan Cotton, and Colin Renfrew.

Corrin, Lisa Graziose, Miwon Kwon, Norman Bryson, and John Berger. *Mark Dion.* London: Phaidon, 1997.

Ikon Gallery, Birmingham, England; Kunstverein, Hamburg, Germany; and De Appel Foundation, Amsterdam. *Natural History and Other Fictions: An Exhibition by Mark Dion* (1997). Exhibition catalogue, texts by John Leslie, Jason Simon, Saskia Bos, Jackie McAllister, Simon Morrissey, Helen Molesworth, Erhard Schüppelz, Miwon Kwon, Carolyn Christov-Bakargiev, and Mark Dion.

Dion, Mark, and Alexis Rockman, eds. *Concrete Jungle.* New York: Juno Books, 1996.

Dion, Mark. *Die Wunderkammer.* Munich: K-Raum Daxer, 1993. Texts by Karola Grässlin, Miwon Kwon, Carolyn Gray Anderson, and Helen Molesworth.

Since 1985 Mark Dion's work has been presented in many international exhibitions, including *Cocido y Crudo*, Museo Nacional Centro de Arte Reina Sofía, Madrid (1994); *Zeichen und Wunder* and *Platzwechsel*, Kunsthalle Zürich (1995); *Hybrids*, De Appel Foundation, Amsterdam, and *Die Berchenbarkeit der Welt*, Bonner Kunstverein, Bonn (1996); *Sculpture. Projects in Münster 1997*, Westfälisches Landesmuseum, and *(naturally artificial)*, Nordic Pavilion, *47th Venice Biennale* (1997); and *The Natural World*, Vancouver Art Gallery, British Columbia (1998–99). Dion has also had solo shows at American Fine Arts, Co., New York (1990, 1992, 1994, 1996, 1998); De Appel Foundation, Amsterdam (1996); Kunstverein, Hamburg, and Wexner Center for the Arts, Ohio State University, Columbus (1997); and Deutsches Museum, Bonn, and Yerba Buena Center for the Arts, San Francisco, California (1998).

Willie Doherty/p.30
Born 1959, Derry, Northern Ireland
Lives and works in Derry

Willie Doherty's photographs and video installations have been shown extensively in group exhibitions throughout Europe since the early 1980s. These include *NowHere*, Louisiana Museum of Modern Art, Humlebæk, and *Face à l'Histoire 1933–1996*, Centre Georges Pompidou, Paris (1996); *no place (like home)*, Walker Art Center, Minneapolis, Minnesota (1997); and *Wounds: Between Democracy and Redemption in Contemporary Art*, Moderna Museet, Stockholm, and *Art from the UK (Part II)*, Sammlung Goetz, Munich (1998). Solo exhibitions of Doherty's work have been presented at Matt's Gallery, London (1990); Third Eye Centre, Glasgow (1991); Grey Art Gallery and Study Center, New York University (1993–94); Alexander and Bonin, New York, Musée d'Art Moderne de la Ville de Paris, Kunsthalle Bern, and Kunstverein München, Munich (1996); Berwick Gymnasium Gallery, Berwick-upon-Tweed, and Le Magasin, Grenoble (1997–98); Tate Gallery Liverpool (1998); and Museum of Modern Art, Oxford, and Renaissance Society at the University of Chicago (1999).

Education

1981 Ulster Polytechnic, Belfast, B.A.

Selected Further Reading

Tate Gallery Liverpool, England. *Willie Doherty: Somewhere Else* (1998). Exhibition catalogue, texts by Camilla Jackson and Ian Hunt.

Firstsite, Colchester, England; Matt's Gallery, London; and Orchard Gallery, Derry, Northern Ireland. *Willie Doherty: same old story* (1997). Exhibition catalogue.

Kunsthalle Bern, Switzerland. *Willie Doherty: In the Dark. Projected Works* (1996). Exhibition catalogue, texts by Carolyn Christov-Bakargiev and Ulrich Loock.

Douglas Hyde Gallery, Dublin; Grey Art Gallery and Study Center, New York University, New York; Matt's Gallery, London. *Willie Doherty* (1993). Exhibition catalogue, text by Dan Cameron.

Ffotogallery, Cardiff, Wales; Orchard Gallery, Derry, Northern Ireland; Third Eye Centre, Glasgow, Scotland. *Willie Doherty: Unknown Depths* (1990). Exhibition catalogue, text by Jean Fisher.

Olafur Eliasson/p.32
Born 1967, Copenhagen, Denmark
Lives and works in Berlin

Olafur Eliasson's installations have been presented in many international exhibitions since 1989, including *Manifesta 1*, Rotterdam (1996); *Trade Routes: History and Geography. 2nd Johannesburg Biennale* and *5th International Istanbul Biennial* (1997); *Sydney Biennial* and *XXIV Bienal de São Paulo* (1998); and *48th Venice Biennale* (1999). His photographs were shown in *Sightings: New Photographic Art*, Institute of Contemporary Art, London, and *New Photography 14*, Museum of Modern Art, New York (1998). Solo exhibitions of his work were presented at neugerreimschneider, Berlin (1995); Kunstmuseet, Malmö (1996); Kunsthalle Basel (1997); Kjarvalstadir Museum, Reykjavik, Galerie für Zeitgenössische Kunst, Leipzig, and Bonakdar Jancou Gallery, New York (1998); and De Appel Foundation, Amsterdam, and Irish Museum of Modern Art, Dublin (1999).

Education

1989–95 Royal Academy of Arts, Copenhagen

Selected Further Reading

Miles, Christopher. "Olafur Eliasson." *Artforum* 37, no. 7 (March 1999): 119.

Haye, Christian. "The Iceman Cometh." *Frieze,* no. 40 (May 1998): 62–65.

Birnbaum, Daniel. "Openings: Olafur Eliasson." *Artforum* 36, no. 8 (April 1998): 106–107.

Kunsthalle Basel, Switzerland. *Olafur Eliasson* (1997). Exhibition catalogue, texts by Jonathan Crary and Madeleine Schuppli.

Bonami, Francesco. "Psychological Atmospheres." *Siksi* 12, no. 3 (fall 1997): 49–55.

Kendell Geers/p.34
Born May 1968
Lives and works in Johannesburg

Kendell Geers's work has been featured in group exhibitions since 1992 and in numerous international exhibitions, including *Bienal de La Habana* (1994); *Inklusion:Exklusion*, Reininghaus and Künstlerhaus, Graz (1996); *Trade Routes: History and Geography. 2nd Johannesburg Biennale* (1997); *New Works: 98.3*, ArtPace, San Antonio, Texas (1998); and *Power*, Galerie für Zeitgenössische Kunst, Leipzig, *Global Conceptualism: Points of Origin 1950s–1980s*, Queens Museum of Art, New York, *Traffique*, S.M.A.K., Ghent, and *High Red Centre*, Centre for Contemporary Arts, Glasgow (1999). Solo shows of Geers's work have been presented since 1988 and every year since 1993, including exhibitions at Villa Arson, Nice (1995); de Vleeshal, Middelberg (1997); and Stephen Friedman Gallery, London, and Secession, Vienna (1999). Geers received the ArtPace/A Foundation for Contemporary Art's International Artist-in-Residence award in 1998.

Selected Further Reading

Secession, Vienna, Austria. *States of Emergency* (1999). Exhibition catalogue, text by Christine Macel.

Hanru, Hou. "Kendell Geers." *Cream*. London: Phaidon, 1998.

ArtPace/A Foundation for Contemporary Art, San Antonio, Texas. *Kendell Geers* (1998). Exhibition brochure, text by Chrissie Iles.

Trade Routes: History and Geography. 2nd Johannesburg Biennale, South Africa (1997). Exhibition catalogue, text by Octavio Zaya.

Enwezor, Okwui. "Altered States: Die Kunst des Kendell Geers." In *Inklusion:Exklusion*. Cologne: DuMont Buchverlag, 1997.

Felix Gonzalez-Torres/p.36
Born 1957, Güaimaro, Cuba
Lived and worked in New York
Died 1996, Miami, Florida

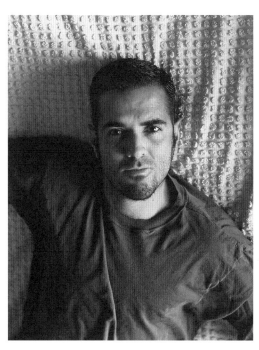

Felix Gonzalez-Torres's first solo exhibition was presented in New York in 1984, and during the last decade his work has been included in numerous group exhibitions, including *El Jardin Salvaje*, Fundación Caja de Pensiones, Madrid, *The Body*, Renaissance Society at the University of Chicago, and *Biennial Exhibition*, Whitney Museum of American Art, New York (1991); *45th Venice Biennale* (1993); *About Place: Recent Art of the Americas*, The Art Institute of Chicago, and *Public Information: Desire, Disaster, Document*, San Francisco Museum of Modern Art, California (1995); and *NowHere*, Louisiana Museum of Modern Art, Humlebæk, and *Jurassic Technologies Revenant*, the 10th Biennale of Sydney (1996). His work has also been presented in solo exhibitions at New Museum of Contemporary Art, New York (1988); Brooklyn Museum, New York (1989); Andrea Rosen Gallery, New York (annually 1990–93, and 1995, 1997); Museum of Modern Art, New York (1992); Milwaukee Art Museum, Wisconsin, and Museum in Progress, Vienna (1993); Museum of Contemporary Art, Los Angeles, traveling to Hirshhorn Museum and Sculpture Garden, Washington, D.C., and Renaissance Society at the University of Chicago (1994); Solomon R. Guggenheim Museum, New York (1995); Musée d'Art Moderne de la Ville de Paris (1996); and Sprengel Museum Hannover, with venues at St. Gallen Kunstmuseum, Switzerland, and Museum moderner Kunst Stiftung Ludwig, Vienna (1997–98).

Education

1983 Pratt Institute, Brooklyn, New York, B.F.A.

1981, 1983 Whitney Museum of American Art, New York, Independent Study Program

1987 International Center for Photography, New York University, M.F.A.

Selected Further Reading

Sprengel Museum Hannover, Germany; St. Gallen Kunstmuseum, Switzerland; and Museum moderner Kunst Stiftung Ludwig, Vienna. *Felix Gonzalez-Torres* (1997–98). Exhibition catalogue, texts by Roland Wäspe, Andrea Rosen, Dietmar Elger, Rainer Fuchs, and David Deitcher. Catalogue raisonné by Dietmar Elger.

The Art Institute of Chicago. *About Place: Recent Art of the Americas* (1995). Exhibition catalogue, texts by Madeleine Grynsztejn and Dave Hickey.

Solomon R. Guggenheim Museum, New York. *Felix Gonzalez-Torres* (1995). Exhibition catalogue, text by Nancy Spector.

Bartman, William S., ed. *Felix Gonzalez-Torres*. Los Angeles: A.R.T. Press, 1993. Essay by Susan Cahan, short story by Jan Avgikos, and interview with the artist by Tim Rollins.

Museum of Contemporary Art, Los Angeles, California. *Felix Gonzalez-Torres* (1994). Exhibition catalogue, texts by Amada Cruz, Russell Ferguson, Ann Goldstein, bell hooks, Joseph Kosuth, and Charles Merewether.

Ann Hamilton/p.38
Born 1956, Lima, Ohio, U.S.A.
Lives and works in Columbus, Ohio

Ann Hamilton has exhibited extensively in group shows since 1981, including *XXI Bienal de São Paulo* and the 1991 *Carnegie International*, Pittsburgh, Pennsylvania (1991); *Sonsbeek 93*, Arnhem (1993); *Outside the Frame: Performance and the Object*, Cleveland Center for the Arts, Ohio (1994); *About Place: Recent Art of the Americas*, The Art Institute of Chicago (1995); *Longing and Belonging: From the Faraway Nearby*, SITE Santa Fe, New Mexico (1995); *Jurassic Technologies Revenant*, the 10th Biennale of Sydney (1996); *Artists Projects*, P.S. 1 Contemporary Art Center, Long Island City, New York, and *Future, Past, Present, 1965–1997, 47th Venice Biennale* (1997); and *48th Venice Biennale* (1999). Solo exhibitions of her work have been presented at Museum of Contemporary Art, Los Angeles (1988); San Diego Museum of Contemporary Art, La Jolla, California (1990); Dia Center for the Arts, New York (1993); Tate Gallery Liverpool and Museum of Modern Art, New York (1994); Institute of Contemporary Art, Philadelphia, Pennsylvania (1995); Wexner Center for the Arts, Ohio State University, Columbus, Carnegie Museum of Art, Pittsburgh, Pennsylvania, and Sean Kelly, New York (1996); Musée d'Art Contemporain, Lyon, and Contemporary Arts Museum, Houston, Texas (1997); and Miami Art Museum, Florida, and Musée d'Art Contemporain de Montréal (1998). In 1989 Hamilton was awarded a Guggenheim Memorial Fellowship, in 1990 a Louis Comfort Tiffany Award, and in 1993 a John D. and Catherine T. MacArthur Foundation grant.

Education

1974–76 St. Lawrence University, Canton, New York

1979 University of Kansas, Kansas City, B.F.A.

1985 Yale School of Art, New Haven, Connecticut, M.F.A.

Selected Further Reading

Simon, Joan. "Ann Hamilton: Inscribing Place." *Art in America* 87, no. 6 (June 1999): 76–85, 130, cover.

United States Pavilion, *48th Venice Biennale. Ann Hamilton: myein* (1999). Exhibition catalogue, texts by Katy Kline and Helaine Posner.

Dia Center for the Arts, New York. *Ann Hamilton: tropos* (1995). Exhibition catalogue, texts by Lynne Cooke, Bruce Ferguson, Dave Hickey, and Marina Warner.

Tate Gallery Liverpool, England. *Ann Hamilton: mneme* (1994). Exhibition catalogue, texts by Judith Nesbitt and Neville Wakefield.

San Diego Museum of Contemporary Art, La Jolla, California. *Ann Hamilton* (1991). Exhibition catalogue, texts by Lynda Forsha and Susan Stewart, interview by Forsha and Hugh M. Davies.

José Antonio Hernández-Diez/p.40
Born 1964, Caracas, Venezuela
Lives and works in Barcelona, Spain, and Caracas

José Antonio Hernández-Diez's work has been presented in international exhibitions, including *Bienal de La Habana* (1994); *1st Kwangju Biennale* (1995); *XXIII Bienal de São Paulo* (1996); and *In Site San Diego 1997*, San Diego and Tijuana (1997). His work has been included in museum shows such as *Cocido y Crudo*, Museo Nacional Centro de Arte Reina Sofía, Madrid (1994); *Sin Fronteras*, Museo Alejandro Otero, Caracas (1996); *The Garden of Forking Paths*, Kunst-foreningen, Copenhagen (1998), which traveled to Edsvik konst och kultur, Stockholm, Helsinki City Art Museum, and Nordjyllands Kunstmuseum, Ålborg (1999); *Amnesia*, Track 16 Gallery and Christopher Grimes Gallery, Santa Monica, California (1998), which traveled to Contemporary Arts Center, Cincinnati, Ohio, and Biblioteca Luis Ángel Arango, Bogotá; and *A vueltas con los Sentidos*, Casa de América, Madrid (1999). Solo exhibitions of his work have been presented since 1991, including Galeria Camargo Vilaça, São Paulo (1995); Sandra Gering Gallery, New York (1995, 1996); Galería Elba Benítez, Madrid (1997); and Sala Mendoza, Caracas (1998).

Education

Centro de Formación Cinematográfica de Caracas

Selected Further Reading

Track 16 Gallery and Christopher Grimes Gallery, Santa Monica, California. *Amnesia* (1998). Exhibition catalogue, texts by Adriano Pedrosa, Charles Merewether, Dan Cameron, and Monica Amor.

Sala Mendoza, Caracas, Venezuela. *José Antonio Hernández-Diez* (1998). Exhibition catalogue, text by Carlota Alvarez-Basso.

Fuenmayor, Jesús. "José Antonio Hernández-Diez." *Poliester*, no. 7 (fall 1997): 48–51.

Ramirez, Yasmin. "José Antonio Hernández-Diez at Sandra Gering." *Art in America* 83, no. 9 (September 1995): 112–13.

Vaisman, Meyer. "Openings: José Antonio Hernández-Diez." *Artforum* 31, no. 4 (April 1992): 92.

Pierre Huyghe/p.42
Born 1962, Paris, France
Lives and works in Paris

Pierre Huyghe's video projects have been presented in international exhibitions since 1994, including *Biennale d'Art Contemporain de Lyon* (1995); *Trade Routes: History and Geography. 2nd Johannesburg Biennale* and *Europarte, 47th Venice Biennale* (1997); *Sydney Biennial* and *Manifesta 2: European Biennial of Contemporary Art*, Luxembourg (1998); and *48th Venice Biennale* (1999). His work has also appeared in group shows in Europe and the United States, including *Shift*, De Appel Foundation, Amsterdam (1995); *Traffic*, CapcMusée d'art contemporain, Bordeaux (1996); *At One Remove*, Henry Moore Foundation, Leeds, *Identités*, Nouveau Musée-Institut d'Art Contemporain, Villeurbanne, and *Coïncidences*, Fondation Cartier pour l'art contemporain, Paris (1997); and *Premises*, Guggenheim Museum SoHo, New York, *Voices*, Witte de With, Rotterdam, Miro Foundation, Barcelona, and Le Fresnoy, Tourcoing, and *Fast Forward*, Kunstverein, Hamburg (1998). Huyghe's first solo exhibition was held in 1995; since then his work has been presented at Galerie Roger Pailhas, Paris (1996); Consortium, Dijon (1997); and Musée d'Art Moderne de la Ville de Paris (1998).

Education

1981–82 École Supérieure des Arts Graphiques

1982–84 École Nationale Supérieure des Arts Décoratifs

Selected Further Reading

Stedelijk Van Abbemuseum, Eindhoven, Netherlands. *Cinéma: Contemporary Art and the Cinematic Experience* (1999). Exhibition catalogue, interview by Françoise Chaloin.

Millet, Catherine. "Pierre Huyghe: Skinned Flicks." *Art Press*, no. 227 (September 1997): 26–27.

Zahm, Olivier. "Openings: Pierre Huyghe." *Artforum* 35, no. 7 (March 1997): 82–83.

Bourriaud, Nicolas. "Pierre Huyghe: Real-Time Human Relations." *Art Press*, no. 219 (December 1996):48–52.

Europarte, 47th Venice Biennale. Venice: Arsenale Editrice, 1997. Exhibition catalogue, text by Tierry Ollat.

Alex Katz/p.44
Born 1927, Brooklyn, New York, U.S.A.
Lives and works in New York

Alex Katz has been exhibiting his work for over forty years in group exhibitions and survey shows in museums worldwide. These include *New York Realism: Past and Present*, organized by the Japan Association of Art Museums and seen at venues across Japan, including the Odakyu Museum, Tokyo, and Museum of Art, Kintetsu, Osaka (1994); *By Night*, Fondation Cartier pour l'art contemporain, Paris (1996); *Pintura Estadounidense, Expressionismo Abstracto*, Centro Cultural Arte Contemporáneo, Mexico City (1996–97); *Views from Abroad: European Perspectives on American Art*, Museum für Moderne Kunst, Frankfurt am Main, and part two of this exhibition at Whitney Museum of American Art, New York, and *Birth of the Cool*, Deichtorhallen Hamburg (1997); and *Surroundings: Responses to the American Landscape*, San Jose Museum of Art, California, and Whitney Museum of American Art, New York (1999–2000). Solo exhibitions of Katz's work have been presented at Marlborough Gallery, New York, since 1973 and also at Whitney Museum of American Art, New York (1986); Brooklyn Museum, New York, and Cleveland Museum of Art, Ohio (1988); Institute of Contemporary Art, London (1990); Staatliche Kunsthalle, Baden-Baden (1995); I.V.A.M. Centre Julio Gonzalez, Valencia (1996); and P.S. 1 Contemporary Art Center, Long Island City, New York, and Saatchi Gallery, London (1998).

Education

1946–49 Cooper Union, New York

1950 Skowhegan School of Painting and Sculpture, Maine

Selected Further Reading

Lauter, Rolf, and Vincent Katz, eds. *Positions in Contemporary Art: Alex Katz, Invented Symbols*. Ostfildern-Ruit, Germany: Cantz Verlag, 1997.

Instituto Valenciano de Arte Moderno, Valencia, Spain. *Alex Katz* (1996). Exhibition catalogue, texts by Juan Manuel Bonet and Kevin Power.

P.S. 1 Contemporary Art Center, Long Island City, New York. *Alex Katz under the Stars: American Landscapes 1951–1995* (1996). Exhibition catalogue, interview by Alanna Heiss; texts by Dave Hickey and Simon Schama.

Staatliche Kunsthalle, Baden-Baden, Germany. *Alex Katz: American Landscape* (1995). Exhibition catalogue, texts by Margrit Brehm, Richard Marshall, Jochen Poetter, and Robert Storr.

Whitney Museum of American Art, New York. *Alex Katz* (1986). Exhibition catalogue, text by Robert Rosenblum.

William Kentridge/p.46
Born 1955, Johannesburg, South Africa
Lives and works in Johannesburg

William Kentridge's work was first exhibited in and around Johannesburg in the late 1970s. In 1989 he began to participate in international group shows, including *Memory and Geography. Africus Johannesburg Biennale* (1995); *Jurassic Technologies Revenant*, the 10th Biennale of Sydney (1996); *documenta X*, Kassel, *Sexta Bienal de La Habana, Truce: Echoes of Art in an Age of Endless Conclusions*, SITE Santa Fe, New Mexico, and *Delta*, Musée d'Art Moderne de la Ville de Paris (1997); and *48th Venice Biennale* (1999). Solo shows of Kentridge's work have appeared at Goodman Gallery, Johannesburg (1992, 1994, 1997); The Drawing Center, New York, Museum of Contemporary Art, San Diego, California, Palais des Beaux-Arts de Bruxelles, Brussels, and Carnegie Museum of Art, Pittsburgh, Pennsylvania (1998); and Museum of Modern Art, New York, and Marian Goodman Gallery, Paris (1999). Kentridge has also directed and designed many theater productions, including the highly acclaimed *Ubu and the Truth Commission* (1997).

Education

1973–76 University of the Witwatersrand, Johannesburg, B.A.

1976–78 Johannesburg Art Foundation

1981–82 École Jacques Lecoq, Paris

Selected Further Reading

Museum of Modern Art, New York. *William Kentridge* (1999). Exhibition brochure, text and interview by Lilian Tone.

Enwezor, Okwui. "Truth and Responsibility: A Conversation with William Kentridge." *Parkett* 54 (1998/1999): 165–70.

Palais des Beaux-Arts de Bruxelles, Belgium. *William Kentridge* (1998). Exhibition catalogue, text by Carolyn Christov-Bakargiev.

Taylor, Jane. *Ubu and the Truth Commission.* Cape Town, South Africa: University of Cape Town, 1998. From the production of *Ubu and the Truth Commission* by William Kentridge and the Handspring Puppet Company.

Goodman Gallery, Johannesburg, South Africa. *William Kentridge: Drawings for Projection: Four Animated Films* (1992). Exhibition catalogue, text by Michael Godby.

Bodys Isek Kingelez/p.48
Born 1948, Kimbembele-Ihunga, Zaïre
Lives and works in Kinshasa, Democratic Republic of Congo

Since 1989, Bodys Isek Kingelez's work has been featured in international group exhibitions, including *Magiciens de la Terre*, Centre Georges Pompidou, Paris (1989); *Out of Africa*, Saatchi Gallery, London (1992); *Cocido y Crudo*, Museo Nacional Centro de Arte Reina Sofía, Madrid (1994); *Big City: Artists from Africa*, Serpentine Gallery, London (1995); *Projects 59: Architecture as Metaphor*, Museum of Modern Art, New York, *97 Kwangju Biennale: Unmapping the Earth*, and *Trade Routes: History and Geography. 2nd Johannesburg Biennale* (1997); and *Unfinished History*, Walker Art Center, Minneapolis, Minnesota (1998), which traveled to Museum of Contemporary Art, Chicago (1999). Solo exhibitions of Kingelez's work have been presented at Jean-Marc Patras Galerie, Paris (1990); Haus der Kulturen der Welt, Berlin (1992); Fondation Cartier pour l'art contemporain, Paris (1995); and Musée d'art moderne et contemporain, Geneva (1996).

Selected Further Reading

Walker Art Center, Minneapolis, Minnesota. *Unfinished History* (1998). Exhibition catalogue, text by Francesco Bonami.

Trade Routes: History and Geography. 2nd Johannesburg Biennale, South Africa (1997). Exhibition catalogue, text by Hou Hanru.

Fondation Cartier pour l'art contemporain, Paris. *Bodys Isek Kingelez* (1995). Exhibition catalogue, texts by André Magnin, Bodys Isek Kingelez, and Ettore Sottsass.

Serpentine Gallery, London. *Big City: Artists from Africa* (1995). Exhibition catalogue, text by Bodys Isek Kingelez.

Museum for African Art, New York. *Home and the World: Architectural Sculpture by Two Contemporary African Artists, Aboudramane and Bodys Isek Kingelez* (1993). Exhibition catalogue, texts by Jean-Marc Patras and David Frankel.

Suchan Kinoshita/p.50
Born 1960, Tokyo, Japan
Lives and works in Maastricht, Netherlands

Suchan Kinoshita's work has been featured in international exhibitions since 1986, including *46th Venice Biennale* and *4th Istanbul Biennale* (1995); *Manifesta 1*, Rotterdam (1996); and *Truce: Echoes of Art in an Age of Endless Conclusions*, SITE Santa Fe, New Mexico, and *Trade Routes: History and Geography. 2nd Johannesburg Biennale* (1997). Her work has also been presented in such group exhibitions as *Inklusion: Exklusion*, Reininghaus and Künstlerhaus, Graz, *Under Capricorn*, Stedelijk Museum, Amsterdam, and *Doppelbindung. Linke Maschen*, Kunstverein, Munich (1996). Kinoshita has had solo exhibitions at De Fabrick, Eindhoven (1991); White Cube, London (1996); Stedelijk Van Abbemuseum, Eindhoven (1997); and Chisenhale Gallery, London (1998).

Education

1981–84 Musikhochschule, Cologne

1988–90 Jan van Eyck Akademie, Maastricht

Selected Further Reading

Lambrecht, Luk. "Suchan Kinoshita S.M.A.K." *Flash Art* 32, no. 204 (January/ February 1999): 105.

Bonami, Francesco. "Suchan Kinoshita." *Cream.* London: Phaidon, 1998.

S.M.A.K. Stedelijk Museum voor Actuele Kunst, Ghent, Belgium, and Chisenhale Gallery, London. *Suchan Kinoshita: Meaning is Moist* (1998). Exhibition catalogue.

Stedelijk Van Abbemuseum, Eindhoven, Netherlands. *NL, Contemporary Art from the Netherlands* (1998). Exhibition catalogue, text by Christiane Berndes.

Steirischer Herbst, Graz, Austria. *Inklusion: Exklusion* (1996). Exhibition catalogue.

Martin Kippenberger/p.52
Born 1953, Dortmund, West Germany
Lived and worked in Vienna, Austria
Died 1997, Vienna

Martin Kippenberger's twenty-year exhibition history includes the recent group exhibitions *documenta X*, Kassel, *Sculpture. Projects in Münster 1997*, Westfälisches Landesmuseum, and *Deutschlandbilder*, Martin Gropius Bau, Berlin (1997); and *Fast Forward (Image)*, Hamburger Kunstverein, Hamburg, and *Mai 98*, Kunsthalle, Cologne (1998). Solo shows of Kippenberger's work have been presented at Galerie Gisela Capitain, Cologne (1987, 1989, 1990, 1997); Kölnischer Kunstverein, Cologne (1991); Centre Georges Pompidou, Paris (1993); Museum Boijmans Van Beuningen, Rotterdam (1994); Hirshhorn Museum and Sculpture Garden, Washington, D.C. (1995); Städtisches Museum Abteiberg, Mönchengladbach, and Metro Pictures, New York (1997); MAK Center for Art and Architecture, Schindler House, Los Angeles, and Kunsthalle Basel (1998); and Deichtorhallen Hamburg (1999).

Education

1972–76 Hochschule für bildende Künste, Hamburg

Selected Further Reading

Deichtorhallen Hamburg, Germany. *Martin Kippenberger: The Happy End of Franz Kafka's "Amerika"* (1999). Exhibition catalogue, texts by Zdenek Felix, Rudolf Schmitz, and Veit Loers.

Kunsthalle Basel, Switzerland, and Deichtorhallen Hamburg, Germany. *Martin Kippenberger* (1998). Exhibition catalogue, texts by Daniel Baumann, Peter Pakesch, Stephen Prina, Franz West, and Michel Würthle.

Ohrt, Roberto. *Kippenberger.* Cologne: Benedikt Taschen Verlag GmbH, 1997.

Kippenberger, Martin. *The Happy End of Franz Kafka's "Amerika."* St. Georgen, Germany: Familie Grässlin, 1993.

San Francisco Museum of Modern Art, California. *Martin Kippenberger: I Had a Vision* (1991). Published in conjunction with the exhibition *Martin Kippenberger: New Work*; text by John Caldwell, interview by Jutta Koether.

Kerry James Marshall/p.54
Born 1955, Birmingham, Alabama, U.S.A.
Lives and works in Chicago

Kerry James Marshall's work has been exhibited in group shows in the United States for over twenty years and in international exhibitions such as *documenta X*, Kassel (1997) and the traveling exhibition *Postcards from Black America: Contemporary African American Art*, De Beyerd, Centrum voor Beeldende Kunst, Breda, Museum van Hedendaagse Kunst Antwerpen, Antwerp, and Frans Hals Museum, Haarlem (1998). His work appeared in *About Place: Recent Art of the Americas*, The Art Institute of Chicago (1995); *Art in Chicago 1945–1995*, Museum of Contemporary Art, Chicago (1996); and *Biennial Exhibition* and *Heart, Mind, Body, Soul: American Art in the 1990s*, Whitney Museum of American Art, New York (1997). Solo exhibitions of his work have been presented at Pepperdine University, Malibu, California (1984); Studio Museum in Harlem, New York (1986); and Jack Shainman Gallery, New York (1993, 1995, 1999). In 1994 Cleveland Center for Contemporary Art, Ohio, organized an exhibition of his work entitled *Telling Stories, Selected Paintings*, which traveled to Gallery of Art, Johnson County Community College, Overland Park, Kansas; Gallery 210, University of Missouri, St. Louis; Pittsburgh Center for the Arts, Pennsylvania; and Southeastern Center for Contemporary Art, Winston-Salem, North Carolina. An exhibition of Marshall's work, organized by Renaissance Society at the University of Chicago (1998), traveled to Brooklyn Museum of Art, New York; San Francisco Museum of Modern Art, California; Institute for Contemporary Art, Boston, Massachusetts; Santa Monica Museum of Art, California; and Boise Museum of Art, Idaho. In 1997 Marshall was awarded a John D. and Catherine T. MacArthur Foundation grant.

Education

1978 Otis Art Institute, Los Angeles

Selected Further Reading

Orlando Museum of Art, Florida. *Currents 6: Kerry James Marshall, A Narrative of Everyday* (1998). Exhibition brochure, text by Sue Scott.

Molesworth, Helen. "Project America." *Frieze*, no. 40 (May 1998): 72–75.

Holg, Garrett. "Realism Today: 'Stuff Your Eyes with Wonder.'" *Artnews* 97, no. 3 (March 1998): 154–56.

Reid, Calvin. "Kerry James Marshall." *Bomb*, no. 62 (winter 1998): 40–47, cover.

Cleveland Center for Contemporary Art, Ohio, in association with Pittsburgh Center for the Arts, Pennsylvania. *Kerry James Marshall: Telling Stories, Selected Paintings* (1994). Exhibition catalogue, text by Terrie Sultan.

Takashi Murakami/p.56
Born 1962, Tokyo, Japan
Lives and works in Tokyo and New York

Takashi Murakami's paintings and sculptures have been featured in international exhibitions, including *TransCulture, 46th Venice Biennale* (1995); and *Asia Pacific Triennial 1996*, Queensland Art Gallery, Brisbane (1996). His work was also included in *Japanese Contemporary Art*, National Museum of Contemporary Art, Seoul, and *Cities on the Move*, Secession, Vienna, CapcMusée d'art contemporain, Bordeaux, and P.S. 1 Contemporary Art Center, Long Island City, New York (1997); and *Abstract Painting, Once Removed*, Contemporary Arts Museum, Houston, Texas, and Kemper Museum of Art, Kansas City, Missouri (1998). Murakami has had numerous solo exhibitions since 1989, including Hiroshima City Museum of Contemporary Art, Japan (1993); Feature, Inc., New York (1996); State University of New York at Buffalo and Blum & Poe, Santa Monica, California (1997); and Marianne Boesky Gallery, New York, and Center for Curatorial Studies, Bard College, Annandale-on-Hudson, New York (1999).

Education

1986–93 Tokyo National University of Fine Arts and Music, B.F.A., M.A., Ph.D.

Selected Further Reading

Center for Curatorial Studies, Bard College, Annandale-on-Hudson, New York. *Takashi Murakami* (1999). Exhibition catalogue, texts by Amada Cruz, Dana Friis-Hansen, and Midori Matsui.

Munroe, Alexandra. *Japanese Art after 1945: Scream against the Sky.* New York: Harry N. Abrams, 1996.

Queensland Art Gallery, Brisbane, Australia. *The Second Asia-Pacific Triennial of Contemporary Art* (1996). Exhibition catalogue, text by Midori Matsui.

TransCulture, 46th Venice Biennale (1995). Exhibition catalogue.

Shiraishi Contemporary Art, Tokyo. *Takashi Murakami: "Which is Tomorrow?—Fall in Love"* (1994). Exhibition catalogue, text by Midori Matsui.

Shirin Neshat/p.58
Born 1957, Qazvin, Iran
Lives and works in New York

Shirin Neshat's photographs and videos have been included in many international exhibitions, including *Jurassic Technologies Revenant*, the 10th Biennale of Sydney (1996); *5th International Istanbul Biennale* and *Trade Routes: History and Geography. 2nd Johannesburg Biennale* (1997); *Unfinished History*, Walker Art Center, Minneapolis, Minnesota (1998) and Museum of Contemporary Art, Chicago (1999); and *Exploding Cinema*, Museum Boijmans Van Beuningen, Rotterdam, *Heavenly Figure*, Kunsthalle Düsseldorf, *Zeit-wenden*, Rheinisches Landesmuseum, Bonn, in cooperation with Kunstmuseum, Bonn, SITE Santa Fe, New Mexico, *La Ville, le Jardin, la Mémoire—1998, 2000, 1999*, Académie de France, Villa Medici, Rome, and *48th Venice Biennale* (1999). In 1996 Neshat's work was presented by Creative Time for Anchorage, Brooklyn Bridge, New York. Solo exhibitions of Neshat's work have been presented at Franklin Furnace, New York (1993); Centre d'art contemporain, Fribourg (1996); Museum of Modern Art, Ljubljana (1997); Whitney Museum of American Art at Philip Morris, New York, and Tate Gallery of Modern Art at St. Mary-le-Bow Church, Cheapside, London (1998); and The Art Institute of Chicago (1999). In 1996 Neshat was awarded a grant from the Louis Comfort Tiffany Foundation.

Education

1979–82 University of California, Berkeley, B.A., M.F.A.

Selected Further Reading

The Art Institute of Chicago. *Focus: Shirin Neshat, Rapture* (1999). Exhibition brochure, text by James Rondeau.

Whitney Museum of American Art at Philip Morris, New York. *Shirin Neshat: Turbulent* (1998–99). Exhibition brochure, text by Neery Melkonian.

Miller, Paul D. "Motion Capture, Shirin Neshat's *Turbulent*." *Parkett* 54 (1998/99): 156–60.

Goodman, Jonathan. "Poetic Justice: Shirin Neshat Defends the Faith." *World Art*, no. 16 (1998).

Bertucci, Lina. "Shirin Neshat: Eastern Values." *Flash Art*, no. 197 (November/ December 1997): 84–87.

Ernesto Neto/p.60
Born 1964, Rio de Janeiro, Brazil
Lives and works in Rio de Janeiro

Ernesto Neto's work has appeared frequently in international exhibitions, including *1st Kwangju Biennale* (1995); and *Sydney Biennial* and *XXIV Bienal de São Paulo* (1998). Neto's group exhibitions include *The Five Senses*, White Columns, New York (1995); *Defining the Nineties: Consensus-making in New York, Miami and Los Angeles*, Museum of Contemporary Art, Miami, Florida (1996); *Arte Contemporânea da Gravura Brasil—Reflexão 97*, Museu Metropolitano de Arte de Curitiba, *As Outras Modernidades*, Haus der Kulturen der Welt, Berlin, and *Material Immaterial*, Art Gallery of New South Wales, Sydney (1997); *Loose Threads*, Serpentine Gallery, London (1998); and *A vueltas con los Sentidos*, Casa de América, Madrid (1999). Solo exhibitions of Neto's work have been presented since 1988, most recently at Fundação Cultural do Distrito Federal, Brasília, and Galeria Camargo Vilaça, São Paulo (1997); and Bonakdar Jancou Gallery, New York, and Museo de Arte Contemporáneo Carrilo Gil, Mexico City (1998).

Education

1994, 1997 Escola de Artes Visuais Pargua Lage, Rio de Janeiro

1994–96 Museu de Arte Moderna, Rio de Janeiro

Selected Further Reading

Ebony, David. "Ernesto Neto at Bonakdar Jancou." *Art in America* 87, no. 6 (June 1999): 118.

Centro Cultural Light, Rio de Janeiro, Brazil. *Poéticas de Cor* (1998). Exhibition catalogue, text by Ligia Canongia.

Galeria Camargo Vilaça, São Paulo, Brazil. *Ernesto Neto* (1998). Exhibition catalogue, text by Carlos Basualdo.

Pedrosa, Adriano. "Ernesto Neto." *Frieze*, no. 39 (March/April 1998): 91.

Galeria Camargo Vilaça, São Paulo, Brazil. *Ernesto Neto* (1994). Exhibition catalogue, text by Paulo Herkenhoff.

Chris Ofili/p.62
Born 1968, Manchester, England
Lives and works in London

Chris Ofili's paintings have been exhibited in important traveling group exhibitions, including *Brilliant! New Art from London*, with venues at Walker Art Center, Minneapolis, Minnesota, and Contemporary Arts Museum, Houston, Texas (1995–96); *About Vision: New British Painting in the 1990s*, which opened at Museum of Modern Art, Oxford (1996) and traveled to Fruitmarket Gallery, Edinburgh, Christchurch Mansion, Ipswich (1997), and Laing Art Gallery, Newcastle (1998); *Sensation: Young British Artists from the Saatchi Collection*, Royal Academy of Arts, London (1997) and Hamburger Bahnhof, Berlin (1998); and *Dimensions Variable*, which was organized by the British Council and traveled to many venues in Scandinavia and Eastern Europe, including Helsinki City Art Museum (1997–98); Stockholm Royal Academy of Free Arts, St. Petersburg Russian Museum, Gallery Zacheta, Warsaw, and Prague National Gallery of Modern Art (1998). Since 1991 Ofili's work has been the subject of solo exhibitions at galleries in England, New York, and Berlin, including Gavin Brown's enterprise, New York (1995) and Victoria Miro Gallery, London (1996). In 1998 Ofili received the Tate Gallery's Turner Prize.

Education

1987–88 Thameside College of Technology, London

1988–91 Chelsea School of Art, London

1992 Hochschule der Künste, Berlin

1991–93 Royal College of Art, London

Selected Further Reading

Southampton City Art Gallery and Serpentine Gallery, London. *Chris Ofili* (1998). Exhibition catalogue, text by Lisa G. Corrin and Godfrey Worsdale.

Newsome, Rachel. "Afrodaze: Chris Ofili." *Dazed and Confused*, no. 48 (November 1998): 75–80.

Buck, Louisa. "Openings: Chris Ofili." *Artforum* 36, no. 1 (September 1997): 112–13.

Myers, Terry R. "Chris Ofili, Power Man." *art/text*, no. 58 (August–October 1997): 36–39.

Morgan, Stuart. "The Elephant Man." *Frieze*, no. 15 (March/April 1994): 40–43.

Gabriel Orozco/p.64
Born 1962, Jalapa, Veracruz, Mexico
Lives and works in New York and Mexico City

Gabriel Orozco's work has been featured in recent international exhibitions, including *1st Kwangju Biennale* (1995); *Everything That's Interesting Is New*, Deste Foundation, Athens, in conjunction with the Museum of Modern Art, Copenhagen (1996); *Biennial Exhibition*, Whitney Museum of American Art, New York, *documenta X*, Kassel, and *Sculpture. Projects in Münster 1997*, West-fälisches Landesmuseum (1997); *XXIV Bienal de São Paulo* and *Berlin Biennial* (1998); and SITE Santa Fe, New Mexico (1999). Orozco has presented solo exhibitions since 1993, including shows at Museum of Modern Art, New York (1993); Museum of Contemporary Art, Chicago (1994); Marian Goodman Gallery, New York (1996, 1998); Art Gallery of Ontario, Toronto, an Artangel project entitled *Empty Club*, Institute of Contemporary Art, London, and Kunsthalle Zürich (1996); DAAD Gallery, Berlin, Staatlichen Museum am Kulturforum, Berlin, and Stedelijk Museum, Amsterdam (1997); and Musée Nationale d'Art Moderne de la Ville de Paris and St. Louis Museum of Art, Missouri (1998).

Education

1981–84 Escuela Nacional de Artes Plásticas, U.N.A.M., Mexico

1986–87 Círculo de Bellas Artes, Madrid

Selected Further Reading

Musée Nationale d'Art Moderne de la Ville de Paris. *Gabriel Orozco (Clinton is Innocent)* (1998). Exhibition catalogue, text by Francesco Bonami and interview by Benjamin H.D. Buchloh.

Orozco, Gabriel. "Gabriel Orozco: Technique de l'Énergie, The Power to Transform." Interview by Robert Storr. *Art Press* 225 (June 1997): 20–27.

Artangel, London. *Empty Club* (1996). Exhibition catalogue, texts by James Lingwood, Jean Fisher, Mark Haworth-Booth, and Guy Brett.

Kunsthalle Zürich, Switzerland; Institute of Contemporary Arts, London; and Deutscher Akademischer Austauschdienst Berliner Künstlerprogramm, Germany. *Gabriel Orozco* (1996). Exhibition catalogue, texts by Benjamin H.D. Buchloh and Bernhard Bürgi.

Kanaal Art Foundation, Kortrijk, Belgium, in association with La Vaca Independiente Promoción de Arte y Cultura, Mexico City, and Les Éditions la Chambre, Ghent, Belgium. *Gabriel Orozco* (1993). Exhibition catalogue, edited by M. Catherine de Zegher, texts by Benjamin H.D. Buchloh and Jean Fisher.

Markéta Othová/p.66
Born 1968, Brno, Czechoslovakia
Lives and works in Prague, Czech Republic

Markéta Othová has been exhibiting her photographs since 1990 and has been included in numerous group exhibitions in Prague such as *New Names* (1993) and *Borders of Photography* (1995), Prague House of Photography; *The Bell '94, Biennial of Young Art*, Prague City Gallery (1994), which traveled to Ján Koniarek Gallery, Trnava; and *Contemporary Collection—Czech Art in the '90s* and *Close Echoes*, Prague City Gallery, and *Body and Photography*, Salmovsky Palace (1998). She has also exhibited in Paris, Berlin, Leipzig, and Trieste. Her work was included in *City Legends—Prague*, Staatliche Kunsthalle, Baden-Baden (1996); *Toward the Object*, Riverside Studios, London (1997); *Intimacies*, Rethymnon Center for Contemporary Art (1998); and *Kunst Im Dialog*, Czech Centre, Berlin (1999). Between 1990 and 1999, Othová mounted eleven solo exhibitions, including *Her Life*, National Gallery, Prague (1998).

Education

1987–89 Film and Television Atelier, University of Applied Arts, Prague

1989–93 Illustration and Graphics Atelier, University of Applied Arts, Prague, M.A.

Selected Further Reading

Moravská Galerie, Brno, Czech Republic. *Markéta Othová: Síla osudu* (1999). Exhibition catalogue, text by Petr Ingerle.

Dům umění, Brno, Czech Republic. *Markéta Othová: Oheň do kapes!* (1997). Exhibition catalogue.

Galerie hlavního města Prahy, Prague. *Markéta Othová: Staré zdroje* (1996). Exhibition catalogue, text by Karel Srp.

Othová, Markéta. "Drawings, Photographs and Poems." *Divus*, no. 1 (1995): 71–81.

Cooke, Andrée. "An Interview with Veronika Bromová and Markéta Othová." *Flash Art* 28, no. 184 (October 1995): 55.

Laura Owens/p.68
Born 1970, Euclid, Ohio, U.S.A.
Lives and works in Los Angeles

Education

1992 Rhode Island School of Design, Providence

1994 Skowhegan School of Painting and Sculpture, Maine

1994 California Institute of the Arts, Valencia

Selected Further Reading

Gagosian Gallery, Beverly Hills, California. *Standing Still & Walking in Los Angeles* (1999). Exhibition catalogue, text by Terry R. Myers.

Kunsthalle Basel, Switzerland. *Nach-Bild* (1999). Exhibition catalogue, text by Frances Stark.

Owens, Laura, and Susan Morgan. "A Thousand Words: Laura Owens Talks About Her New Work." *Artforum* 37, no. 10 (summer 1999): 130–31.

Avgikos, Jan. "Laura Owens." *Artforum* 37, no. 5 (January 1999): 118.

Darling, Michael. "Laura Owens." *Art Issues*, no. 56 (January–February 1999): 43.

Laura Owens's paintings have been exhibited in group exhibitions in museums in the United States and Europe, including *L.A.C.E. Annuale*, Los Angeles Contemporary Art Exhibitions (1994); *Wunderbar*, Kunstverein, Hamburg (1996); *Hot Coffee*, Artists Space, New York (1997); *Young Americans 2: New American Art*, Saatchi Gallery, London (1998); and *Nach-Bild*, Kunsthalle Basel, and *Examining Pictures*, Whitechapel Art Gallery, London (1999). Since 1995, she has had solo shows in galleries in the United States, Germany, England, and Italy, including Gavin Brown's enterprise, New York (1996, 1998) and Galerie Gisela Capitain, Cologne (1999).

Edward Ruscha/p.70
Born 1937, Omaha, Nebraska, U.S.A.
Lives and works in Los Angeles

Edward Ruscha has participated in group exhibitions nationally and internationally since the 1960s, including such significant museum shows in the last decade as *Hand-Painted Pop: American Art in Transition, 1955–62*, Museum of Contemporary Art, Los Angeles (1992); *Visions of America: Landscape as Metaphor in the Late 20th Century*, Denver Art Museum, Colorado (1994); *Biennial Exhibition*, Whitney Museum of American Art, New York, and *47th Venice Biennale* (1997); and *The Museum as Muse: Artists Reflect*, Museum of Modern Art, New York (1999). Ruscha's first solo exhibition was held in 1963, and many exhibitions of his work have been presented each year since then, including Gagosian Gallery, New York (1993) and Los Angeles (1996, 1998). Museum exhibition highlights include *The Works of Edward Ruscha*, San Francisco Museum of Modern Art, California (1982), which traveled to Whitney Museum of American Art, New York, Vancouver Art Gallery, British Columbia, San Antonio Museum of Art, Texas (1982–83) and Los Angeles County Museum of Art (1983); Institute of Contemporary Art, Nagoya (1988); Centre Georges Pompidou, Paris (1989), which traveled to Museum Boijmans Van Beuningen, Rotterdam, Fundació "la Caixa," Barcelona, Serpentine Gallery, London (1990) and Museum of Contemporary Art, Los Angeles (1990–91); Whitney Museum of American Art, New York (1990); J. Paul Getty Museum, Los Angeles (1998); and *Editions 1959–1999*, Walker Art Center, Minneapolis, Minnesota (1999).

Education

1956–60 Chouinard Art Institute, Los Angeles

Selected Further Reading

Gagosian Gallery, New York. *Ed Ruscha/Metro Plots* (1998). Exhibition catalogue, text by Dave Hickey.

Anthony d'Offay, London. *Ed Ruscha: New Paintings and a Retrospective of Works on Paper* (1998). Exhibition catalogue, texts by Neville Wakefield and Dave Hickey.

Centre Georges Pompidou, Paris. *Edward Ruscha* (1989). Exhibition catalogue, texts by Pontus Hulten and Dan Cameron, interview by Bernard Blistène.

Parkett, no. 18 (1988). Collaboration Edward Ruscha: Dave Hickey, Dennis Hopper, Alain Cueff, John Miller, and Christopher Knight.

San Francisco Museum of Modern Art, California. *The Works of Edward Ruscha* (1982). Exhibition catalogue, texts by Henry T. Hopkins, Anne Livet, Dave Hickey, and Peter Plagens.

Gregor Schneider/p.72
Born 1969, Rheydt, West Germany
Lives and works in Rheydt

Gregor Schneider has been exhibiting his work since 1992 and has had gallery exhibitions in Mönchengladbach, Düsseldorf, Berlin, Cologne, Tokyo, Amsterdam, London, Warsaw, and Milan, including Konrad Fischer Galerie, Düsseldorf (1993, 1999); Galerie Luis Campaña, Cologne (1995, 1997, 1999); and Galeria Foksal, Warsaw (1997). He has presented solo exhibitions at Museum Haus Lange, Krefeld (1994); Kunsthalle Bern and Künstlerhaus Stuttgart (1996); Portikus Frankfurt am Main (1997); Städtisches Museum Abteiberg Mönchengladbach, Musée d'Art Moderne de la Ville de Paris, and Århus Kunstmuseum (1998). Recently, his work was included in several important group exhibitions, including *No Man's Land*, Museum Haus Lange, Krefeld (1997); *Performing Buildings*, Tate Gallery, London (1998); and *Anarchitecture*, De Appel Foundation, Amsterdam, and *Zeitwenden*, Rheinisches Landesmuseum, Bonn, in cooperation with Kunstmuseum Bonn (1999).

Education

1989–92 Akademie der Bildenden Künste, Munich

1989–92 Hochschule für bildende Künste, Hamburg

Selected Further Reading

Richie, Matthew. "Franz Ackermann, Manfred Pernice, Gregor Schneider: The New City." *art/text*, no. 65 (May–July 1999): 72–74.

Dziewior, Yilmaz. "Gregor Schneider: Städtisches Museum Abteiberg." Translated by Diana Reese. *Artforum* 36, no. 10 (summer 1998): 142–43.

Städtisches Museum Abteiberg Mönchengladbach, Germany, in collaboration with Portikus Frankfurt am Main, Germany, and Galeria Foksal, Warsaw, Poland. *Gregor Schneider: Dead House ur 1985–1997* (1997). Exhibition catalogue, text by Viet Loers, Brigitte Kölle, Adam Szymczyk, and Ulrich Loock, and interview by Ulrich Loock.

Krefelder Kunstmuseen, Germany. *Gregor Schneider: Museum Haus Lange Krefeld, 1994* (1994). Exhibition catalogue.

Galerie Löhrl am Abteiberg, Mönchengladbach, Germany. *Impulse 17: Gregor Schneider* (1992). Exhibition brochure.

Ann-Sofi Sidén/p.74
Born 1962, Stockholm, Sweden
Lives and works in Stockholm and New York

Ann-Sofi Sidén's cinematic works have been presented in the *Swedish Avant-Garde Film Program 1990–94* at Anthology Film Archives, New York (1991). Her films and sculptural works have been featured in major group exhibitions, including *See What It Feels Like*, Rooseum Center for Contemporary Art, Malmö, and *Electronic Undercurrent*, Statens Museum for Kunst, Copenhagen (1996); *Around Us, Inside Us*, Borås Konstmuseum, *Clean and Sane*, Edsvik konst och kultur, Stockholm, and *Zonen der Ver-Störung*, Steirischer Herbst, Graz (1997); *Nuit Blanche*, Musée d'Art Moderne de la Ville de Paris, *The King is not the Queen*, Nordiska Museet (Arkipelag), Stockholm, *Manifesta 2, European Biennial of Contemporary Art*, Luxembourg, and *XXIV Bienal de São Paulo* (1998); and *48th Venice Biennale* (1999). Solo exhibitions of Sidén's work have been presented since 1988, including shows at Galerie Nordenhake, Stockholm (1995, 1999), and Secession, Vienna (1999). Sidén had residencies at Skowhegan School of Painting and Sculpture, Maine (1989), and P.S. 1 Studio Programs, New York (1993–94).

Education

1986–88 Hochschule der Künste, Berlin

1988–92 Royal Academy of Art, Stockholm

Selected Further Reading

Sidén, Ann-Sofi. *No. 144 It's by Confining One's Neighbor That One Is Convinced of One's Own Sanity.* Translated by Eric van der Heeg. Stockholm: Utica Publishing, 1999.

Birnbaum, Daniel. "Shrink Wrap: The Art of Ann-Sofi Sidén." *Artforum* 37, no. 10 (summer 1999): 138–41.

Fleck, Robert. "Ann-Sofi Sidén: Who Told the Chambermaid?" In *48th Venice Biennale*. Venice: Marsilio Editori, 1999.

Ericsson, Lars O. "The Queen of Mud Strikes Again." *Siksi*, no. 1 (1998).

Lind, Maria, and Mats Stjernstedt. *Ann-Sofi Sidén, XXIV Bienal de São Paulo.* Stockholm: Moderna Museet International Programme, 1998.

Roman Signer/p.76
Born 1938, Appenzell, Switzerland
Lives and works in St. Gallen, Switzerland

Roman Signer's exhibition history includes over twenty-five years of gallery and museum shows throughout Europe and the United States. His work was featured in *37th Venice Biennale* (1976) and *documenta 8*, Kassel (1987) and in group exhibitions such as *A Swiss Dialectic*, Renaissance Society at the University of Chicago (1991); *Voorwerk 3*, Witte de With, Rotterdam (1992); *Heart of Darkness*, Kröller-Müller Museum, Otterlo (1994); *Self-Construction*, Museum moderner Kunst Stiftung Ludwig, Vienna, and *Shift*, De Appel Foundation, Amsterdam (1995); *Wunschmaschine Welterfindung*, Kunsthalle Wien, Vienna, and *Model Home*, Clocktower Gallery, New York (1996); *Sculpture. Projects in Münster 1997*, Westfälisches Landesmuseum (1997); *Unfinished History*, Walker Art Center, Minneapolis, Minnesota (1998); and *The Sultan's Pool*, Art Focus, Jerusalem, *Panorama 2000*, Centraal Museum, Utrecht, and *Provisorium I*, Bonnefantenmuseum, Maastricht (1999). Solo exhibitions of Signer's work have been presented at Kunstmuseum Winterthur (1983); Kunsthalle, St. Gallen, Switzerland (1988); Creux de l'Enfer, Centre d'art contemporain, Thiers, and FRI-ART, Centre d'art contemporain, Fribourg (1992); St. Gallen Kunstmuseum, Switzerland (1993); Künstlerhaus, Bremen (1995); Galerie Hauser & Wirth, Zurich (1997, 1999); and Secession, Vienna, and Bonnefantenmuseum, Maastricht (1999).

Education

1966 Schule für Gestaltung, Zurich

1969–71 Schule für Gestaltung, Lucerne

1971–72 Academy of Fine Arts, Warsaw

Selected Further Reading

Swiss Pavilion. *Roman Signer. 48th Venice Biennale* (1999). Exhibition catalogue.

Westfälisches Landesmuseum, Münster, Germany. *Sculpture. Projects in Münster 1997* (1997). Exhibition catalogue, text by Susanne Jacob.

Goldie Paley Gallery, Moore College of Art and Design, Philadelphia, Pennsylvania. *Roman Signer: Works* (1997). Exhibition catalogue, texts by Elsa Longhauser, Bice Curiger, Max Wechsler, Kristine Stiles, and William Horrigan.

Parkett, no. 45 (1995). Collaboration Roman Signer: Konrad Bitterli, Colin de Land, Christoph Doswald, Jean-Yves Jouannais, Pia Viewing, and Max Wechsler.

Kunstverein St. Gallen im Kunstmuseum, St. Gallen, Switzerland. *Roman Signer: Sculpture* (1991). Exhibition catalogue, texts by Konrad Bitterli, Roland Wäspe, and Lutz Tittel.

Sarah Sze/p.78
Born 1969, Boston, Massachusetts, U.S.A.
Lives and works in Brooklyn, New York

Sarah Sze began showing her work in 1996 in New York at the SoHo Annual and at P.S. 1 Contemporary Art Center, Long Island City, New York (1997). Since then she has been included in several major international exhibitions, including *Cities on the Move*, Secession, Vienna, and *Migrateurs*, Musée d'Art Moderne de la Ville de Paris (1997); *Manifesta 2, European Biennial of Contemporary Art*, Luxembourg, and *Berlin Biennial* (1998); and *48th Venice Biennale* (1999). Solo exhibitions of Sze's work have been presented at White Columns, New York (1997); Institute of Contemporary Art, London (1998); Museum of Contemporary Art, Chicago (1999); and Fondation Cartier pour l'art contemporain, Paris (1999–2000).

Education

1991 Yale University, New Haven, Connecticut

1997 School of Visual Arts, New York

Selected Further Reading

Kastner, Jeffrey. "Tipping the Scale." *art/text*, no. 65 (May–July 1999): 68–73.

Kastner, Jeffrey. "Discovering Poetry Even in the Clutter around the House." *New York Times*, 11 July 1999, 36.

Museum of Contemporary Art, Chicago. *Sarah Sze* (1999). Exhibition catalogue, texts by Francesco Bonami and Staci Boris.

Institute of Contemporary Art, London. *Sarah Sze* (1998). Exhibition catalogue, text by John Slyce.

Hanru, Hou. "Sarah Sze." *Cream*. London: Phaidon, 1998.

Sam Taylor-Wood/p.80
Born 1967, London, England
Lives and works in London

Sam Taylor-Wood has been exhibiting her videos and photographs in group exhibitions since 1991 and had her first solo show in London in 1994. Important group exhibitions include *Information Dienst*, Kunsthalle, Stuttgart (1993); *Don't Look Now*, Thread Waxing Space, New York (1994); *Masculin/Féminin*, Centre Georges Pompidou, Paris, and *Young British Artists (Project for General Release), 46th Venice Biennale* (1995); *Brilliant! New Art from London*, Walker Art Center, Minneapolis, Minnesota, and Contemporary Arts Museum, Houston, Texas (1995–96); *Festival for Contemporary British Artists*, Magazzini d'Arte Moderna, Rome, *Prospect 96*, Kunstverein, Frankfurt, *Manifesta 1*, Museum Boijmans Van Beuningen and Witte de With, Rotterdam, *The Event Horizon*, Irish Museum of Modern Art, Dublin, *Contemporary British Art*, Toyama Museum, *Life/Live*, Musée d'Art Moderne de la Ville de Paris and Centro de Exposições do Centro Cultural de Belém, Lisbon, and *Full House*, Kunstmuseum Wolfsburg (1996); *Sam Taylor-Wood and Pierrick Sarin*, Creux de l'Enfer, Centre d'art contemporain, Thiers, *47th Venice Biennale, Home Sweet Home*, Deichtorhallen Hamburg, *Truce*, SITE Santa Fe, New Mexico, *Sensation*, Royal Academy of Arts, London, *Worldwide Video Festival*, Stedelijk Museum, Amsterdam, *Montreal Film Festival*, *Trade Routes: History and Geography. 2nd Johannesburg Biennale*, and *5th International Istanbul Biennial* (1997). She has had one-person shows in Stockholm and London, including exhibitions at White Cube/Jay Jopling, London (1995–96); Fundació "la Caixa," Barcelona (1997); and Hirshhorn Museum and Sculpture Garden, Washington, D.C. (1999).

Selected Further Reading

Hirshhorn Museum and Sculpture Garden, Smithsonian Institution, Washington, D.C. *Sam Taylor-Wood* (1999). Exhibition brochure, text and interview by Olga M. Viso.

Fondazione Prada, Milan, Italy. *Sam Taylor-Wood* (1998). Exhibition catalogue, texts by Bruce W. Ferguson, Nancy Spector, and Michael Bracewell, and interview by Germano Celant.

Fundació "la Caixa," Barcelona, Spain. *Sam Taylor-Wood: Five Revolutionary Seconds* (1997). Exhibition catalogue, texts by Rosa Martínez and Gregor Muir.

Kunsthalle Zürich, Switzerland, and Louisiana Museum of Modern Art, Humlebæk, Denmark. *Sam Taylor-Wood* (1997). Exhibition catalogue, texts by Bernhard Bürgi, Kjeld Kjeldsen, Waldemar Januszczak, and Will Self.

Chisenhale Gallery, Sunderland, England, and Jay Jopling, London. *Sam Taylor-Wood* (1996). Exhibition catalogue, texts by Michael O'Pray and Jake Chapman.

Nahum Tevet/p.82
Born 1946, Kibbutz Mesilot, Israel
Lives and works in Tel Aviv

Nahum Tevet's sculptures and installations have been exhibited for over twenty-five years. He has participated in numerous group exhibitions, including *documenta 8*, Kassel, and *Similia/Dissimilia*, Kunsthalle Düsseldorf (1987); *Life Size: A Sense of the Real in Recent Art*, Israel Museum, Jerusalem (1990); *Art in Israel Today*, Detroit Institute of Arts, Michigan (1991); *XXII Bienal de São Paulo* (1994); *Painting—The Extended Field*, Rooseum Center for Contemporary Art, Malmö, and Magasin 3 Stockholm Konsthall (1996–97); *Bienale d'Art Contemporain de Lyon* and *ARKEN*, Museum for Modern Kunst, Copenhagen (1997); *The Seventies in Israeli Art*, Tel Aviv Museum of Art (1988); and *This Is Not a Ready Made*, Israel Museum, Jerusalem (1999). Tevet has had solo shows in galleries in Jerusalem, Düsseldorf, Paris, New York, Zurich, and Tel Aviv, including Dvir Gallery (1998). Solo museum shows include Israel Museum, Jerusalem (1976, 1984); Kunsthalle Mannheim (1986); Tel Aviv Museum of Art (1991); Museum moderner Kunst Stiftung Ludwig, Vienna (1997); and Chapelle des Jésuites, Nîmes (1998).

Education

1980–86 Bezazel Academy of Art, Jerusalem

Selected Further Reading

Tevet, Nahum, Sarah Breitberg-Semel, and Ohad Meromi. "How Much Wealth Can Originate from this Reductionism: A Conversation with Nahum Tevet." *Studio Israeli Art Magazine* 91 (March 1998): 20–34.

Museum moderner Kunst Stiftung Ludwig, Vienna, Austria. *Nahum Tevet* (1997). Exhibition catalogue, texts by Lóránd Hegyi, Sarit Shapira, and Eli Friedlander.

Israeli Society for Culture and the Arts, XXII International Biennial of São Paulo, Brazil. *Black Holes: The White Locus* (1994). Exhibition catalogue, text by Sarit Shapira.

Tel Aviv Museum of Art, Israel. *Nahum Tevet: Painting Lessons, Sculptures 1984–1990* (1991). Exhibition catalogue, texts by Yona Fischer, Joshua Decter, Yonah Foncé, and Ido Bar-El.

Städtische Kunsthalle Mannheim, Germany. *Nahum Tevet* (1986). Exhibition catalogue, texts by Michael Newman and Wolfgang Becker.

Diana Thater/p.84
Born 1962, San Francisco, California, U.S.A.
Lives and works in Los Angeles

Diana Thater began exhibiting her video instal-
lations in 1990. Since then her work has been
featured in major international exhibitions, includ-
ing *1st Kwangju Biennale* and *Biennale d'Art
Contemporain de Lyon* (1995); *Jurassic Tech-
nologies Revenant*, the 10th Biennale of Sydney
(1996); *Sculpture. Projects in Münster 1997*,
Westfälisches Landesmuseum and *Trade Routes:
History and Geography. 2nd Johannesburg
Biennale* (1997); and *Sunshine & Noir: Art in L.A.
1960–1997*, Louisiana Museum of Modern Art,
Humlebæk, which also traveled to Kunstmuseum
Wolfsburg (1997), Castello di Rivoli, and Armand
Hammer Museum of Art, Los Angeles (1998).
Solo shows of Thater's work have been presented
since 1991, including gallery exhibitions at David
Zwirner, New York (1993, 1996) and 1301, Santa
Monica, California (1993). Recent U.S. venues
include the Walker Art Center, Minneapolis, Minne-
sota (1997); Museum of Modern Art, New York,
and MAK Center for Art and Architecture, Schindler
House, Los Angeles (1998); and St. Louis Art
Museum, Missouri, and Carnegie Museum of Art,
Pittsburgh, Pennsylvania (1999). Major interna-
tional solo shows include installations at Witte
de With, Rotterdam (1994); Kunsthalle Basel
(1996); and Kunstverein, Hamburg (1997). Thater
received the ArtPace/A Foundation for Contem-
porary Art's International Artist-in-Residence
award in 1998.

Education

1984 New York University,
New York, B.A.

1990 Art Center College
of Design, Pasadena,
California, M.F.A.

Selected Further Reading

Museum of Modern Art,
New York. *Projects 64:
Diana Thater* (1998).
Exhibition brochure, text
by Fereshteh Daftari.

MAK Center for Art and
Architecture, Schindler
House, Los Angeles. *The
best animals are the flat
animals—the best space
is the deep space* (1998).
Exhibition catalogue, texts
by Amelia Jones, Carol
McMichael Reese, Diana
Thater, and Daniela Zyman.

Renaissance Society at
the University of Chicago,
Chicago. *Diana Thater:
China* (1996). Exhibition
catalogue, texts by Colin
Gardner, Timothy Martin,
and Diana Thater.

Kunsthalle Basel,
Switzerland. *the individual
as species, the object
as a medium. Diana Thater:
Selected Works 1992–1996*
(1996). Exhibition catalogue,
interview by Kathryn Kanjo.

Cahiers #3. Witte de
With, Centre for Con-
temporary Art, Rotterdam,
Netherlands (1995).
Text by Timothy Martin,
cover by Diana Thater.

Luc Tuymans/p.86
Born 1958, Mortsel, Belgium
Lives and works in Antwerp, Belgium

Luc Tuymans's paintings have been featured in numerous international group exhibitions since 1988, including *Ripple across the Water*, Watari Museum of Contemporary Art, Tokyo, and *Change of Scene VII*, Museum für Moderne Kunst, Frankfurt am Main (1995); *Face à l'Histoire*, Centre Georges Pompidou, Paris, and *Painting—The Extended Field*, Rooseum Center for Contemporary Art, Malmö, and Magasin 3 Stockholm Konsthall (1996–97); and *Future, Past, Present, 1965–1997, 47th Venice Biennale* and *Biennale d'Art Contemporain de Lyon* (1997). Solo gallery exhibitions of Tuymans's work have been presented at Zeno X Gallery, Antwerp (annually between 1990 and 1997, and in 1999) and at David Zwirner, New York (1994, 1996, 1998). Solo museum shows include Creux de l'Enfer, Centre d'art contemporain, Thiers (1991); Kunsthalle Bern (1992); Portikus Frankfurt am Main (1994); De Pont Foundation, Tilburg, and Renaissance Society at the University of Chicago (1995); Kunstmuseum, Bern, and Berkeley Art Museum, California (1997); CapcMusée d'art contemporain, Bordeaux (1998); and Salzburger Kunstverein, Salzburg, Bonnefantenmuseum, Maastricht, and Kunstmuseum Wolfsburg (1999). In 1999 Luc Tuymans curated the exhibition *Trouble Spot* at Museum van Hedendaagse Kunst Antwerpen, Antwerp.

Education

1976–79 Sint-Lukasinstituut, Brussels

1979–80 École Nationale Supérieure des Arts Visuels de la Cambre, Brussels

1980–82 Koninklijke Academie voor Schone Kunsten Antwerpen, Antwerp

1982–86 Vrije Universiteit, Brussels

Selected Further Reading

Bonnefantenmuseum Maastricht, Netherlands, and Kunstmuseum Wolfsburg, Germany. *The Purge* (1999). Exhibition catalogue, concept by Luc Tuymans and Alexander van Grevenstein.

Fundação de Serralves, Porto, Spain. *Luc Tuymans/ Mirosław Bałka: Privacy* (1998). Exhibition catalogue, texts by Julian Heyman, Alexandre Melo, and Vicente Todolí.

Kunstmuseum, Bern, Switzerland; Berkeley Art Museum, California; and CapcMusée d'art contemporain, Bordeaux, France. *Prémonition: Luc Tuymans* (1997–98). Exhibition catalogue, texts by Josef Helfenstein, Hans Rudolf Reust, and Lawrence Rinder.

Loock, Ulrich, Juan Vicente Aliaga, and Nancy Spector. *Luc Tuymans*. London: Phaidon, 1996.

Art Gallery of York University, Toronto, Canada; Renaissance Society at the University of Chicago; Institute of Contemporary Arts, London; Goldie Paley Gallery, Moore College of Art and Design, Philadelphia, Pennsylvania. *Luc Tuymans* (1994). Exhibition catalogue, texts by Gregory Salzman, Peter Schjeldahl, Luc Tuymans and Robert Van Ruyssevelt, and Hans Rudolf Reust.

Kara Walker/p.88
Born 1969, Stockton, California, U.S.A.
Lives and works in Providence, Rhode Island

Kara Walker began exhibiting in 1991 in Atlanta, Georgia, and her work has since been included in many international group exhibitions such as *La Belle et La Bête*, Musée d'Art Moderne de la Ville de Paris (1995); *Conceal/Reveal* at SITE Santa Fe, New Mexico, and *New Histories*, Institute for Contemporary Art, Boston, Massachusetts (1996); *no place (like home)*, Walker Art Center, Minneapolis, Minnesota, and *Whitney Biennial*, Whitney Museum of American Art, New York (1997); *Global Vision: New Art from the '90s*, Deste Foundation, Athens, and *Secret Victorians, Contemporary Artists and a 19th-Century Vision*, Hayward Gallery for the Arts Council of England, London (1998), which also appeared at Armand Hammer Museum of Art, Los Angeles (1999); and *Other Narratives*, Contemporary Arts Museum, Houston, Texas (1999). Numerous solo shows of Walker's work have been presented, including those at Wooster Gardens/Brent Sikkema, New York (1995, 1996, 1998); San Francisco Museum of Modern Art, California, and Renaissance Society at the University of Chicago (1997); and California College of Arts and Crafts, Oliver Art Center, Oakland (1999). In 1997 Walker received a John D. and Catherine T. MacArthur Foundation grant.

Education

1991 Atlanta College of Art, Atlanta, Georgia, B.A.

1994 Rhode Island School of Design, Providence, Rhode Island, M.F.A.

Selected Further Reading

California College of Arts and Crafts, Oakland, California. *Capp Street Project: Kara Walker* (1999). Exhibition brochure, interview with the artist by Lawrence Rinder.

Art Pool, Museum in Progress, and the Vienna State Opera, Vienna, Austria. *Kara Walker, Safety Curtain, 1998/99* (1998). Texts by Vitus H. Weh and Nancy Spector.

Hannaham, James. "Pea, Ball, Bounce: Interview with Kara Walker." *Interview* (November 1998): 114–19.

San Francisco Museum of Modern Art, California. *Kara Walker: Upon My Many Masters—An Outline* (1997). Exhibition brochure, text by Gary Garrels and interview with the artist by Alexander Alberro.

Renaissance Society at the University of Chicago. *Kara Walker* (1997). Exhibition catalogue, designed and written by Kara Walker.

Jeff Wall/p.90
Born 1946, Vancouver, British Columbia, Canada
Lives and works in Vancouver

Jeff Wall's work has been widely exhibited for over thirty years. Recent group shows include *Art and Film*, Museum of Contemporary Art, Los Angeles, *Projections*, Ydessa Hendeles Art Foundation, Toronto, *Public Information*, San Francisco Museum of Modern Art, California, *About Place: Recent Art of the Americas*, The Art Institute of Chicago, and *Whitney Biennial*, Whitney Museum of American Art, New York (1995); *Contemporary Photography, Absolute Landscape—Between Illusion and Reality*, Yokohama Museum of Art, and *documenta X*, Kassel (1997); *XXIV Bienal de Saõ Paulo* (1998); and *The Museum as Muse: Artists Reflect*, Museum of Modern Art, New York, and *The Time of Our Lives*, New Museum of Contemporary Art, New York (1999). Solo gallery exhibitions of Wall's work have been presented at Galerie Johnen & Schöttle, Cologne (1986, 1987, 1989, 1991, 1994, 1998) and at Marian Goodman Gallery, New York (1989, 1992, 1995, 1998). Recent museum shows include Museo Nacional Centro de Arte Reina Sofía, Madrid (1994); Jeu de Paume, Paris (1995); Whitechapel Art Gallery, London, Museum of Contemporary Art, Helsinki, and Städtische Galerie im Lenbachhaus, Munich (1996); Hirshhorn Museum and Sculpture Garden, Washington, D.C., Museum of Contemporary Art, Los Angeles, and Art Tower Mito, Japan (1997); Henry Moore Institute, Leeds (1998); and Musée d'art contemporain de Montréal, Espai d'art Contemporaneu, Castellon, and Mies van der Rohe Foundation, Barcelona (1999).

April 1 1999

Education

1968 University of British Columbia, Vancouver, B.A.

1970 University of British Columbia, Vancouver, M.A.

1970–1973 Courtauld Institute, London

Selected Further Reading

Musée d'art contemporain de Montréal, Canada. *Jeff Wall Œuvres 1990–1998* (1999). Exhibition catalogue, texts by Marcel Brisebois, Réal Lussier, and Nicole Gingras.

Museum of Contemporary Art, Los Angeles. *Jeff Wall* (1997). Exhibition catalogue, texts by Richard Koshalek and Kerry Brougher.

De Duve, Thierry, and Boris Groys. *Jeff Wall*. London: Phaidon, 1996.

Kunstmuseum Wolfsburg, Germany. *Landscapes and Other Pictures: Jeff Wall* (1996). Exhibition catalogue, texts by Gijs van Tuyl, Jeff Wall, and Camiel van Winkel.

Wall, Jeff. Interview by Els Barents. In *Jeff Wall: Transparencies*. New York: Rizzoli, 1987.

Jane and Louise Wilson's video installations and photographs have been included in numerous group exhibitions since 1992, including *NowHere*, Louisiana Museum of Modern Art, Humlebæk, *Auto Reverse 2*, Le Magasin, Grenoble, and *Attitude Adjustment*, 5th New York Video Festival, Lincoln Center (1996); *Hyperamnesiac Fabulations*, Power Plant, Toronto, and *Pictura Britannica*, which traveled to Museum of Contemporary Art, Sydney, Art Gallery of South Australia, Adelaide, and City Gallery, Wellington (1997); and *Spectacular Optical*, Thread Waxing Space, New York (1998). Their video installation *Stasi City* toured to Kunstverein Hannover, Kunstraum Munich, Musée d'art moderne et contemporain, Geneva, and Kunstwerke, Berlin (1997), and to 303 Gallery, New York (1998). Their work has also been presented at Serpentine Gallery, London (1999). The 1999 *Carnegie International* is the first United States presentation of *Gamma*, which premiered at Lisson Gallery, London (1999).

Education

1989 Duncan of Jordanstone College of Art, Dundee, B.A. (Louise)
Newcastle Polytechnic, B.A. (Jane)

1992 Goldsmiths College, London, M.F.A. (Jane and Louise)

Selected Further Reading

Schwabsky, Barry. "Jane and Louise Wilson." *Artforum* 37, no. 9 (May 1999): 187.

Anton, Saul. "Jane and Louise Wilson." *art/text* 63 (1998): 91–92.

Wakefield, Neville. "Openings: Jane and Louise Wilson." *Artforum* 37, no. 2 (October 1998): 112–13.

Kunstverein Hannover, Germany, and Berliner Künstlerprogramm, Deutscher Akademischer Austauschdienst, Germany. *Jane & Louise Wilson: Stasi City* (1997). Exhibition catalogue, text by Paolo Colombo and Elizabeth Johns; interview by Raimund Kummer.

Hilty, Greg. "Greg Hilty on Jane and Louise Wilson." *Frieze*, no. 18 (September/October 1994): 40–43.

Chen Zhen/p.94
Born 1955, Shanghai, China
Lives and works in Paris, New York, and Shanghai

During the last decade, Chen Zhen has presented his work at venues throughout Asia, Africa, Europe, and North America, including international exhibitions such as *First Shanghai Biennial*, Shanghai Art Museum (1996); *Biennale d'Art Contemporain de Lyon*, *97 Kwangju Biennale: Unmapping the Earth*, and *Trade Routes: History and Geography. 2nd Johannesburg Biennale* (1997); *1998 Taipei Biennal: Site of Desire*, Taipei Fine Arts Museum, and *Global Vision: New Art from the '90s*, Deste Foundation, Athens (1998); and *Cities on the Move*, Louisiana Museum of Modern Art, Humlebæk, *48th Venice Biennale*, and *3rd Asia-Pacific Triennial of Contemporary Art*, Queensland Art Gallery, Brisbane (1999). Solo exhibitions of Chen Zhen's work have been presented at New Museum of Contemporary Art, New York (1994); Centre international d'art contemporain de Montréal and Deitch Projects, New York (1996); National Maritime Museum, Stockholm, and Tel Aviv Museum of Art (1998); and ADDC-Espace Culturel François Mitterrand, Périgueux (1999).

Education

1973 Shanghai Fine Arts and Crafts School, Shanghai

1978 Shanghai Drama Institute, Shanghai

1986 École Nationale Supérieure des Beaux-Arts, Paris

1989 Institut des Hautes Études en Arts Plastiques, Paris

Selected Further Reading

Chen Zhen and Xian Zhu. *Chen Zhen: Transexperiences.* Kitakyushu, Japan: Center for Contemporary Art, CCA Kitakyushu, and Korinsha Press & Co., Ltd., 1998.

Deste Foundation, Athens, Greece. *Global Vision: New Art from the '90s, Part II* (1998). Exhibition brochure, text by Katerina Gregos.

Tel Aviv Museum of Art, Israel. *Chen Zhen: Jue Chang/Fifty Strokes to Each* (1998). Exhibition catalogue, texts by Nehama Guralnik, Mordechai Omer; correspondence between Nehama Guralnik and Chen Zhen.

Pujo, Aline. *Chen Zhen: Les Pas Silencieux/Silent Paces, 5 Projets aux États-Unis 1994–1997.* Paris: L'Association Française d'Action Artistique, Ministère des Affaires Étrangères, 1997. Published on the occasion of Chen Zhen's installation in *Artists Projects*, the re-opening show at P.S. 1 Contemporary Art Center, Long Island City, New York, 1998.

Centre international d'art contemporain de Montréal. *Chen Zhen* (1996). Exhibition catalogue, texts by Claude Gosselin and Hou Hanru.

Contributors

Jonathan Crary is associate professor of art history at Columbia University, New York. A founding editor of Zone Books, he is the author of *Techniques of the Observer: On Vision and Modernity in the Nineteenth Century* (1991) and *Suspensions of Perception: Attention, Spectacle, and Modern Culture* (1999). Crary was also coeditor of *Incorporations (Zone 6)*, 1992. A graduate of the San Francisco Art Institute, he has taught in the visual arts department at the University of California, San Diego, and has been a visiting critic in the sculpture department at Yale School of Art. Crary has been the recipient of National Endowment for the Arts, Mellon, Getty, and Guggenheim fellowships and was a member of the Institute for Advanced Study at Princeton University. He has written widely on issues of perception, visuality, technology, and contemporary culture.

Jean Fisher studied fine art at the University of Newcastle upon Tyne, England, and has subsequently written for various publications about issues of contemporary art practice, especially its relationship to postcolonialism and multiculturalism. She has written extensively on the work of James Coleman, Susan Hiller, Willie Doherty, and Gabriel Orozco, and has edited books of writings by Jimmie Durham (*A Certain Lack of Coherence*, 1993) and Lee Ufan (*Selected Writings*, 1996). Fisher is also the editor of two anthologies: *Global Visions: Towards a New Internationalism in the Visual Arts* (1994) and *Reverberations: Tactics of Resistance, Forms of Agency* (in preparation). She was editor of the international journal *Third Text* (1992–99) and is currently Research Fellow at the Jan van Eyck Akademie, Netherlands, and Course Leader of the M.A. program in Visual Culture at Middlesex University, London.

Saskia Sassen is professor of sociology at the University of Chicago and Centennial Visiting Professor, London School of Economics. She is one of the foremost theoreticians on the subject of the emerging information society. Sassen won an international reputation with her book *The Global City* (1991), in which she shows how, in the development of major urban centers, localized effects of the new global economy become visible. Her most recent books are *Guests and Aliens* (1999), *Globalization and Its Discontents* (1998), and *Losing Control? Sovereignty in an Age of Globalization* (1996). Sassen's work has appeared in translation in ten languages; *The Global City* has appeared in French (1996), Italian (1998), and Spanish (1998). Currently, she is completing *Cities and Their Crossborder Networks* and the research project "Governance and Accountability in a Global Economy." Sassen is a member of the Council on Foreign Relations and a Fellow of the American Bar Foundation.

Slavoj Žižek is senior researcher at the Institute for Social Sciences, University of Ljubljana, Slovenia. A leading intellectual in the new social movements in Eastern Europe, Žižek has used the psychoanalytic theory of Jacques Lacan (along with Kant, Hegel, Marx, and Althusser) to construct new accounts of ideology, critique, radical evil, and, most recently, the political disintegration and reconfiguration of Eastern Europe. He is well known in the United States for his Lacanian analyses of film, especially the work of Alfred Hitchcock. Žižek's published works in English include *The Sublime Object of Ideology* (1989); *Looking Awry: An Introduction to Jacques Lacan through Popular Culture* (1991); *Enjoy Your Symptom! Jacques Lacan in Hollywood and Out* (1992); *Tarrying with the Negative: Kant, Hegel, and the Critique of Ideology* (1993); *For They Know Not What They Do: Enjoyment as a Political Factor* (1996); and *The Ticklish Subject: The Absent Centre of Political Ontology (Wo Es War)* (1999). In 1990, Žižek ran as a pro-reform candidate for the presidency of the Republic of Slovenia, then part of Yugoslavia.

Carnegie Institute Officers and Trustees

Carnegie Museum of Art Board

Carnegie Museum of Art Staff

Richard Armstrong
The Henry J. Heinz II Director

Michael J. Fahlund
Assistant Director

Champ Knecht
*Administrative and
Financial Coordinator*

Nicky Taylor
*Executive Secretary
to Director and
Assistant Director*

Meg Bernard
Director of Development

William Devlin
*Information Systems
Manager*

Chris Rauhoff
Exhibitions Coordinator

Tey Stiteler
Communications Manager

Conservation
William A. Real
Chief Conservator

Ellen J. Baxter
Paintings Conservator

Hal Gill
Secretary

Rhonda Wozniak
Objects Conservator

Contemporary Art
Madeleine Grynsztejn
Curator of Contemporary Art

Alyson Baker
Curatorial Assistant

Lynn Corbett
Secretary

Jennifer Hulme Curry
Research Assistant

Decorative Arts
Sarah Nichols
*Chief Curator and Curator
of Decorative Arts*

Elisabeth Agro
*Assistant Curator
of Decorative Arts*

Elizabeth Teller
Research Assistant

Wendy Weckerle
Secretary

Education
Marilyn M. Russell
*Chair and Curator
of Education*

Megan Burness
*Education Programs
Specialist, School Programs*

Patty Jaconetta
*Education Programs
Specialist, Tours and
Research*

Charlene Shang Miller
*Education Programs
Specialist, Public Programs*

Wendy Osher
*Assistant Curator
of Education,
Children's Programs*

Madelyn Roehrig
*Education Programs
Specialist, Studio Classes*

Lucy Stewart
*Education Programs
Assistant*

Anne Walters
*Manager, Group Visits and
Program Registration*

Darnell Warren
*Education Programs
Assistant, Children's
Programs*

Wendy Zirngibl
*Education Programs
Assistant, Gallery Programs*

Film and Video
William D. Judson
Curator of Film and Video

Amy de Camp
Program Assistant

Amy Wilson
Curatorial Assistant

Fine Arts
Louise Lippincott
Curator of Fine Arts

Linda Batis
*Associate Curator
of Fine Arts*

Lauren Friedman
Secretary

**The Heinz
Architectural Center**
Tracy Myers
*Assistant Curator
of Architecture*

Bethany Mummert
Secretary

Publications
Gillian Belnap
Head of Publications

Elissa Curcio
Publications Associate

Beth Levanti
*Coordinator of Photographic
Services*

Office of the Registrar
B. Monika Tomko
Registrar

Allison Revello
Assistant to the Registrar

Heather Wahl
Assistant to the Registrar

Workshop
Frank Pietrusinski
Supervisor

Ray Sokolowski
Assistant Supervisor

Jim Dugas
Workshop Crew

Andrew Halapin
Workshop Crew

James Hawk, Jr.
Workshop Crew

Ross Kronenbitter
Workshop Crew

Dale Luce
Workshop Crew

Photo Credits

Franz Ackermann
pp. 16–17
Courtesy the artist and
neugerriemschneider, Berlin

Matthew Barney
pp. 18–19
Photos: Michael
James O'Brien
© Matthew Barney, 1999
Courtesy Barbara Gladstone
Gallery, New York

Janet Cardiff
pp. 20–21
Courtesy Carnegie Library
of Pittsburgh

John Currin
p. 22
Photo: Madeleine Grynsztejn
p. 23
Photo: Fred Scruton
Courtesy Andrea Rosen
Gallery, New York

Hanne Darboven
pp. 24–25
Photos: Richard A. Stoner

Thomas Demand
p. 26
Courtesy Victoria Miro
Gallery, London
p. 27
Courtesy 303 Gallery,
New York

Mark Dion
p. 28
Photos: Mark Dion
Courtesy American Fine
Arts, Co., New York
p. 29
Courtesy the American
Philosophical Society,
Philadelphia

Willie Doherty
pp. 30–31
Courtesy Alexander and
Bonin, New York, and
Matt's Gallery, London

Olafur Eliasson
pp. 32–33
Photos: Olafur Eliasson

Kendell Geers
pp. 34–35
Photos of John White
Alexander mural:
Richard A. Stoner
Inset photos of restoration
project: Courtesy
Carnegie Museum of Art
Conservation Department

Felix Gonzalez-Torres
p. 36
Photo: Peter Muscato
Courtesy Andrea Rosen
Gallery, New York
p. 37
Courtesy The Baltimore
Museum of Art

Ann Hamilton
pp. 38–39
Photo: Thibault Jeanson
Courtesy the artist and Sean
Kelly Gallery, New York

José Antonio
Hernández-Diez
pp. 40–41
Photo: Ernesto Valladares
Courtesy Museo
Alejandro Otero, Caracas

Pierre Huyghe
pp. 42–43
Courtesy the artist and
Marian Goodman Gallery,
New York and Paris

Alex Katz
pp. 44–45
Photo: Nicholas Walster

William Kentridge
p. 46
Photos: Roger Wooldridge
Courtesy the artist and
The Goodman Gallery,
Johannesburg (top)
Courtesy the artist and
Marian Goodman Gallery,
New York (bottom)
p. 47
Photo: Roger Wooldridge
Courtesy the artist and
Marian Goodman Gallery,
New York

Bodys Isek Kingelez
pp. 48–49
Photo: Dan Dennehy, 1998
Courtesy C.A.A.C. – The
Pigozzi Collection, Geneva

Suchan Kinoshita
pp. 50–51
Courtesy the artist

Martin Kippenberger
pp. 52–53
Photo: Jannes Linders
Courtesy The Estate
of Martin Kippenberger
and Galerie Gisela Capitain,
Cologne

Kerry James Marshall
pp. 54–55
Photos: Richard A. Stoner

Takashi Murakami
pp. 56–57
Photos: Nomadic Factory
Courtesy the artist and
Blum & Poe, Santa Monica

Shirin Neshat
p. 58
Photo: from the book
Above Los Angeles by
Robert Cameron
p. 59
Courtesy the artist

Ernesto Neto
pp. 60–61
Courtesy the artist

Chris Ofili
p. 62
Courtesy Victoria Miro
Gallery, London, and
Gavin Brown's enterprise,
New York
p. 63
Photo: J. Littkemann
Courtesy Victoria Miro
Gallery, London, and
Gavin Brown's enterprise,
New York

Gabriel Orozco
pp. 64–65
Courtesy Marian Goodman
Gallery, New York

Markéta Othová
pp. 66–67
Photos: Markéta Othová

Laura Owens
p. 69
Courtesy Gavin Brown's
enterprise, New York

Edward Ruscha
pp. 70–71
Courtesy Gagosian Gallery

Gregor Schneider
pp. 72–73
Photo: Gregor Schneider
Courtesy the artist, Galerie
Luis Campaña, Cologne,
and Konrad Fischer Galerie,
Düsseldorf

Ann-Sofi Sidén
pp. 74–75
Courtesy Galerie
Nordenhake, Stockholm

Roman Signer
pp. 76–77
Photos: © Aleksandra Signer
Courtesy the artist
and Galerie Hauser &
Wirth, Zurich

Sarah Sze
pp. 78–79
Courtesy Marianne Boesky
Gallery, New York

Sam Taylor-Wood
pp. 80–81
Courtesy Jay Jopling,
London

Nahum Tevet
pp. 82–83
Courtesy the artist

Diana Thater
pp. 84–85
Photos: Richard A. Stoner
Courtesy the artist; 1301PE,
Los Angeles; and David
Zwirner, New York

Luc Tuymans
pp. 86–87
Photos: Felix Tirry
Courtesy Zeno X Gallery,
Antwerp

Kara Walker
p. 89
Photo: Richard A. Stoner
Courtesy the artist

Jeff Wall
pp. 90–91
Courtesy the artist

Jane & Louise Wilson
pp. 92–93
Courtesy the artists, The Arts
Council of England, and
Lisson Gallery, London, with
thanks for the support of
303 Gallery, New York

Chen Zhen
pp. 94–95
Courtesy Deitch Projects,
New York

pp. 100, 107, 114, 123
Slides taken by Madeleine
Grynsztejn, 1997–99

p. 138
Courtesy Marian Goodman
Gallery, New York

p. 139
Courtesy Gagosian Gallery

p. 141
Courtesy Alexander and
Bonin, New York, and
Matt's Gallery, London

Franz Ackermann
p. 162
Photo: Jens Ziehe, Berlin
Courtesy neugerriem-
schneider, Berlin

Matthew Barney
p. 163
Photo: Michael
James O'Brien
© Matthew Barney, 1999
Courtesy Barbara Gladstone
Gallery, New York

Janet Cardiff
p. 164
Photo: George Bures Miller

John Currin
p. 165
Photo: Kevin Landers
Courtesy Andrea Rosen
Gallery, New York

Hanne Darboven
p. 166
Photo: David Leiber
Courtesy Sperone
Westwater, New York

Thomas Demand
p. 167
Photo: Albrecht Fuchs

Mark Dion
p. 168
Photo: Bob Braine

Willie Doherty
p. 169
Photo: Melissa Leith
Courtesy Alexander and
Bonin, New York

Olafur Eliasson
p. 170
Photo: Madeleine Grynsztejn

Kendell Geers
p. 171
Photo: Kendell Geers

Felix Gonzalez-Torres
p. 172
Photo: © Estate of David
Seidner, 1999
Courtesy the Estate of
David Seidner

Ann Hamilton
p. 173
Photo: Richard Ross, 1994
Courtesy Sean Kelly Gallery,
New York

José Antonio
Hernández-Diez
p. 174
Photo: Aitor Ailanto

Pierre Huyghe
p. 175
Courtesy Marian Goodman
Gallery, Paris

Alex Katz
p. 176
Photo: Vivien Bittencourt

William Kentridge
p. 177
Photo: Peter Rimell
Courtesy The Goodman
Gallery, Johannesburg

Bodys Isek Kingelez
p. 178
Photo: André Magnin, 1990

Suchan Kinoshita
p. 179
Photo: Madeleine Grynsztejn

Martin Kippenberger
p. 180
Photo: © Elfie Semotan
Courtesy Galerie Gisela
Capitain, Cologne

Kerry James Marshall
p. 181
Photo: © Jon Randolph,
1998

Takashi Murakami
p. 182
Photo: Yoshiki Sumikura
Courtesy Blum & Poe,
Santa Monica

Shirin Neshat
p. 183
Photo: Larry Barns

Ernesto Neto
p. 184
Photo: Liliane Kemper

Chris Ofili
p. 185
Photo: Peter Doig
Courtesy the artist

Gabriel Orozco
p. 186
Photo: Roman Mensing
Courtesy Marian Goodman
Gallery, New York

Markéta Othová
p. 187
Courtesy the artist

Laura Owens
p. 188
Photo: Scott Reeder
Courtesy the artist

Edward Ruscha
p. 189
Photo: Danna Ruscha

Gregor Schneider
p. 190
Photo: Gregor Schneider

Ann-Sofi Sidén
p. 191
Photo: Nils Claesson
Courtesy Galerie
Nordenhake, Stockholm

Roman Signer
p. 192
Courtesy the artist
and Galerie Hauser &
Wirth, Zurich

Sarah Sze
p. 193
Courtesy Marianne Boesky
Gallery, New York

Sam Taylor-Wood
p. 194
Photo: Phil Poynter
Courtesy Jay Jopling,
London

Nahum Tevet
p. 195
Photo: Tal Shani, Tel Aviv

Diana Thater
p. 196
Photo: © Roman Mensing
Courtesy David Zwirner,
New York

Luc Tuymans
p. 197
Photo: © Ludo Geysels
Courtesy Zeno X Gallery,
Antwerp

Kara Walker
p. 198
Photo: © Dana L. Walker
Courtesy Brent Sikkema,
New York

Jeff Wall
p. 199
Courtesy the artist

Jane & Louise Wilson
p. 200
Photo: Patrick
Fetherstonhaugh

Chen Zhen
p. 201
Photo: Hu Fengchuen

CI:99/

00/V.01